THE INSTANT IMAGE

THE INSTANT IMAGE

Edwin Land and the Polaroid Experience

Mark Olshaker

STEIN AND DAY/*Publishers*/New York

First published in 1978
Copyright © 1978 by Mark Olshaker
All rights reserved
Designed by Ed Kaplin
Printed in the United States of America
Stein and Day/*Publishers*/Scarborough House,
Briarcliff Manor, N.Y. 10510

Library of Congress Cataloging in Publication Data

Olshaker, Mark, 1951–
 The instant image.

 Bibliography: p. 268
 Includes index.
 1. Land, Edwin Herbert, 1909- 2. Polaroid
Corporation, Cambridge, Mass. I. Title.
TR140.L28047 338.7'68'14180924 [B] 77-15965
ISBN 0-8128-2442-3

For my parents,

Thelma and Bennett Olshaker

Contents

List of Illustrations

Introduction

Large corporations do not, as a rule, want to have un-authorized books written about them, and Polaroid at no exception. When I originally announced this project, the company stated that I could expect no cooperation. When officials there resigned themselves to the fact that the book would be written in any event, the attitude changed some-what although Polaroid remained aloof. After the manuscript was completed the galley page proofs were reviewed, and some suggestions were offered by Polaroid on some technical and scientific points. The decisions as to which to accept were mine alone. This remains a book written independently of Polaroid Corporation and Dr. Land. It was neither authorized nor approved by them. Responsibility for both fact and interpretation is solely mine.

Because my requests for interviews with individual com-pany leaders were repeatedly deferred, most of the contact between myself and Polaroid employees was conducted outside official channels. I am therefore obliged to respect their desire for anonymity, while thanking them collectively for their invaluable contribution.

The one person at the company I did have access to was Donald A. Dery, Polaroid's director of publicity and commu-nications, who met with me on several occasions and impressed me with his candor and insight. He also furnished me with many of the corporate materials I used in this project, and I thank him for his courtesy, cooperation, and interest.

I would also like to thank Eugene Richner of the Eastman Kodak Company and the other Kodak employees

who took the time to speak with me, and all of the people in various fields whose cooperation contributed to this book. A partial list would include Ansel Adams, Marie Cosindas, Dr. Jerome Lettvin, Kenneth Showalter, Peter Sherer, Richard Dudman, Stephen Allen Whealton, Gene Klavan, Ross Klavan, Ray Hubbard, Isaac Fleischmann, and U.S. Commissioner of Patents C. Marshall Dann. I am grateful to Larry Klein for his aid in helping me structure the manuscript, and to A. E. Claeyssens and my father, Bennett Olshaker, for their careful readings and invaluable suggestions for improving the work. The same is of course true of my editor, Patricia Day. My brother, Robert Olshaker, provided extensive guidance on the scientific sections of the book. A number of people kept me abreast of what was being written about the subject in the major publications, and without their concern I would have missed much of it. Among them are Cabbe Arnold, Michael Bass, and Donna Sullivan.

My special thanks go to Jay Acton, who conceived of the idea for this book with me and who can take the credit for its becoming a reality, and to Marty Bell, whose enthusiasm, encouragement, and editorial insight were largely responsible for my ability to see this project through.

Finally, my complete and utter gratitude goes to my wife, Carolyn, whose aid, support, and morale-boosting were unending, and who took over the ordering of my life to an extent that made the writing of this book not only possible but enjoyable.

To all of these people I will only say further that I hope someday I can at least partially repay all their kindnesses.

Mark Olshaker
Washington, D.C., May 1978

THE INSTANT IMAGE

"An institution is the lengthened shadow
of one man."

RALPH WALDO EMERSON,
Self-Reliance

Perspectives

The Annual Meeting

The traffic is heavy on every approach into Needham. From each one, special signs and policemen point cars to a concentric ring of parking lots commandeered for the day by the company. Shuttle busses are waiting to ferry shareholders from the lots to the debarkation point in front of the Distribution Center. From there, additional policemen and company security agents funnel the crowds into an orderly line that snakes around the back of the huge modern warehouse. Those at the front of the queue face a single set of solid metal doors where at precisely 1:00 P.M. smiling young women in identical brightly colored suits begin checking credentials and admitting people inside. The more than 2000 automobiles have caused no traffic jams, and the 4000-plus individuals present no crowd-control problems as they wait patiently under a threatening New England sky to reach the doors. The company, it seems, has everything well under control.

The interior of the warehouse extends farther than the visitor—adjusting to the dim lighting conditions—can at first make out. It gradually becomes apparent that the cavernous room contains an expanse of folding chairs greater than the area of a football field. And throughout, the excited buzz of

anticipation centers on the white brochure handed to each shareholder. The slim booklet's center spread confirms the rumor that an important new invention is, in fact, about to be revealed.

Near the temporary stage at the front of the hall, one becomes aware of a strange quieting of the audience, although nothing has been broadcast over the public address system. Almost magically, starting in the back of the room and moving in waves toward the front, silence begins to drown out the buzzing as each row in turn suddenly becomes aware of the chairman's presence in the auditorium. Surrounded by a small group of aides and carrying a notebook under his arm, the chairman moves ceremoniously from the rear of the building forward, offering a barely perceptible nod to random persons seated close to the aisle. As this executive procession moves closer to the stage, recognition turns the silence into respectful applause. All energy in the hall is focused on one man.

He leaves his aides standing in a small cluster at the base of the stage as he climbs the steps, walks slowly to the middle of the platform, grips the lectern with both hands, and surveys the 4000 people he calls his partners, whom he will— once again—not disappoint this afternoon. The chairman is something under five-foot-nine. His black hair is tinged with gray only on the sides. He is wearing a white shirt, red and blue striped tie, and a black suit of nondescript cut, though the opening sleeve buttons indicate that the suit is probably custom-made; the jacket creases unevenly across the too-large gut. The chairman looks down at his prepared text, apparently waiting for the specific moment when he can sense the crowd is most with him.

"I am Edwin Land, Chairman of the Board of the Polaroid Corporation," he finally announces to the audience, which has come from all parts of the country to bear witness to his one annual public appearance. He looks down again at his text, looks up, and the 40th annual meeting is underway at 2 P.M. on April 26, 1977.

Dr. Land weaves a verbal texture of philosophical images,

enthralling the gathering. Commenting that the corporation is currently involved "not with products and industries, but new concepts of what a company should be," he will, later on, refer to the actual new product as "layers of concepts." He speaks with a patrician Boston accent, but his voice is somewhat higher-pitched than expected. He hesitates even when reading a prepared text. His deep, sunken eyes, however, are riveting across the total length of the converted warehouse. And even if they were not, he would hold the assembly on reputation—or as some would say, legend—alone.

Before coming to the key elements of his presentation, he introduces William McCune, president of the company, the man to whom he finally relinquished one of the top three posts he has held since founding the firm. McCune, taller, trimmer, and more elegant than Dr. Land, replaces the chairman at the lectern to report that sales and earnings have both set records in the past year and have grown by more than 70 percent since 1972. Demand for products is at an all-time high and construction of a major new factory is well along. The news is all good, just what stockholders like to hear. But they knew this already from the annual report and a flood of recent articles. They had come to the meeting for something more.

The nomination of directors, which McCune conducts, is as well-ordered as the traffic flow had been outside. There is not one single objection, withdrawal of proxy, or alternative vote. The entire slate is elected unanimously, and all further, legally required business is dispatched in a matter of minutes. A brief business review follows, highlighting a number of newly marketed cameras using the most modern film the company manufactures. And then McCune defers to Dr. Land.

The chairman and an aura of electricity return to the lectern. He holds up a small, slim camera as if it were a battle flag and announces "the beginning of a new science, art and industry . . . The era of immediately visible, living images is now at hand."

Lights dim, a fetching girl in a red and white sailor suit

prances onstage, twirls her cane, and begins tap-dancing to the piped-in strains of the Washington Post March. She is so enthusiastic, she almost jumps from side to side, her knees higher in the air with each note. Her smile entices the audience into thinking that this dance-hall frolic is what they really came to see. Dr. Land has stepped to the side, where he opens the camera he has been holding, and attempts to jam in a film cassette. It will not go in. The man who invented the industry smiles knowingly, sharing this technological joke with the applauding crowd. He flips the cassette over. This time it goes in, and he begins filming. He must have done it a hundred times in the laboratory, but still he displays the zeal of a father recording his daughter's first steps. The shooting stops. Dr. Land removes the cassette from the camera and pops it into a television-like viewer. Ninety seconds of rewinding and a full-color movie of the dancing girl appears on the screen, exactly the same as the audience has just seen her in life.

The movie is clear, vivid, and just what the 4000 spectators have come to see. They burst into a round of applause, realizing they will be able to go out from this meeting and tell their friends, associates, and, one day, their grandchildren that they were present at a history-making moment. It will be a moment equal, perhaps, to that moment 30 years earlier when the same man first announced instant still pictures to a far less prepared world, as yet unjaded by the steady stream of technological wonders which have appeared in the interim.

"This is a rather miraculous cassette," the chairman explains. From anyone else, it would sound like shameless boasting. But from Dr. Land it is different. He is merely sharing a secret with the audience before it is public knowledge.

Now the "partners" get to share the actual experience. Led off in groups of a hundred, the shareholders are ushered behind the platform into a series of rooms where 40 colorful stages are peopled by dancers and mimes, every bit as poster-like as the girl who interpreted the Washington Post March

for Dr. Land's camera. Each person in the group gets to shoot 8 seconds of film at one of the scenes. John McCann of the Vision Research Lab stands in the middle of the human surge, deftly orchestrating the movements of the eager but orderly crowd.

The groups of a hundred are further broken down to contingents of twenty each. When they have finished off a cassette, they are led to a viewer to watch their results. The films are surprisingly steady and clear, considering none of the "cameramen" has ever used the instrument before. Each member of the group nods approvingly as his or her own segment appears. The people are then directed to return to their seats to await the continuation of the meeting.

Throughout the 40-minute interlude, the chairman stands on the floor near the left front of the stage, talking to the members of his inner circle. One shareholder pauses on his way back to his seat, opens up the SX-70 camera he has brought with him, and takes a step closer.

"Can I take a picture of Dr. Land?" he asks the red-armbanded usher who rapidly approaches him.

"No," she declares. "You have to return to your seat."

When everyone is safely back in his own place, the chairman ascends the platform once again and states, "There's a rule they don't teach you at the Harvard Business School. It is, if anything is worth doing, it's worth doing to excess." This leads him into a loving discourse on the instant movie system everyone has just become acquainted with. "We're serious about this field," he assures. "It's a new mechanism for relating to life and each other."

Standing beside the large projection screen on which the financial figures had been shown, Dr. Land narrates a test reel made in the laboratory. It shows an adorable dog romping. It is the kind of animal Walt Disney's artists must use as models for their drawings; the type of canine countless little girls have rescued from countless dog pounds. Land tells about the dog and how the lab researchers developed such an attachment to him. Then, as if to emphasize the human value of the device he is demonstrat-

ing, Dr. Land reveals that the dog has since passed on, and all that is left is this graphic, living memory captured on instant movie film.

The chairman and president each take questions from the floor. No price is quoted, and marketing dates are vaguely left at "some time in the fall."

Most of the queries center on the marvel the audience has just witnessed. The chairman speaks in general terms, as if each question is merely a prompt for the next thing he wanted to say. When he is questioned on the specifics of the instant movie system, he tends to speak philosophically, not of capabilites but of possibilities.

One questioner is not satisfied. This is all well and good, he asserts, but what will the system do for Polaroid's long-range profitability—the "bottom line," as it is called?

"The only thing that counts is the bottom line?" Dr. Land retorts. "What a presumptuous thing to say!"

"The bottom line," he adds, "is in heaven."

The Lengthened Shadow

"High technological drama" was the way Edwin Herbert Land described his company's situation in the spring of 1971. This phrase impressed me more than any other single thing I had read from him, perhaps because it was so characteristic of his entire outlook and approach. At the time he said it, the SX-70 camera system—one of the dreams of Land's life—had already cost millions of dollars and had not yet turned back a dime. The company was establishing manufacturing capability and experiencing wrenching growing pains in the process. And the solutions to the myriad of scientific issues attending the camera's evolution were looming just out of reach. I could easily imagine other corporation leaders of international stature retreating behind such well-worn expressions as "negative cash flow," "unfavorable balances," and

"unforeseen developmental increments." But to Edwin Land, facing what *Fortune* magazine would call "the biggest gamble ever made on a consumer product" amidst this onslaught of seemingly insurmountable problems—inside the corporation in the form of cost overruns and the technologies which refused to be born, and outside in the form of a gradually deflating consumer economy—was to be regarded as the stuff of high technological drama.

The next several years after 1971 would be increasingly difficult ones for Polaroid, a company whose dazzling success had little prepared it for lean times. But I was struck by the observation that the word "problem" had completely departed from Edwin Land's vocabulary, to be replaced by the word "opportunity." And a series of pronouncements that I would have perceived as empty optimism from most sources sounded from Dr. Land like articles of faith.

What was it about this man and his company that allowed such confidence and seeming lack of concern with the traditional top priorities of American business? My continuing interest, as I attempted to analyze it, seemed to stem at least partially from the elements that set Polaroid apart from virtually every other major American company, and also from a man who was impossible to "type" by any readily applicable standard.

The Polaroid story is several different but interrelated stories, all converging in the singular personality of Edwin Herbert Land. Polaroid is far from the largest, nor has it grown the fastest of the high-technology bellwethers; Xerox and Sony, to name but two, have grown faster and larger in a shorter period of time. There is, however, something unique about Polaroid, having to do both with the human dimension of the company and with the unity of vision of its founder and guiding genius. Polaroid executives now take great pains to point out that the almost 70-year-old Land is not *the* company, but its development and the development of the industry it pioneered is the story of Edwin Land.

In Land I saw a number of American types and traditions coming together. He is a New England inventor in direct

spiritual lineage from Eli Whitney, Charles Goodyear, and George Westinghouse, the breed who inspired the term "Yankee ingenuity." He is perhaps the last of the major technological visionaries-cum-business entrepreneurs in the larger-than-life tradition of Henry Ford and the other photographic giant, George Eastman. He is also a leading exponent of reform in the fields of education and labor conditions, and an accomplished scientist who came up with a completely original approach to the theory of color vision.

And he is the contemporary incarnation of the American Dream.

Perhaps the single most important aspect of Land's character, and the one to which he owes his and Polaroid's success, is his ability to regard things around him in a new and totally different way, without regard to that which has come before. There is the instant camera, his most famous invention; the polarizing filter which began his career and founded his company; the "retinex theory" of color perception; and, most recently, the Polavision system of instant motion pictures. All of these are radical departures from previous thought and practice, each one coming at a propitious moment and forming into an "instant image" of what needed to be done to see it through to reality.

Right from the beginning of his career Land has paid scant attention to what the "experts" had to say, trusting his own instincts instead. For example, most experts who continually predicted that Land and Polaroid would fail in the marketplace with each new product or development were evaluating those products only in terms of the way they fit into the current market. Clearly, in most cases, the new products had little to do, technologically, with what was available on the current market except that they, too, produced photographs—and there was a market for cameras. But Land has always believed that for any item sufficiently ingenious and intriguing, a new market could be created. Conventional wisdom has little capacity with which to evaluate a market that did not exist prior to the product that

defines it. Land had already gotten his co-workers out of the habit of relying on what was already there. It is not merely a concept of successful marketing, but the basis of his theory of inventiveness and creativity.

"Nearly every worthwhile invention," he has said, "will ... seem to be a war comprising many battles, every battle being against fixed attitudes."

He feels that creativity is an individual thing, not generally applicable to group generation. Land wrote in *Product Engineering* in 1964, "This process of successful attack upon a whole domain of our social structure is what we mean by creativity."

And 5 years earlier he had written in the *Harvard Business Review*, "I think human beings in the mass are fun at square dances, exciting to be with in a theater audience, and thrilling to cheer with at the California-Stanford or Harvard-Yale games. At the same time, I think whether outside science or within science there is no such thing as *group* originality or *group* creativity or *group* perspicacity."

Land is a man deeply caught up in the creative potential of the individual. This is not surprising, really, since Land owes his success to the realizing of his own creative potential. But it is not just himself, his scientific brethren, and his artistic peers that Land is talking about. He is talking about all of us.

Land's contribution to photography and popular culture—the instant-developing camera that bears his name—is an attempt to bring creativity within the realm of the "average" person. By removing both technical and temporal barriers, Land feels that the picture-taker is put in a truer and more direct relationship with his subject. He need be concerned only with the "what" of his interest, and not with the "how" of conveying it.

Land and Polaroid seldom speak, however, merely of "taking pictures." Words such as "relating" and "experience" more often characterize their philosophy. Land genuinely does believe, I think, that his company is in the business of

facilitating life experiences for his customers, in the same way that he believes Polaroid is in the business of enhancing work experiences for his employees. And as the record of the past four decades indicates, he has been at least partially fulfilled on both counts.

2

The Beginning

Origins

Edwin Herbert Land, who is universally referred to as "Doctor" and who holds high professorial rank at both Harvard and MIT, never graduated from college. At the time when he might have been completing requirements for the B.A., Land had more important things to do.

His early education began traditionally enough for a young New Englander in the upper middle class. He had been born in Bridgeport, Connecticut, on May 7, 1909 to Harry M. and Martha F. Land. Harry owned an iron and scrap business and also had extensive real estate holdings throughout Connecticut. During Edwin's early childhood, the family moved across the southern end of the state to Norwich. The Lands were Jewish, but there is no record of the extent of young Edwin's involvement with religion.

Throughout his public life, Land has always been extremely—some might say excessively—guarded in the details of his personal existence. This yen for privacy is so pervasive that for an article *The New York Times* was doing when the SX-70 camera was introduced, Polaroid would not even reveal the names of Land's two married daughters. (The *Times* did secure the names through a private source.) So not surprisingly, the penchant for personal secrecy extends to Land's formative years.

From all accounts, though, his early educational experience was typical and, from the outside, virtually interchangeable with that of any number of individuals who went on to become moderately successful in later life. At the private Norwich Academy, Land's grades were good, and his science teachers spoke of his exceptional ability and potential. His two most prominent extracurricular activities were membership in the school track and debating teams. His interest in athletics surfaced in later life with a mild, ongoing interest in tennis. And his interest in debating (he was reportedly a very good one) seems to have left him completely once he became a "public" person.

On one of the few occasions that Land did briefly open up to someone outside his small and fiercely loyal inner circle, he confided to a professor friend while vacationing in New Mexico that he had always been tremendously impressed and overwhelmed by his businessman father, and determined from an early age that he would someday outdo him. This confession seems to be typical of great men, and has a sort of classical ring to it. It helps to explain, however, only the drive—and not the imagination and insight, which must have been waxing almost from the beginning. Incidentally, the professor reported that after this one offhand remark, Land never again offered a single detail about his life, though they spoke often in the following years of scientific subjects they were mutually interested in.

Upon graduating from Norwich Academy in 1926, Land enrolled in Harvard College, as was undoubtedly expected of a bright young man in his position. Here began a lifelong association with the University and the intellectual bustle of the Cambridge environment. Land and his wife still live only a few blocks from Harvard Square on a residential Cambridge street.

One of the scientists who influenced Land was R.W. Wood. Speaking at the Roland-Wood Symposium at Johns Hopkins in 1975, Land said, "I grew up in a small town in Connecticut where there was one physics book, a copy of Ganot's *Physics*, and not much science, but I was a proud

possessor, somehow, of the second edition of Wood's *Physical Optics*, and as a boy I would take that to bed with me and read it every night and be inspired by the limitations of R.W. Wood which were the basis of his understandable genius."

Another person whom Land has mentioned as an important childhood influence was Michael Faraday, who is generally considered to be one of the greatest of all experimental scientists. In the introduction to Faraday's published diaries in 1932, Sir William H. Bragg, then director of the Laboratory of the Royal Institute of Great Britain, wrote, "Nearly every science is in his debt. And some sciences owe their existence mainly to his work. . . . It is extraordinary that a man who did such excellent work should also have excelled in his description of it."

Once at Harvard, Land did not remain an ordinary university undergraduate for long. During a college break in his freshman year, Land was in New York. Walking alone down Broadway, he was at once overpowered by the spectacle of the theater marquees, giant illuminated billboards, and fashionable automobiles, and disconcerted by the oppressive glare from the countless light sources.

At this specific moment it occurred to the 17-year-old freshman that there must be a way to preserve the majestic illumination of a place like the Great White Way, while at the same time eliminating the glare that made each light source compete with every other one. There was also, he correctly figured, the very real danger to both pedestrians and motorists of being momentarily blinded by the glaring headlights of on-coming traffic. The answer came to him then and there. He knew from his interest in optics that light actually vibrates in a multitude of planes. By the use of a polarizing filter, the light could be made to emerge vibrating in only one plane, or direction. The illumination could be controlled by a second polarizing filter so that it would not produce that unwanted and bothersome glare.

Here we see the first important example in Land's career of the "instant image"—an idea of tremendous moment and

far-reaching implication occurring without warning in a flash of brilliant inspiration. Nearly every major insight of Land's career would happen in a similar fashion. In each case, the instant image would be neither the beginning nor the end of the work, merely the moment when all the elements came magically together so that the problem could be seen, understood, and approached.

The inspiration, Land would be quick to point out, was neither blind luck nor a fortunate gift of the gods. He had thus prepared himself through countless hours of familiarization with all the elements of the challenge—whether consciously or not—and he would spend the next several years filling in the many gaps in his—and the world's—understanding of the subject.

When it comes right down to it, of course, creativity in either the sciences or the arts cannot ultimately be defined or explained. In essence, the unpredictable and unpatterned ability of certain men and women under certain circumstances to rise above the commonplace in life and in themselves is precisely what we mean by creativity. The instant image is merely the way creative and inventive insight has taken hold of Edwin Land and some of those who work with him—or vice versa.

But perhaps a partial explanation of why it repeatedly happened to Land, and why it happened in this way, lies in one particular trait. Land seems never to have been bound by or wedded to what has happened before. Though he has always been able to build on past knowledge and discoveries, he has not been put off by what, previously, had been considered impossible. This notion is not so unusual in a 17-year-old college freshman. What is unusual is that the idea and the faith in its workability did not abandon him the day after that glorious night on Broadway, and that he was able to see his interests through to a successful resolution. And what is more unusual than this is that Land was able to maintain this fresh and unburdened outlook into mature life and infuse it in so many of his associates, co-workers, and students.

Shortly after his night of inspiration on Broadway, Land took a leave of absence from Harvard and moved to New York City. During the day he availed himself of the voluminous resources of the New York Public Library, reading everything he could get his hands on relative to the subject of light polarization. In the evenings he began conducting experiments in a lab he set up in the modest room he had rented on 55th Street, just a short distance from where the light bombarded him. When he found himself in need of more sophisticated equipment than he personally owned, Land scouted out a well-equipped physics laboratory uptown at Columbia University. Unfortunately Land had no standing to use the laboratory, but he discovered he could get in after dark by entering through an habitually unlocked window and conduct his experimental inquiries there into the early morning hours.

His supposedly brief leave of absence ended up lasting three years. In 1929, Land finally did return to Harvard. He brought with him significant sophistication in the field of polarization of light. He also brought with him the woman who had assisted him in much of his work, Helen "Terre" Maislen. Land married her that year.

By this point some of the powers-that-be at Harvard were beginning to realize what they had on their hands in Edwin Land. They furnished him and Terre with a modern laboratory equipped with the materials he needed to continue his work. Within three more years Land had developed and perfected the first usable material to artificially polarize light. This development was announced publicly by Land at a Harvard physics colloquium in 1932. He was 23 years old.

The concept of light polarization had been understood since the early 1700s. The Dutch physicist Christian Huygens observed that certain natural crystals, such as Iceland spar, could limit the direction of light waves passing through them. In 1818, the French scientist Etienne Louis Malus discovered that light was effectively polarized by reflection from a pile of glass plates. The British physician William Bird Herapath studied the polarizing properties of platelets of iodoquinine

sulfate under a microscope. But Herapath and his successors were unable to grow large enough or stable enough crystals to be used on any kind of large-scale or economically practical basis. Land visualized a large sheet of polarizing material incorporating many small crystals of herapathite. And this had been the thrust of his research.

Land's singular achievement was in discovering a way to synthesize a sheet material that could align light waves in the desirable planes of vibration. The invention was a combined achievement in chemistry and optics. Specifically, he incorporated countless needle-shaped crystals into a plastic sheet and stretched it mechanically in such a way that all the microscopic crystals fell into parallel "rows." All previous experimenters had used large single crystals to redirect light waves. Land realized he could gain the desired result with a multiplicity of extremely tiny ones.

Even prior to the public announcement of the polarizing sheet, Land became concerned with protecting his invention, and in the process began his lifelong involvement and belief in the American patent system. He consulted a long-time friend, a young attorney named Julius Silver. Silver, a few years older than Land, had been been a camp counselor in Connecticut and had had the 12-year-old Land as a charge. The two men had been exceptionally close ever since. Silver referred his friend to a New York patent lawyer, Donald Brown. The meetings turned out to be fortunate for all three. Land would later name both Silver and Brown as vice presidents of the company he went on to form.

Once he had demonstrated the success of his experimental work at the 1932 colloquium, Land was anxious to see the scientific potential for his new product. So anxious was he, in fact, that he applied for a second leave of absence. At this time Land was only about a semester short of graduation. He never did receive his degree.

While at Harvard, Land's physics section leader, George Wheelwright III, became interested in the undergraduate's work in optics. When Land departed from the University as a student for the last time, in 1932, Wheelwright went with him. In a barn in nearby Wellesley, the two men established

the Land-Wheelwright Laboratories, Land's first business enterprise.

The First Company

Neither Land nor Wheelwright had much in the way of business experience, both being in their twenties. (When asked if Wheelwright was substantially older than himself, Land replied, "Oh yes. He was two years older.") But they had enough enthusiasm for their work and enough confidence in their own abilities to be basically unconcerned about making money. On a larger scale, Land has maintained this trait throughout his life.

Knowing his market ahead of time has never been one of Land's primary concerns. He feels—and already did at the beginning of his career—that a market would come to exist for any worthwhile product or service he could come up with. Both Land and Wheelwright came from prosperous New England families, which put up the capital necessary to finance the venture, and Land was convinced they would eventually make enough money to pay back the two families. In the meantime, the partners invested the vast majority of their time and energy in the laboratory.

Employees were taken on as new business—or the prospect of new business—warranted. But the basement laboratory could scarcely contain Land and Wheelwright and their equipment, which was being added to as finances allowed. So before too long the firm moved to a larger, more centrally located basement on Dartmouth Street in Boston.

The only tangible product, of course, was the polarizing sheet plastic, which Land dubbed "Polaroid"—a particularly apt name for the synthetic material that imitated the physical qualities of the natural polarizing crystals. "Oid" is a suffix connoting likeness or resemblance, and is applied throughout the scientific and literary worlds. Some decades after Land's appropriation, Norman Mailer in his book,

Marilyn, referred to the possible truths he was concocting as "factoids."

Land had no difficulty in obtaining a patent on the basic polarizing sheet. But to make it a viable economic property, there clearly had to be some way of marketing the product on a somewhat mass basis. The obvious answer was the polarization, for safety's sake, of all automobile headlights in the United States, which had been, after all, Land's original impetus for working out the invention. And here is where the first problem originated.

Though no one else had come up with a workable synthetic light polarizer, the antiglare auto headlight had been conceived by at least four other inventors. The Patent Office's earliest claim went back to 1920, a full six years before freshman Land's night of inspiration on Broadway. He and Wheelwright therefore temporarily shelved the marketing—though not the development—of the headlight until the Patent Office could sort out the various claims.

The importance of the headlight idea in the early days of the company as an ongoing dream and motivation cannot be overstated. It represented, at the same time, a chance for a financially secure base. (There were more than 20 million cars on the road at that time, and they would all have to be converted.) Also, it would represent a significant improvement in public safety in the United States. The notion that they would one day see this idea come to fruition is the basic motivation that kept Land and Wheelwright in business; again, an abiding sense of faith in self and that everything eventually would "work out."

But, for the moment, they would have to concoct humbler and less sweeping applications for the filter. Having produced a scientific product that no one else had been able to come up with, it was natural that Land's work should attract the interest of some of the major corporations. The first to put out feelers was Eastman Kodak, whose research people in Rochester had actually been following Land's experiments for some time. Land-Wheelwright Labs accepted its first large contract on November 30, 1934, when Kodak agreed to use Polaroid for photographic light filters, to

be called Polascreens. With this first contract with the photographic giant began an unaltered trend of success.

The revenue from the Kodak contract furnished Land and Wheelwright with a little breathing space, allowing them to continue their research without quite so much scrambling. It kept them going, in fact, for another year. Then, on November 5, 1935, Land signed his second major.contract, this one with the American Optical Company for the manufacture of "Polaroid Day Glasses."

The circumstances of the contract award demonstrate not only Land's early scientific ingenuity but his marketing flare as well. Not wanting to have to meet the American Optical representatives in his unimpressive basement laboratory, Land rented a room at Boston's Statler Hotel. He then went out and bought a tank full of goldfish, which he placed in the hotel room directly in front of a large window. When the American Optical people arrived, the sun's glare on the fish tank was so intense that nothing at all could be seen inside it. In fact, looking directly at the tank was similar in effect to staring at the noontime sun itself. Land then distributed the Polaroid lenses he had prepared for the occasion. The blinding glare disappeared and the fish could clearly be seen swimming merrily along in the tank. This highly theatrical display was perhaps the first in Land's career as technological showman, a role he still assumes once a year at Polaroid's annual shareholders meetings. The American Optical contract led to the introduction of the Polaroid Day Glasses about a year later, in December of 1936, and for the first time got the name Polaroid before the consuming public at large. It also led to another licensing arrangement with Bausch and Lomb Optical Company, which assured Land-Wheelwright a solid financial base.

At about the same time Polaroid products were coming before the public in another form—the basic material itself was introduced on the market in disc form in January of 1936. Purchasers of the Polaroid discs generally fell into two groups: schools and universities using them to demonstrate a scientific phenomenon to their students, and various types of professional and amateur specialists who gradually discovered

that light polarization could be helpful in their work. Jewelers found that the light patterns within the structure of genuine and artificial gems were easily distinguishable when viewed through Polaroid filters. Manufacturers examined all manner of materials through the filters, which aided them in detecting structural imperfections. And fishermen used Polaroid lenses to see through the blinding surface glare of lakes and rivers so that they—like Land's customers from American Optical—could view their prey swimming under water.

By July of 1936 Land-Wheelwright had generated enough regular business to have amassed a staff of 50 employees, and the company had outgrown its Dartmouth Street quarters. A decision had to be made on the future of the company. Would Land and Wheelwright continue as they had been, adding an employee here and there as contracts dictated, or would they take advantage of the momentum that had been building in the last 2 years and make a play for large-company status? For a man of Land's ambition and confidence, the conclusion was forgone. The only real question was timing, and now the time seemed right.

So far this story has most of the elements of the standard American business venture saga: the two bright and optimistic entrepreneurs with an idea they are sure, in time, will catch on; there is little to distinguish it from numerous other undertakings. In fact, at this stage of the narrative, we half expect young Land to sell his ideas and few products to, say, a Dupont, 3M, or Kodak, pocket a nice profit, and possibly return to Harvard where he would fulfill the perfunctory requirements for his degree, quickly pick up a Ph.D., and retire to the pleasant life of academic stardom.

Land, however, had other ideas, and this is where we begin to diverge from the traditional scenario. First of all, the business world, where he could be his own boss in his own company and not to be constrained by typical university formality, appealed to him. Also, he saw himself primarily as an inventor and innovator, and figured the best place to carry on his work was in an environment of his own creation. As Land later explained, "I planned a company in which I could

work scientifically and still have my inventions used." What the 28-year-old inventor vaguely envisioned, the 68-year-old corporate chairman still adheres to.

The Land-Wheelwright organization was growing at an impressive rate, still with little attention being paid to financial growth or planning. But financial powers were beginning to pay attention to the company. Within a couple of months Land was dealing with some of the big guns in New York, introductions having been arranged with such Wall Street luminaries as W. Averell Harriman, James P. Warburg, and Lewis Strauss. These three also held substantial influence in the investment houses of Kuhn, Loeb and Company and Schroder-Rockefeller. Contrary to published reports that he sought out money for outside capitalization, Land commented, "I never sought out anyone in Wall Street. The fact is I got word they had heard of our work and wanted to come see me. And I said, 'Well, why should we? Who's Kuhn, Loeb?' I had quite a disdain for that whole world, only to find in that first group some of my wisest and kindest lifelong friends." Land's presentations to these establishment bastions must have been impressive, though; the financial and corporate arrangements they worked out were nothing short of extraordinary, considering Land's age and almost complete anonymity in the American business community.

The agreement signed on August 10, 1937, absorbed the Land-Wheelwright interests into the new Polaroid Corporation, named for the only tangible product the new company had to sell. Land was named president, chairman of the board, and director of research. Capital stock was authorized in three varieties: 7500 shares of 5-percent-cumulative Class A stock with a par value of $100 a share; 2500 shares of $5.00 cumulative Class B stock with a par value of $5.00 a share; and 100,000 shares of common stock with a $1.00 per-share par value. The money for this arrangement was provided by the $750,000 put up in two installments by Schroder-Rockefeller, Kuhn-Loeb, and Harriman, Warburg, and Strauss individually. Under the terms of the agreement,

Edwin and Helen Land and George Wheelwright received all
of the Class B stock and about 60 percent of the common.
All of the Class A stock went to the backers.

The abiding hope that every automobile headlight in
America might soon be equipped with a Polaroid filter was
one of the primary investment lures to the original backers.
Land was convinced that as soon as the Patent Office sifted
all the claims, he could get on with the research and the
Detroit auto magnates would jump at the chance to install
the system. This remained one of the predominant goals
throughout the first 10 years of its corporate history, though
events both internal and external would soon necessitate a
change in direction.

There were two other significant provisions to the incor-
poration; both related to the actual chief asset of the new
company. For the agreement to be binding, Edwin Land had
to enter into a 10-year personal employment contract (at
$25,000 per year), which indicated the indispensability of his
participation in the eyes of the backers. Even more notewor-
thy was a 10-year voting trust set up with 71,500 shares of the
common stock, which essentially authorized Land to call all
the shots, something he had been fairly insistent upon during
the negotiations. The voting trust consisted of three men:
Land, Wheelwright, and Julius Silver, who had started the
ball rolling on Land's original patent application. But
according to the ground rules of the trust, Land was given the
power to replace either or both of the other two at his own
discretion.

So even at this stage, the 28-year-old Land struck the
Wall Street establishment as being so unique that they
turned back control of the company they had just bought
and made the man they had bought it from promise to stay
around for at least a decade. Everyone acknowledged that
the future of Polaroid Corporation would be determined by
what went on in the brain of Edwin Land. Unlike most new
business capital ventures, what they had bought into was not
a new technology, a product, or an array of concrete assets,
but one man's mind.

Polaroid: the Early Years

Like many companies wishing to take advantage of that state's favorable business laws, Polaroid was incorporated in Delaware. However it did not abandon its Massachusetts ties, but it did move into larger premises. The first Polaroid corporate headquarters were in a former tobacco company warehouse on Columbus Avenue in Boston. Along with Harriman, Warburg, and Strauss, Julius Silver was also named to the original board of directors, where he has continued to serve for 40 years. Harriman stayed on until 1940, when he was tapped by President Roosevelt for one of his periodic diplomatic assignments.

Polaroid sheets were still the only synthetic light polarizer on the market, and sales of the material continued at a respectable pace. The sheets sold for $25.00 per square foot, which, according to published reports at the time, represented an 80-percent profit margin. Research and development costs on this phase of the product were largely behind the company now, and Land was undoubtedly beginning to see the advantages of producing items no one else could offer. He decided then, with a clarity of vision few others could adhere to, that there was no point in ever having Polaroid produce products that were already on the market.

Thirty years later Land wrote in an annual report, "Fortunately, our company has been one which has been dedicated throughout its life to making only things which others cannot make." Land's genius was such that others could not think up what he could or turn out the kinds of products his company could turn out. And the ever more impressive wall of patents he erected between his discoveries and the outside world, enforced by a dedicated cadre of specialist patent attorneys, meant that once the technological cat was out of the bag, it was still exclusively Polaroid's.

On those rare occasions when Polaroid was not first at the

post, other more conventional strategies were sometimes necessary. Though Land held the patent on the polarizing sheet, the automobile headlight application he was so passionately wedded to belonged to others. After years of examining claims and evidence on the various sides, the U.S. Patent Office awarded the headlight patent rights to Frank Short and Lewis Warrington Chubb, who still had no practical means of producing or manufacturing the system.

In 1938, with several months of corporate life behind it, Polaroid purchased the patent rights from Short and Chubb. The two patent holders, who themselves hoped to clean up on an industry-wide usage of their idea, realized that Land was far down the road in the applied technology of the invention, while they had nothing practical to market for the foreseeable future. So in March of that year they agreed to accept a cash payment and a sizable block of Polaroid stock. Chubb, at least, kept his hand in related fields, and shortly after selling out to Polaroid became director of the Westinghouse Research Labs.

The effectiveness of the headlight system depended on outfitting every car in the nation with specially designed headlight covers and polarized fold-down visors. Even in the late 1930s, the automobile was beginning to be perceived as one of this country's major killers, and the nighttime fatality rate was about three times the daytime rate. Much of this, highway researchers believed, was due to motorists and pedestrians being blinded by the glare of approaching vehicles.

Once they had exclusive rights established, Land and his still small group of engineers set to work on a practical system. The concept they eventually evolved consisted of a polarizing sheet covering each headlight and an adjustable Polaroid visor in front of the driver's eyes. Within each of the polarizers, the optical grain, or polarizing axis, of the headlight and visor sheets would allow through light waves vibrating in one direction. The axis of the polarizing sheet covering the headlights of each car would be set on the diagonal and would therefore be perpendicular to the visor

sheet polarizing axis of an approaching car, blocking out nearly all of the light from its headlights. These oncoming headlights would then show up only as a dull blue glow, while one's own headlights would still properly illuminate the road ahead. Additional refinements took care of such situations as vehicles approaching each other on a nonflat surface.

In the course of development, a number of problems had to be worked out. One of the first of these was that existing polarizing sheets tended to deteriorate when exposed to heat such as would be generated by a headlight. The synthesis of the "K Polarizer" by Land and Howard Rogers produced a material stable to both heat and light. Another factor was that since a stronger headlight would be needed to shine through the extra layers of covering, a more powerful battery would have to be installed. The subsequent, nearly universal adoption of the 12-volt battery has since resolved this problem as well.

And despite the burgeoning size of his newly-financed company, Land's motivations still had little to do with profit. "At that age and date," he explained, "we had no interest in money whatsoever. On the blackboard up there it would say 400 people killed every night. We'd work all day and all night ... dedicated to [our] pursuit, just as if you set up a medical student working on a virus for leukemia."

Land approached the leaders of the major automobile manufacturing companies and called for quick industry-wide implementation of the system. Detroit kicked around the idea—in every sense of the term—for 10 years. It would be expensive, they said, and the public was already balking at what it thought were inflated car prices. It would be too complicated because all cars on the road would have to be refitted. How could they be sure it would always work, and how could they be sure it would actually save lives? And, anyway, the American automotive industry had never been able to use safety as a selling point.

Most of the arguments revealed more about the essential nature of Detroit than about the specific workability of Land's system. In a 1940 study that at the time did not get

much circulation beyond corporate board rooms, auto indus-
try engineers figured it would cost no more than $4.00 extra
per car to install the polarizing system and not much more
than that to convert cars already on the road.

The headlight system never was implemented, in this
country or anywhere else, although auto manufacturers did
trot it out at trade shows and press conferences from time to
time until the middle 1950s as an example of their diligence
in continually perfecting their product.

Today, more than 20 years after the industry finally
shelved the headlight idea, the Department of Transporta-
tion is once again studying its feasibility. Certain of the
inherent problems have taken care of themselves. The 12-volt
battery is now a standard feature. And the numerous recalls
prompted by other glaring safety defects have proved that a
large-scale automotive logistical operation is quite workable.

The Transportation Department is considering an in-
depth test on Canada's Prince Edward Island, where the
enclosed area would provide a good sample site. The island
also meets two other test requirements: It has maintained
accurate accident records for many years and, because of its
far northern setting, has a long period of darkness every day
during the winter months. And the government of Sweden
has also lately shown interest in the headlight polarization
program.

For Land, the sense of disappointment over Detroit's
trifling and eventual rejection of his invention extended far
beyond the obvious loss of millions of dollars in royalties. He
is a man who had brought himself up to believe that any
good and worthwhile innovation would find general accep-
tance and rise to its own level of usefulness. This was the first
major setback of his life. And it was a setback caused by
forces completely outside his control. Given the less sophisti-
cated times of the 1930s and his own abiding optimism
concerning every one of his ideas, Land was more trau-
matized than the average person by a system that he felt was
putting profits over safety, as well as failing to reward
individual ingenuity. The headlight polarization program
remains one of Land's largest unfulfilled dreams, and it had an

effect on every subsequent endeavor of his professional life.

The disappointment over the headlight system was more of an emotional blow than a financial one. True, had the project gained the universal acceptance Land had envisioned, it would have helped put Polaroid in the corporate big-time fairly rapidly. But there were other marketable products employing the light-polarizing principle, and they did generate sufficient income to keep the company at least hovering around the black. Eastman Kodak and several other companies were producing products covered by Polaroid patents. And early in 1938, Polaroid Lighting, Inc., was organized in West Haven, Connecticut, to develop the market for products made of Polaroid material.

By the fall of 1938, Polaroid began to try its hand in direct product marketing with a glare-free desk lamp that was initially sold by four licensed manufacturers but was then taken over by Polaroid itself. To prove the benefit of glare-free illumination, each desk lamp was sold with a sheet of film, dubbed a "cancellator," which, when held between the lamp and the object, effectively cancelled the polarizing effect and brought back the glare. Land wanted his customers to see what they were missing.

An essential source of income in the early years remained the sunglasses. Up to the beginning of World War II, they remained the company's bread and butter, and have, in fact, been turning a substantial profit for over 40 years. The licensing arrangement was so beneficial to Polaroid that it did not take over the manufacturing of the glasses itself until 1976.

With the company developing an array of products and patented concepts to sell, Land was free once again to devote more of his time to his first calling—applied scientific research. At this point a man who would prove critical in Polaroid's growth and development came on—William J. McCune. Shortly after this, George Wheelwright essentially dropped out of the picture. He enlisted in the Navy, becoming a navigator in the war-time Navy Air Force. After his discharge he decided not to come back to Polaroid but to go to California instead, where he bought large amounts of

land in Marin County. He achieved substantial wealth as a landowner (in addition to his holdings in Polaroid) before eventually giving the land to the state. At this writing he is still alive and Land reports that he occasionally still attends annual meetings. Surprisingly, though, few people at Polaroid today know anything about Wheelwright other than the fact that he was Edwin Land's partner long ago.

William McCune, who was born in Glens Falls, New York, joined Polaroid in 1939, two years after graduating from Massachusetts Institute of Technology. He had originally accepted a job with General Motors and the promise of a post at an automobile plant in Germany, but the outbreak of the war in Europe forced him to modify his plans. He was subsequently interviewed by Polaroid and hired to set up the corporation's quality-control department. As Land began involving himself in an ever-increasing number of seemingly unrelated projects, McCune provided engineering support to each of the projects. Over the years, McCune acquired responsibility for manufacturing and engineering as well as a strong influence in research. And in 1975, when Land got ready to relinquish one of the three crowns he had worn since the inception of the company—that of president—it was McCune who got the job: the ultimate, one might say, in delegating authority.

Another name that was to be involved with almost all of the company's first two decades was added to the Polaroid hierarchy not too long after McCune's. Carlton Fuller had been an original member of the board of directors by virtue of his position in Schroder-Rockefeller, which handled the 1937 corporate organization. In 1941 Fuller took a leave of absence from his job as president of the brokerage house to serve as Polaroid financial officer to get its economic affairs in order. He never went back to his old post; and even after eventually retiring as Polaroid's vice president and treasurer, he remained on the board until 1975.

Now that a viable corporation had been established, which could function on its own on a day-to-day basis, Land could go on with his original purpose for establishing the business—his research. Despite his numerous talents, Land

considered himself a scientist, and each project he was working on had some scientific application and in some way furthered the range of scientific understanding. Every facet of his work at this time had some bearing on the field of optics: most with the polarizing effect itself, the others with the properties and behavior of light. Additionally, Land seemed to be testing, experimenting with, and observing his own interests and technological perceptions to see objectively where he and the company were heading.

There is no evidence to suggest that Edwin Land was averse to becoming rich, although his family's comfortable circumstances probably prevented his having the kind of security-grounded hunger for success of, say, a Charles Goodyear, whose family was literally starving when he came upon the formula for vulcanized rubber. And if one examines the biographies of many other successful businessmen, it can be noted that their amassing of fabulous wealth became a goal in itself. That is, they had to have a way of gauging their success because of a very real need to accomplish and achieve, and success in accumulating dollars was the most easily quantifiable standard. Being a man who could measure his success in scientific and technical terms, Land had no such need for large sums of money as a tangible symbol of personal advancement.

This is occasionally a difficult point to drive home to those in whom profit is the end-all and be-all of any professional endeavor. In a study of Polaroid conducted by the venerable Harvard Business School in the early 1940s, the authors J. Keith Butters and John Lintner did not quite know what to make of a company with such a strange set of motivations. The report is entitled "The Effects of Federal Taxes on Growing Enterprises." Throughout much of it, the tone suggests that the writers were not quite sure their staid, business-oriented readers would believe they had actually gotten a grasp on what made Land and Polaroid tick. They found it necessary to include a footnote:

The importance of motivations other than maximization of profits in influencing business behavior cannot be emphasized too

strongly, especially for the academic reader. Economic theory generally is constructed on the rigid assumption that businessmen act in a coldly rational manner with the sole aim of earning the largest possible profit. Polaroid is perhaps an extreme case in which other motivations are of compelling importance.

Land, no doubt, would suggest that his was the coldly rational manner of doing things, and that money for its own sake was not very rational at all. The body of the text goes on to explain the Harvard findings:

Why, then, does Land continue to invest a large percentage of his personal assets in a speculative endeavor such as Polaroid? The answer is simply that his primary motivation is not monetary. Rather, his driving interest is in scientific research. Land organized a business enterprise in preference to withdrawing to the shelter of a university laboratory because of his conviction that his research could be carried on more effectively through a profitable business organization. . . . Over the years . . . Polaroid is convinced that its all-out research program will produce a sufficiently large number of commercially valuable developments to justify the amounts so spent, even from a narrow financial point of view.

That Land had far more faith in his own potential and that of the company he inspired than did any of the "experts" looking in from outside is born out by another selection from the Harvard study. When viewed from the safety of more than 30 years of twenty-twenty hindsight, the analysis has a sort of quaint irony about it.

From a narrow dollar and cents point of view, Land and his colleagues might easily benefit financially by selling out to a large, established firm. Certainly, Land would acquire greater financial security by doing so. If acquisition of control were added to the prospective earnings of Polaroid, an industrial purchaser might be willing to bid even more than the present market price for the stock. Land could probably acquire several million dollars for his personal interest in the firm, enough to assure him a substantial income for life. Moreover, he could undoubtedly command a salary

from a large industrial company in excess of the $25,000 now paid him by Polaroid.

Twenty-four years after the Harvard Study was published, *Fortune* listed Land as one of the eight wealthiest men in America.

Not only in the rather close-ranked business circles was Land establishing his reputation. At a dinner hosted by the National Association of Manufacturers in New York's Waldorf-Astoria Hotel on February 27, 1940, Land was awarded a silver plaque as one of 29 "national modern pioneer" inventors. Among the others feted were Irving Langmuir, whose General Electric Laboratories helped establish the phrase "research and development," and RCA's Vladimir K. Zworykin, inventor of the cathode ray tube used in both television and radar. The dinner was held to celebrate the 150th anniversary of the U.S. Patent System. In a ceremony held in February of 1977, both Land and Zworykin were inducted into the U.S. Patent Office's own Hall of Fame, two of only six living inventors then holding that honor.

Added Dimensions

In the years following Polaroid's incorporation, Land concerned himself both with developing marketing avenues for the company's basic stock in trade and furthering his general optical research. In April of 1941 he was awarded a patent on a "variable density window" through which light could be totally regulated without the use of blinds or curtains. It was constructed of two panes of polarized glass whose orientation to each other could be varied. The first important public usage was in the 29 round windows on the Copper King, the observation car of the Union Pacific Railroad's City of Los Angeles. In the car, one round window fitted over another, the darkening effect being achieved when the passenger turns a crank in response to the varying sun and surface conditions as the train traverses the countryside.

Still convinced he would crack the Detroit auto market one way or another, Land came out with a polarized car headlight bulb in August 1941. The light rays were screened at the actual point of origination, rather than at the headlight cover and at the oncoming driver's visor, as had been the basis for the previous system. Unfortunately, this idea fared no better in the commercial market.

Perhaps the most interesting of Land's early inventions, and the first major one to foretell his attraction to picture-making, is the Vectograph three-dimensional image. Natural depth perception is made possible by the two eyes seeing a scene or object from two slightly different perspectives (that is, the distance between the eyes). The images are then combined for us in the brain. A normal painting or photograph appears flat because it is rendered from only one perspective.

The Vectograph provides two oppositely-oriented polarizing images on the same piece of film. In three-dimensional Vectographs—one of the most interesting applications of the process—the two images are a stereoscopic pair which have been transferred to the same sheet of Vectograph film, one on the front, the other on the back. To separate the images (which are thus overlapping), the Vectograph is viewed through a pair of polarizing glasses (which correspondingly have their lenses oriented at right angles to each other) so that each eye sees only one of the overlapping images. The image seen by each eye is the one which is oppositely oriented with respect to that eye's viewing lens. And as happens in viewing three-dimensional objects in "nature," the brain fuses the two views into one three-dimensional image.

Applications for Vectograph technology were legion. Aside from providing simpler means of viewing stereoscopic pictures than through the stereoscopes that were fixtures in so many nineteenth- and early twentieth-century drawing rooms, Vectographs could be useful for any situation in which depth perception would be enhancing or where there was a need to see two unlike images in relation to each other. If two different images were printed on the two sides of a

sheet of Vectograph film, by rotating a polarizing lens in front of it, one could fade from the first image to the second. While some of the marketing outlets for this capability might come most quickly to mind, Land wrote in the June, 1940 issue of the *Journal of the Optical Society of America*, that "It is hoped that this apotheosis of the 'before and after' picture will serve science as much as advertising."

The polarizing application that showed the greatest potential for capturing the public imagination during this time was three-dimensional motion pictures. An earlier form of 3D color movies using polarizing filters over paired projectors and polarizing glasses for viewing had been mounted for the Chrysler Motors exhibit at the 1939 New York World's Fair. This was one of the last of the great international expositions to have the impact of old-fashioned wonderment on a generation not yet jaded by media blitz, and the film produced just such a reaction of wonderment. Although two projectors were required, the principle of separating the images for the eye was similar to the Vectograph principle in that two oppositely oriented images were overlapped and then viewed through oppositely oriented Polaroid lenses.

Though Land knew the original Vectograph concept would work equally well for a reliable, single-projector movie system, the early forms of commercial 3D movies employed two synchronized projectors which showed two separate pictures through oppositely oriented polarizers. The audience members were each given a pair of disposable Polaroid glasses to watch the film. A key problem with this type of method, though, was the difficulty of keeping the two projectors precisely synchronized and exactly balancing the brightness of their respective pictures.

Once the technique of producing motion pictures with two images on a single piece of Vectograph movie film was perfected, the 3D motion pictures would be no more difficult to project than the standard two-dimensional films. And as the company declared in the 1952 annual report, there did not seem to be any substantial resistance on the part of theater patrons to wearing the special lenses.

The Vectograph represented only one set of applications for the field of polarizing light, which Land had nearly single-handedly built into an industry. And he and the other Polaroid scientists were convinced that numerous other avenues lay before them waiting to be explored.

During this period a steady stream of inventions and new applications were emerging from Edwin Land's brain and Polaroid's labs, and were meeting with varying degrees of financial success. But the company had yet to make the big splash, which its founders and backers had hoped would come with the polarized headlights. Sales were loping along at around the three-quarters-of-a-million figure, with profits hovering steadily near one side or the other of the bottom line. The interesting thing about the company was more its ingenious founder and offbeat products than the weight of its yearly balance sheet. In the eyes of Polaroid officials, Detroit had dropped the ball handed to them within 2 yards of the goal line. Something else "big" was needed to take its place.

The 3-dimensional movies seemed to fit the bill perfectly. Here was a product with a potential for mass appeal which, unlike the headlight system, did not involve a complete overhaul of the existing equipment. But to get a bit ahead of our story, 3-dimensional movies never caught on as Land had dreamed. But meanwhile before Vectograph motion pictures had been perfected, the movie companies began cranking out short subjects in 3 dimensions, using the 2-projector system as an added lure, along with free dishes and souvenir spoons. They had not waited for Land to perfect his single-projector system. By and large, Hollywood considered 3-dimensional a gimmick to be kept on the back burner until such time as it was needed to boost badly flagging attendances. The industry that, as long as it possibly could, avoided the advent of sound saw no reason to tamper with the status quo.

The crunch came in the early 1950s as the TV home screen diminished the sacred rite of weekly movie attendance by about two-thirds. So finally, in 1953, through an independent production company, Hollywood trotted 3-dimensional movies out of the closet for the first feature-length film.

"Bwana Devil," a jungle potboiler starring Robert Stack and Nigel Bruce, was written and directed by veteran radio writer Arch Oboler, who deserved better. Critics had nothing good to say about it, except that it was no worse than "Man in the Dark" and "Fort Ti," the next two 3-dimensional entries. The public loved the effect of spears hurtling menacingly through the air at them, just as an earlier public had thrilled to "The Great Train Robbery" half a century before. They predictably liked the subsequent 3-dimensional offering less, since no effort was made to integrate the special effect with a coherent plot or character development. And by the time of Warner's semirespectable "House of Wax," the fleeting fascination with 3D movies was on the wane. The process used differed in some respects from Land's original concept (and probably lacked some clarity as a result), but during the brief heyday of 3-dimensional movies, Polaroid did sell over 5 million pairs of cardboard-frame glasses a year. According to reports, the craze was over so quickly that the company and the movie studios were left sitting on warehouses full of the lenses.

After the war, Land collaborated with Hollywood's Technicolor, Inc., on the idea of coming up with a new 3-dimensional movie system employing his old Vectograph technology and using only one projector instead of the two used in the commercial system. But the drawbacks of the need for special viewers outweighed the depth-enhancing gimmickry the system offered; and this newer, simplified process never got beyond the planning stage. Land was too much of a realist not to pick up on a lesson he now felt had twice been put before him. The polarized headlight system and three-dimensional movies were the first two inventions that had the potential to move Polaroid into the corporate big time. Each would have involved millions of dollars in revenue for the company, which in turn would have given Land the financial security he sought to conduct his research. But each invention involved a certain degree of transformation of an existing industry controlled by an existing power structure. Both industries are basically conservative establishments in which leaders generally do not stand behind

innovations. Land had no control over these industry leaders other than to try to convince them of the efficacy and sensibility of his product.

Approaching the 3-dimensional experience from Land's perspective, how do you get someone who is both less forward-thinking and less intelligent than yourself to come around to your way of thinking in his own supposed field of expertise, especially when he is a nationally known corporate titan and you are a relative newcomer without standing in the national business community? The answer is that it may be impossible. Polaroid could go on supplying filters for Kodak cameras and lenses for sunglasses and polarizing discs for school rooms. But this is essentially the role of a supplier, and we have to conclude that a man of Land's depth and scope did not see his company spending its corporate existence tapping into other people's visions.

Vice-President Julius Silver hinted at Polaroid's upcoming reevaluation of its position at that time in an interview he gave some years later (1969) to *Forbes* magazine:

We learned an important lesson. In the movie business there were too many forces, too many people to deal with. It was an undisciplined industry. We learned that the best way is to sell as directly to the consumer as possible where we could control as many factors as possible in the marketplace.

Land seems to have decided at some point in the early 1940s that his company's next major breakthrough would not be dependent for its application and ongoing life on leaders of other industries over which Land had no control. The next big invention (and Land certainly was confident there would be one) would have to be controlled right from the Cambridge headquarters. No longer trusting outsiders for the translation of his ideas into usable commodities, the inventor would next time take his case directly to The People. Men who catered only to existing markets could not be expected to visualize a realm that did not at the moment exist. Polaroid would do the next one themselves from beginning to end. And those aspects that they could not practically

handle on their own, they would still rigidly watch and control.

As we shall see, in terms of what was to come, then, the headlight and 3D movie "failures" were of tremendous significance. They set the ground rules under which the company would operate from then on, and they helped mold the personal style of Edwin Land. Land had always been a loner of sorts, extremely guarded about his private life. His scientific approach, which holds that the major creative discoveries are the products of individual minds confronting the basic physical truths, dictated that he would be something of a technological loner as well. The realization that his company might be the only entity capable of bringing forth his and his associates' discoveries into the real world and exploiting them to the fullest once they were there completed the equation. As soon, and as completely, as possible, Polaroid would separate itself from others and create its own destiny. The degree of the corporation's later stress on control of everything it was involved in becomes understandable from more than the mere perspective of the profit motive.

The big invention the company hoped would eventually come was still several years off. It had not yet even manifested itself as an instant image in Land's consciousness. But ironically, the something "big" that Polaroid leaders were looking for at the beginning of the 1940s to help them turn the financial corner turned out to be bigger than they or anyone else had bargained for—World War II. The Polaroid product of the moment, 3-dimensional film, had an immediate military use, and was classified by the Army.

The defense establishment was not concerned that commercial audiences could watch movies with realistic depth. They were interested in the fact that a piece of film with two separate images on each frame could serve a definite intelligence function. Vectographs prepared from stereoscopic aerial photographs could represent actual terrain conditions. And by printing two photographs of the same reconnaissance scene taken several days apart on a single piece of Vectograph film, then fading from one to the other, enemy troop and supply movements could be easily charted. Classifying the

techniques prevented their development and use by the enemy. Vectography is still in use today in a number of scientific areas, and, while Polaroid does not heavily market them, the company's Vectograph section is still active.

As it did for a number of companies, World War II made Polaroid a profitable concern. Most of the company's resources were absorbed into the war effort, and Land himself headed up a number of research teams developing war products. During the war, Polaroid became a leader in the development of plastic optics, a field in which they had done a fair amount of research prior to the hostilities. Plastic molding eliminated the expensive and time-consuming glass-polishing operation, which is one of the crucial steps in lens production.

Gun barrel recoil had been a tremendous problem to tank gunners. If they stayed close enough to the gunsight to aim accurately, they risked serious injury if the weapon recoiled too far. There had been numerous cases of total or partial blinding as a result. Polaroid plastic optics allowed the tank gunners to keep 6½ inches back of the telescopic sight without sacrificing accuracy. The new sight, based on a fixed-focus principle, which would later be employed in some of the less expensive cameras, was fully operational in time for the North African campaign of 1943.

Polaroid's traditional standby, sunglasses, were transformed for military use into variable-density goggles; fliers cruising above the clouds could screen out the direct glare of the sun. And with Polaroid's "dark-adaptor" goggles, pilots could precondition their eyes for night missions. In fact, Polaroid ended up developing about as many varieties of glasses and goggles for the War Department as certain athletic supply companies today make specialized varieties of shoes. Nearly every type of optical device used by one of the services was improved upon by Polaroid, from blind-flying training equipment to signaling devices to position angle finders to all manner of filters and precision optical components.

In 1941, for the first time, sales cracked the million-dollar

mark and put the company in the black for only the third time. One year later sales quadrupled and they more than doubled again in 1943. The next 2 years showed nearly as impressive gains. Each year the net profit grew accordingly. But Land realized that this activity was not directly transferable to a peacetime situation, and he spent what little free time he had during the war years trying to determine through research and economic planning where Polaroid would find itself 5 and 10 years down the road.

Some of the planning still held out the hope that the headlight system would eventually be adopted, particularly with the anticipated burgeoning of new car production when the consumer halt was lifted. In line with this hope, Polaroid kept up a steady stream of inventions related to automobile safety. One device was a traffic sign, which at night was visible only when the motorist was using the wrong polarized headlight beam.

One of the firm's most impressive scientific achievements of the war was in some ways a response to a threat to its main product. While the war did bail Polaroid out of its financial hole, it presented problems aside from the shift in production orientation. In the late 1930s, the Japanese controlled nearly all of the earth's known sources of quinine, a derivative of the bark of the cinchona tree. The most important use of quinine was in the treatment of malaria or other related diseases. Polaroid had another use for it: as one of the prime ingredients in the baths used to treat the plastic sheets made into polarizing material. When war began to look more and more likely, Land assigned a team of Polaroid chemists and outside consultants from the academic community to conduct research into the artificial synthesis of quinine.

Several companies, including the formidable Dupont had been trying, but were unable to come up with a viable replacement for the chemical. The only alternatives for the treatment of malaria—atabrine and plasmochin—were not as effective. Nor had the war alone signaled the beginning of quinine research. Scientists here and in Europe had been

attempting to manufacture it for more than 100 years. In 1855, the German scientist Strecker figured out its basic structure of hydrogen, carbon, oxygen, and nitrogen atoms. The following year the English chemist Sir William Henry Perkin had run up against a solid wall when he tried to produce quinine simply by bonding the requisite number of the four atomic components together. Though his attempts failed, he unintentionally discovered the first coal-tar dyes and began the sizable coal-tar industry based on them. In 1908, two German chemists, Rabe and Koenigs, figured out how the atoms were arranged in the molecules, but little progress was made from then on.

The Polaroid team, which finally did successfully produce quinine in a test tube, was headed by Dr. Robert Burns Woodward of Harvard and Dr. William von Eggers Doering of Columbia. The announcement of the success in May of 1944 was hailed as a tour de force of organic chemistry, as are many of the syntheses involving the highly complex carbon atom. Edwin Land announced that Polaroid's interest in the discovery lay "in the scientific and military contribution involved in the project and any proceeds [would] be utilized, as far as practicable, in furthering similar scientific research." He went on to say that Polaroid Corporation did not plan to get into the quinine-manufacturing business. What Land, and just about every journalistic account at the time, declined to add was that while Polaroid had no interest in marketing its discovery for profit, it did at first have a significant corporate stake in coming up with the substance.

War-time security considerations might have accounted for some of the paucity of specific details attending the announcement of quinine synthesis. And by that time Land was essentially carrying on the search for essentially scientific purposes. He had found since the war began that he could replace the quinine-based polarizing sheet with a new non-crystalline sheet polarizer made of stretched polyvinyl alcohol combined with iodine molecules.

Artificial quinine continued to be too costly and complex

to produce commercially on a large scale. After the war, the shortage was alleviated by renewed access to the cinchona-tree-growing areas of the Pacific, and progress was made in alternative malaria treatments. Today malaria is routinely treated with such new synthetics as chloroquine hydrochloride, amodiaquine, and primaquine. Despite these more recent advances, the synthesis of quinine opened up new fields in chemical research, and remains a scientific milestone in its own right. And despite Land's less-than-complete explanations of his reasons for going into quinine research, the project stands as one of the best examples of his motivation for setting up the kind of company he did—a place to do the sort of research he thought was interesting and important.

Dr. Woodward's career was equally as inspired after his work with Polaroid. He achieved the first successful synthesis of a steroid in 1951, which led to wide-scale use of such drugs as cortisone. He went on to synthesize a wide range of other steroids and alkaloids such as strychnine, lysergic acid, chlorophyll, and tetracycline. His advanced work in the field of chemical synthesis led to the Nobel Prize in chemistry for 1965.

The Instant Image

Throughout the war years Land maintained the double responsibilities of corporate executive and defense research team leader. As we have indicated, one of his overriding concerns during this period was the peacetime success of his company. The great inspiration, which was to provide the solution, began unobtrusively enough, far away from the laboratory. During the summer of 1943, Edwin and Helen Land were vacationing in Santa Fe, New Mexico, with their 3-year-old daughter, Jennifer. Land stopped to take a picture

of the little girl, who was then known in the family as Jeffie. She posed. He clicked the shutter. She asked to see the picture. He said it was not ready. She asked how long it would be. He got to thinking.

At just about the time it was needed, here we see the second great "instant image" of Edwin Land's career. When Jennifer asked that portentous question, her father's first instinct was to fall back on "reality" and explain in rather elementary form that there was no way of seeing pictures right after they were taken. But what is crucial is that this first instinct was dismissed almost as soon as it was acknowledged, and Land immediately went to the next logical step of "why not?"—the *sine qua non* of all scientific and social progress.

why not?.

As Land explained to a *Life* Magazine reporter in 1972,

Within an hour [after Jennifer's question] the camera, the film and the physical chemistry became so clear that with a great sense of excitement I hurried to the place where a friend was staying, to describe to him in detail a dry camera which would give a picture immediately after exposure. In my mind it was so real that I spent several hours on this description.

He goes on to comment that

All that we at Polaroid had learned about making polarizers and plastics, and the properties of viscous liquids, and the preparation of microscopic crystals smaller than the wavelengths of light was preparation for that day in which I suddenly knew how to make a one-step photographic process.

How often have we been able to pinpoint the very second when an important invention comes into existence in the consciousness of the inventor? A surprising number in our own history: Charles Goodyear, for instance, noticing that a piece of experimental rubber accidently left too close to an iron stove had charred but not melted; or George Westinghouse, hearing that his journey would be delayed because two freight trains had not been able to stop on the track ahead in time to avoid a collision.

Given Edwin Land's character and personality, we must conclude that at the moment the idea of an instantly developing picture came into his mind, he saw it not in the vacuum of pure discovery but as the keystone of a new form of photography and of the future of his company. A few years ago Land stated, "By the time Jennifer and I returned from our walk I had solved all the problems except for the ones that it has taken from 1943 to 1972 to solve."

There is as much truth as humor in this statement, because it implies that Land was thinking not just about how to develop photographic film instantaneously, but also about the attendant considerations. Land was coming up with a new industry. It does not, however, evolve in the real world as quickly or efficiently as it does in the mind of a technological genius. In the hour after the instant camera came to him, Land must have been anticipating 30 years of development.

The way in which Land sees invention taking place gets to the heart of the question; What is the fundamental nature of progress? He is repeatedly concerned with the argument over whether scientific—and, to a lesser extent, artistic—progress is an inevitable result of that which has preceded it, or whether it stems from the imagination of the individual. As might be guessed from the circumstances surrounding his own instant images, Edwin Land holds emphatically with the latter view. He used an artistic example to illustrate his point in an article he wrote for *Product Engineering* magazine in 1964:

I would say that the world at this moment divides into two parties. They are not Republican or Democratic, or capitalist or communist. Rather, they are composed of people who would say that Beethoven was a necessary, inevitable and predictable racial consequence of his predecessors; and people, on the other hand, who would say that had he never lived, the history of music would have been entirely different. . . . Our second group . . . would say that while in retrospect society must always look continuous in its progress, in prospect society is completely unpredictable. For the most part there will be no change and there must be no change, but

what real changes do occur are entirely the result of accidents called individuals.

The question that next arises is whether Land, with his self-acknowledged years of preparation for the moment of creativity in Santa Fe, would have come up with the discovery on his own had 3-year-old Jeffie not innocently posed that critical query. A person who believes, as Land does, that invention and creativity derive from the individual and are not transferable from one human being to another, would probably hold that if a specific cause did not take place, neither would the result. The fact that he believes creative people spend their lives preparing for the instants of inspiration indicates at least a degree of scientific determinism. But to Land, there is little question as to whether the entire course of instant photography would have been different were the circumstances of inspiration altered. In fact, he doubts whether instant photography as we know it would have come into existence at all. "Anything of that significance," he stated, "requires the integration of enough lines of insight in enough different fields so that the chance those lines will pass through one person . . . is so small it would be incredible. . . . Both to be able to do it and to hold onto the sense of significance . . . is just an improbable thing."

One additional level must enter the consideration—and that is the context of the world Land was dreaming his conscious dreams in. Tens of millions of Americans saw "The March of Time" and the others newsreels along with their feature films each week. Millions more read *Life*. Newspapers gave heavy play to photographs. Countless families had cameras. By the mid 1940s, the United States had become a visually oriented culture.

Evidence of this transformation was to be seen everywhere. During the Depression, when Assistant Secretary of Agriculture Rexford Guy Tugwell had concluded that his Resettlement Administration must document the plight of the "Submerged Third of the Nation," he chose photography as his medium. One has only to look at the impact of the

work of Tugwell's group, headed by Roy Stryker under the auspices of the Farm Security Administration, (FSA) to realize the special significance pictures by then had to the American public. The documentary photographs of Lewis Hine a generation before and of Jacob Riis a generation before that had shocked an outraged public into legislation. The FSA portfolio helped a more visually oriented public past the outrage to relate to the pictured subjects as fellow human beings.

Taking nothing away from the brilliance of his insight or foresight, Edwin Land was realizing an idea in a world ready to receive it.

receptivity

The New Beginning

Within 6 months of his original inspiration, Land had worked out most of the essential details of the instant photography system. The work was done by him and a small group of associates in secret; the rest of the company's employees knew nothing of the research going on in the locked laboratory. The majority of Land's time was still being taken up with defense contracts and the exploitation of light-polarizing applications for the civilian market. By the end of the war he had adapted his light-polarization research to the production of sound tones, for which he predictably saw worldwide uses once the public came to understand the value of the invention.

Very simply stated, by rotating two polarizing elements rapidly enough to make a beam of light fluctuate at a set frequency, the frequency could be translated into electrical oscillations. The oscillations, in turn, were translated into mechanical vibrations, which, with the help of a diaphragm and loudspeaker, became sounds. Land foresaw this research leading to a musical instrument "of the general characteristics of an organ." The technology could also be adapted to marine warning beacons.

The end of the war all but pulled the rug out from under the now moderate-sized company. Development and produc-

tion of optical equipment for the armed services had necessitated the hiring of large numbers of employees who now, with the cessation of the demand for military supplies, had little to do. Yearly sales for 1947 were about $1.5 million—less than 10 percent of the 1945 level. Because of expanded war production, the company had grown too large to survive long on these newly diminished figures. The first 3 postwar years saw Polaroid strapped with record deficits, while the great hope of the corporate future, the automobile headlight project, continued to languish in the stultified boardrooms of Detroit.

Land seldom had to learn his lessons twice. When World War II ended, he decided that the company would never again be so involved with defense contracts that their removal would mean a major loss of revenue and laying off of employees. He had a couple of reasons for this. Despite an apparent old-style patriotism, and despite his dedicated work on several defense research teams during the war, Land seems to have had a personal distaste for being associated with the manufacture of products used in connection with fighting and destruction. The type of humanist company he envisioned could not continue for long producing war materials, particularly in peacetime, and still tell itself it was working generally toward the improvement of life.

The second reason for his refusal to further entrench himself in large-scale defense contracts pinpoints the other side of the dual perspective from which Land always regarded Polaroid. Not only must a corporation produce a well-made, useful product, it must also provide a worthwhile and dignified work experience for its employees. Land did not view the hiring and laying off of people by the project as quite in keeping with his ideas of worker dignity or company stability. Steady, manageable growth seemed a much more sensible course. This basic corporate conservatism, in opposition to the innovative, almost daring nature of Polaroid's scientific side, also helps explain Land's refusal over the years to assume any type of company debt. All capital expenditures are financed internally from existing funds; and on the few occasions when this arrangement was not possible, borrowing

has been declined in favor of issuing additional stock. That way, even though money is "owed," it is owed to the company itself.

When viewed against the total backdrop of the problems any moderate-sized corporation has with employee satisfaction, Land's refusal to take on the types of defense contracts which would cause mass worker dislocation is almost symbolic. For any company involved in manufacturing, there are inherent problems that are just about impossible to eliminate (at least nobody has so far). To his credit, Land has spent the decades since World War II trying, just the same. Once the hostilities with Germany and Japan had been concluded, Land could calmly decide his workers' spirits would not be further tarnished by having to produce instruments of destruction. He would eventually spend much more time confronting the destruction done to those same spirits by the assembly line and the factory.

Land's own major technical strengths were in physics and chemistry, which allowed him to previsualize not only the finished product he sought in the way of instant photographic film, but what the processes were that would be needed to reach it. Responsibility for the engineering and mechanical phase of the project went to William McCune, who headed up a Polaroid team that eventually designed the original camera and the machinery that would produce both the camera and Land's new film. He has also been responsible for overseeing the manufacturing operations of Polaroid's several outside camera and component suppliers, a formidable quality-control task. As one long-time Polaroid employee put it, "Land told us what we were going to make. Bill McCune showed us how to make everything."

Among the most interesting—and fuzziest—of the stories surrounding the early days of the camera research is one on which both principals remain—at least publicly—unclear. The story has it that after realizing he had a potentially workable system, Edwin Land offered to sell the instant-picture technology to Eastman Kodak. Placing oneself back in time, one can see a certain logic to this. Polaroid, though prominent in optics, was not a photographic company, and the

name Kodak was literally synonymous with cameras and commanded a worldwide distribution network for picture-taking products. Polaroid's treasurer did not need very much imagination to foretell insolvency. But if "Big Yellow" would take over and exploit the Land instant-film system, Polaroid could be out of the financial hole and make up all the ground lost by the cessation of war-related work.

The logic is all there to support the story that Land was willing to sell. Others had followed a similar route and had become extremely wealthy in the process. What does not quite square is the character of Edwin Land himself, who had been twice burned at the hands of others outside his own company. Certainly, the situation is not quite the same here in that Polaroid had been dealing with Eastman Kodak almost since the beginning of its corporate history, and Kodak would have had nearly as much to gain as Polaroid in the arrangement. But it would have meant giving up the control that had become so important to Land. And it would have meant letting someone else fulfill his vision. This is the most difficult factor on which to affix a dollar value; but in any event, it is hard to conceive of Land being willing to accept the trade-off at any price.

Kodak has no public thoughts on the veracity of the story. One opinion at Polaroid comes from Donald A. Dery, Director of Publicity and Communications:

My understanding is that it's true. But I'd be careful of the word "offer." Knowing Land as I do, I seriously doubt he would offer something like that outright. He may have been willing to bring them in on it in some fashion.

Whatever the case, Land was never again willing to relinquish Polaroid's control over its own innovations and technologies. From time to time they would align themselves with others in a joint research and development effort, and they would almost always take advantage of outside vendors to produce the actual product. But from this point on, Polaroid, personified by Edwin Land, would always be running the show.

3

The New Medium

Photography Before Polaroid

"Instant" imaging, in actuality, is older than photography itself. Only it took the medium more than a century to come back to a practical way of using it.

Both painters and scientists had been experimenting with so-called "sun pictures" made in large *cameras obscura* since the sixteenth century. A German physician, Johann Heinrich Schulze, obtained the first images created by the action of light on a chalk and silver mixture at the University of Halle in 1727. This was the beginning of the use of silver salt as the basic chemical ingredient in photographic plates and, later, film. It never occurred to Schulze, however, to try to make his images stable. Once he shook the bottle containing his image-bearing solutions, the pictures were lost.

Like many other technologies, photography benefitted in its various aspects from the general pace of scientific interest in many fields. Among the most important were the early seventeenth-century work of Johannes Kepler, who worked out the mathematical laws governing mirrors, and Galileo's invention of the compound telescope. By about 1615, Kepler had discovered enough about the properties of ground glass lenses to make them reliable instruments.

The first example of what we might actually call a

photograph was a fuzzy view taken from a window in Gras, France, by the Frenchman Joseph Nicéphore Niepce onto a pewter plate. But it was a younger Frenchman who joined into partnership with Niepce and made his invention work. Although the two men were supposed to share equally in the partnership, the younger man proved to be as good a businessman as he was an inventor. Niepce died impoverished and—until our own time—all but forgotten. The younger man, Louis-Jacques-Mandé Daguerre, became wealthy and lent his name to the first photographic process.

Daguerre announced his process publicly in Paris in 1839, 6 years after the death of Niepce. There were 12 main steps to his image-forming, beginning with a thin sheet of silver soldered onto a thicker sheet of copper. The sheet had to be polished to a brilliant shine, then treated with iodine fumes to make it sensitive to light. Once placed in the camera, the photographic plate had to be exposed in bright sunlight for at least 15 minutes, then removed and subjected to a heated mercury spirit lamp, immersed in cold water, and finally treated with salt and washed. The product of all this, the Daguerreotype, was a one-of-a-kind item. The plate exposed in the camera and finished picture were one and the same. Unlike today's photography, there was no transfer of image from negative to positive.

Meanwhile in England, William Henry Fox Talbot was perfecting the negative-positive technique and the idea of printing the final picture on paper. In this fashion, the reversed image (a basic phenomenon of optics) recorded on the photographic plate could be re-reversed on the positive to resemble the actual scene or person. More importantly, multiple prints could be obtained from the same negative, something that apparently never occurred to photography's earliest pioneers. Fox Talbot's negative-positive process, which he called the "calotype" (from the Greek for "beautiful picture"), was the basis for all of modern photography. In 1844, Fox Talbot took advantage of the innovation of his own process by publishing *The Pencil of Nature*, the world's first book illustrated with photographs. It is interesting to

note that as he grew in prominence, Fox Talbot too succumbed to the heady lure of name identification, and changed calotype to "Talbotype." Daguerre was the first in this trend, but Fox Talbot was not the last.

Despite the greater ease and lower cost of the calotype and the attractiveness of its reproducibility, the Daguerreotype held its own in the European and American public's favor for a good number of years. A single look at a Daguerreotype, which can be seen in a museum or private collection, will give a strong indication why. The image is at the same time exquisitely detailed and subtle, seeming to bring out the inner qualities—both good and bad—of its subject. And framed as they were in beautifully worked leather and velvet closing cases, each Daguerreotype must have been to its possessor something quite special. The overwhelming majority of them, dating from the middle of the century, record individuals. Groups are uncommon and scenes are almost nonexistent. People apparently knew what they wanted pictures of when photography became available—each other. Persons of all types began trooping into the portrait-maker's studio, and initiated for their successors a new legacy: a direct and intimate bond with all the generations of their line.

There was another advantage to the Daguerreotype, as well as its followers the ambrotype and tintype, particularly once Daguerre's adherents got the exposure time down to something more manageable. The processing was performed as soon as the plate was removed from the camera, and the customer could generally walk away with his picture within about 10 or 15 minutes. This was, in effect, the first instant photography. Just as the early photographers had not realized that a recorded image could be reproduced more than once, so too it never occurred to them that one should have to wait several days to see his results.

What these early practitioners were also not foreseeing was the incredible impact photography would have on both the European and American continents. Not only would the average citizen want to come into a portrait studio to have

his picture taken, he would eventually want to go out on his own and take pictures himself. If Mathew Brady could obtain his striking images in the midst of actual battles of the Civil War, they might have figured, they could at least record the family's Sunday afternoon visit to Niagara Falls.

Convenience and ease of operation were not the hallmarks of early amateur photography. The "wet-plate" cameras, and even the later dry-plate ones, required a virtual wagon full of chemicals, supplies, and related equipment for even the simplest photographic outing. There had to be a better way.

It came from a young bank employee in Rochester, New York, by the name of George Eastman. He spent his evenings working out the details of a new, more stable form of dry plate and a machine to coat them uniformly. He eventually left banking and continued his experiments full time, coming up with a treated paper plate and later a gelatin one. This led ultimately to roll film, an ingenious invention which could be fitted into any existing camera. By 1886 Eastman had designed a relatively small camera which could take 48 4-by-5-inch negatives. Two years later he came out with an even smaller wooden box, which came equipped with 100 negatives and sold for 25 dollars. The accompanying manual listed only four instructions: (1) Point the camera. (2) Press the button. (3) Turn the key. (4) Pull the cord. When the 100-shot roll was completed, it was sent back to the factory for processing. A replacement roll cost 10 dollars.

George Eastman wanted a word for his device that would suggest the same thing—and only that—in every language throughout the world. He understood well the universality of his product, and did not want any semantic obstacles getting in his way. He had always liked the forceful "K" sound, and so he stuck it at the beginning and the end of his made-up word: "Kodak."

It would be difficult to overstate the impact the Kodak No.1 had on the culture of the late nineteenth century. For the first time the average citizen could take his own pictures,

and exercise his own personal vision. And hundreds of thousands did just that. Eastman's Kodak made photography into the first truly democratic art form. The company he founded in his home town of Rochester dominated the world of photography through its ubiquitous films and processing. And, of course, it still does. The company's advertising slogan for the original Kodak set the tone for the product and remains one of the most memorable and effective messages in the history of merchandising:

You press the button, we do the rest.

Eastman's influence lived long after him. (He himself lived into his seventies, at which point he decided he had had enough and put a bullet through his heart in an upstairs bedroom on March 14, 1932.) Consumer photography remained an extension of the first Kodak, and the Rochester titan grew larger and larger, moving millions of those little yellow boxes each year to hundreds of thousands of amateurs and professionals.

This was the setting in whch Edwin Land brought his new developing system closer to completion. In fact, before he and McCune could come up with their own prototype, Land equipped an existing camera with rollers for this experiment.

If the public had been conditioned by the visual media proliferation of the 1930s to accept photography as an integral part of its collective life, that same public had become even more enthusiastic by the early postwar years. Husbands were being reunited with their wives, and in many cases getting to know their young children for the first time. Families were discovering the delights of more leisure time. And, to a large extent, a joyous mood had replaced the protracted anguish of the most wrenching conflict in the history of the world. The newness of photographs had worn off within a few years of Eastman's first Kodak. The delight of capturing each other on film never did.

Pictures in a Minute

Edwin Land publicly demonstrated his instant picture camera on Friday, February 21, 1947, at the winter meeting of the Optical Society of America, held in New York City at the Hotel Pennsylvania. The descriptive material in the Society's program hearkened back to Eastman in calling the new camera "a new kind of photography as revolutionary as the transition from wet plates to daylight-loading film." Lest the significance of his black-and-white system be in any way diminished, Land announced that the process was "inherently adaptable" to color and motion pictures.

The news photographs taken at the meeting show a trim and dignified-looking Edwin Land peeling an 8-by-10-inch positive print of himself away from the negative 50 seconds after exposure. He is a darkly handsome man in those pictures, but what is most striking in the not yet 38-year-old inventor is his unrelenting intensity. Not surprising for a man of Land's interests and achievements, it is his eyes that immediately distinguish him. This is true in every company publicity shot, up to the most revealing studies by his friend Ansel Adams. And it is even more apparent upon seeing Land in person. Attendees at the Optical Society meeting must have come away with the impression of a missionary about to announce the Good News for the first time.

Though Polaroid made it clear that the so-called "Land Camera" would not be available for sale for several months at the earliest, the technical community was taken by storm. This was not so much due to their desire to take instant snapshots as to their reaction to Land's scientific virtuosity. The public, once the news got out, seemed less impressed with the *how* of the process as the *when* they could buy it.

When the process was explained, a number of publications wondered why no one had thought of it up until then. *Business Week* magazine stated, "The device [Land] used is so simple that it is hard to believe it can really do the job."

The New York Times commented, "All this seems so simple that, as usual, we wonder why it was not done before." The point is, of course, that nobody did come up with the system before Land, who not only conceived of it but made it a working reality in less than 4 years. One of Land's close associates heralded the achievement by saying, "I would be willing to bet that 100 Ph.D.s would not have been able to duplicate Land's feat in 10 years of uninterrupted work."

Land himself explained, in somewhat compelling terms, what Polaroid was offering: ". . . the realization of an impulse: see it, touch it, have it." Actually, the mechanical process involved with the first demonstration camera was not overly complex. But it is important to remember that this mechanical process was merely the way to begin a highly sophisticated chemical reaction, which is the heart of Land's inspiration. The image is exposed on a roll of negative photographic paper, which is pulled down from the top of the camera into view of the bellows-mounted lens. It meets up at a set of rollers leading outside the camera with a roll of positive paper pulled up from the bottom. Interspersed one frame apart on the positive roll are small pods of developing chemicals known as "reagent." The two basic chemicals in the original developing process were the standard photographic developer, hydroquinone, and the standard fixer, sodium thiosulphate, or "hypo."

As the negative and positive papers are pulled through the rollers together and out of the camera body, the pressure of the rollers bursts the reagent pod, spreading the chemical evenly through the middle of the positive-negative "sandwich." The chemical reaction takes about a minute to complete, the main difference from the traditional developing process being the actual "migration" of silver salts from the negative to the finished positive print. Once out of the camera, the sandwich is clipped from the respective rolls by a pair of knife blades and peeled apart. What the operator has is a negative and a positive sepia-toned print. Since it involves the transfer of silver salts from the negative to the positive rather than merely shining light through it onto

a sheet of positive paper, the Land process does not produce a reusable negative. In a sense, Land was returning to the earliest traditions of photography: an instant one-of-a-kind image.

Coincidentally, the Optical Society of America became for a few years the prime forum for the introduction of bold new technical ideas. One year after Land introduced instant photography at an Optical Society meeting, the Haloid Company of Rochester announced a new document-copying process at another society meeting. Based on the research of a former patent attorney from Seattle named Chester F. Carlson, the process was eventually given a descriptive named taken from the Greek—xerography. The name and the process both caught on. And so did Haloid, which changed its own name in commemoration.

When Land came up with the instant-picture idea in New Mexico, what first struck him was the potential feasibility of the system. Though he had always been interested in the fields related to optics, his photographic work had been mainly concerned with stereo and Vectograph images. But in the intervening years between Santa Fe and New York City, he obviously had the time to come up with an aesthetic philosophy to go along with his technical acumen. This is not to suggest that Land's philosophy was merely rhetorical appendage or a bow in the direction of slick marketing. Land genuinely does see his work as a unified whole in which the scientific and humanistic halves not only complement each other but are mutually dependent.

In an article he wrote for the *Photographic Journal* shortly after the Optical Society meeting, Land defined his intentions with regard to what he had now come to call "one-step photography":

By making it possible for the photographer to observe his work and his subject matter simultaneously, and by removing the manipulative barriers between the photographer and the photo-

graph ... the photographer ... by definition need think of the art
in the taking and not in making photographs.

"One-step," by the way, is a name that stuck. And it is
not surprising, given Land's penchant for keeping company
names and traditions in circulation, that the latest SX-70
camera, an inexpensive fixed-focus model designed to slug it
out with the bottom-of-the-line Kodak instant, is called the
One Step.

At the time of the public announcement of Land's
instant system, Eastman Kodak, in keeping with its position
of Olympian grace in the business, was publicly encouraging
to the new kid on the picture-taking block. So pervasive was
Big Yellow's influence in the field, that a company spokes-
man in Rochester was able to be taken quite seriously when
he issued that now-famous declaration, "Anything that is
good for photography is good for Kodak."

Kodak correctly figured that while increasing the general
level of interest in amateur photography, Polaroid's new
offering would not cut into its own sizable slice of the pie.
Since George Eastman's first marketing effort in the 1880s,
Kodak had always gone for the mass market, producing
cameras and film that were financially and technically
accessible to just about anyone who wanted to take pictures.
From everything the Kodak engineers had to go by, the first
Land cameras would have to be larger, slightly more complex,
and—most important—substantially more expensive than the
low end of their own product line. The new camera would
appeal to a different class of buyer, no matter how many
thousands of units Polaroid would be able to sell in the first
several years.

This fundamental line of demarcation in the pho-
tographic market would actually last until well into the
1960s, when both Kodak and Polaroid would begin making
forays into the other's territory. Until then, as we shall see,
the existence of these two radically different style companies
in the same business would be financially beneficial to both.
Kodak had been the fledgling Polaroid's first important

customer. And in the years to come, Polaroid would come to rely on Kodak as its largest single supplier. Besides, from Kodak's point of view in 1948, there was more of an existing threat from the more similarly oriented competitors, such as Bell & Howell and General Aniline and Film (GAF).

In the year and a half between the first announcement of the instant camera and when it hit the market, Land was spending at least part of his time on other fields of what he considered significant scientific research. Around that time, Land developed an optical technique for observing living human cells in their natural color. Its immediate application was in cancer research, and the public announcement was made at the dedication of the Sloan-Kettering Cancer Institute of New York on April 16, 1948.

Research also continued on other pet Land projects. An outgrowth of Vectograph research was a new process for printing color motion pictures economically, using sequential color development of the same type of film as was then employed in black and white printing. Paramount Pictures was the first company to use this type of film, which was introduced in a one-reel cartoon entitled *The Circus Comes to Clown*. The process was named Polacolor, another of the company names that resurfaced years later with the introduction of the first Polaroid color print film.

And in an exercise more tantalizing than productive, Detroit once again played with the prospect of polarizing automobile headlights in an industry demonstration conducted by the American Association of Motor Vehicle Administrators. The rhetoric attending the meeting was suitably high blown, and Land was even given the opportunity to explain the system's benefits in saving lives. After the demonstration the matter was "taken under advisement" and then quietly dropped.

From the public's, and media's standpoint, though, Polaroid's name was now associated most clearly with the instant camera, a consumer product that had yet to appear in a single store. At the 1948 convention of the Photographic Society of America, held in Cincinnati, Edwin Land's technical demonstration of instant photography was the

overwhelming hit of the show. This highlights a phenomenon that has always been a sore point in photography: the professional's and serious amateur's obsession with hardware to the frequent exclusion of craft, a phenomenon that can be verified to this day by a quick glance at the pages of the numerous photographic magazines. As a sidelight, at the 1948 convention, a symposium with the heady title, "Can the press photographer influence the course of history and improve the lot of mankind?," had to be cancelled for lack of interest. Though the premise is admittedly a study in rhetorical exorbitance (though there may be some truth to it) one might have expected at least some skeptical curiosity for so incredible a topic.

The first Polaroid Land camera, the Model 95, weighed about 4 pounds and sold for a list price of $89.75. It was a rather elegant, old-fashioned-looking device with a prominent folding bellows connecting the lens housing to the body, which was covered in imitation leather. With the bellows folded up into the body of the camera, the complete unit was about the size and shape of the large portable radios that first started appearing a few years later. The Model 95 produced photographs measuring 3¼ by 4¼ inches; there were eight to a $1.50 roll. In the Model 95, Land's original design had been somewhat modified to keep the film in the back of the camera for the minute it took to develop. Then a back cover was lifted and the deckle-edged print lifted out. Its corresponding negative would be removed just before the next picture on the roll was processed.

There was one further aspect to the package, which gave it the look and feel of tradition, even though it was a radically new product. Instead of black and white, the original Polaroid prints were sepia-toned: that warm, reddish-brown coloration, which characterized the earliest photographic prints and which seems to render an air of endurance and stability to even the most transitory scene. Sepia prints, no matter how sharply focused, appear to have no harsh edges. And, years later, these early pictures are still pleasing to look at. But the reasons for the sepia coloration were chemical rather than aesthetic, and as soon as Land's

researchers could come up with a workable formula for sharp, modern-looking black-and-white prints, they lifted their sepia film and replaced it. This happened about 18 months after the initial sales.

One of the other important photographic innovations represented by the Model 95 was the "exposure value system," which greatly reduced the complexity of figuring shutter speed and lens (aperture) opening. The basic concept of incorporating a semi-automatic exposure system, which would be based on keying certain shutter speeds to certain lens openings depending on lighting conditions, was subsequently adopted throughout the photographic industry.

Since Land was determined never again to relive the disappointments of his automobile headlight and 3 dimension movie experiences, Polaroid would have to handle the marketing of the instant camera itself. This was one field of business in which the company had relatively little experience: in the past, most of its products had been manufactured for other companies and, during the war, for the military. Another factor was that though the public and journalistic interest in the camera had been high since the day Land introduced it, both the Wall Street and photographic establishments had been far from overwhelmed by its commercial prospects. The Polaroid chairman even admitted that "it was reasonable to snicker at the idea."

Land apparently lost little sleep over this initial situation, calling to mind that the same sort of reaction had greeted the public introduction of Bell's telephone 70 years earlier in the same city. The telephone has been a dominant symbol in Land's thinking. In later years, he began making numerous connections between his camera and the telephone, which remains the single most significant technological innovation in American history.

There were several possible routes for the marketing of the camera. For a while Land and the other Polaroid officers tossed around the idea of selling directly to the public through a national force of salesmen, who might even go door to door with their campaign. But Polaroid had no experience whatsoever in direct marketing of this kind, and a

national sales force similar to the one so effectively employed by IBM would cost a fortune to start up, train, and provide branch outlets for. So after a number of lengthy planning sessions with consultants brought over from the Harvard Business School, Land concluded that the company would follow the traditional sales route and offer its product through retail stores.

They were not quite sure how to go about actually putting the cameras in the stores; nationally, it would take months to build sufficient inventories of both the cameras and film. Though he had compelling faith that the public would clamor for his product, Land had little personal background in sales, so he sought out someone who did.

J. Harold Booth had about 20 years of experience in sales and marketing, much of it as a vice president of Bell & Howell. Land therefore figured he must know a fair amount about selling cameras and film. He appointed Booth executive vice president and general manager. The nonexistent sales force was not the only obstacle Booth had to contend with. The plummeting sales figures and increasing annual deficits left Polaroid with little money to spend on advertising.

Booth and his sales manager, Robert C. Casselman (who was promoted to vice president for sales in 1956) came up with a marketing plan that would hopefully give the aura of hard-to-get desirability and exclusivity, while at the same time attracting the maximum of (free) press publicity. The Polaroid Model 95 Land camera was first offered for sale to the public at Jordan Marsh department store in Boston on November 26, 1948. As this was the only retail outlet in the country selling the camera, demand was intense—so intense, in fact, that store sales people quickly found themselves selling counter display models, not realizing that parts were missing.

Other than the sale of incomplete floor samples, this was exactly the reaction Booth and Casselman had hoped for. Nearly any reasonably good product that had had some publicity could find enough enthusiastic buyers to cause a run at a particular store. After all, how many customers does

one photographic counter have to handle to reach capacity? But this display of enthusiasm, to the point where the retailer was unable to keep up with demand, gave the camera an added fascination. Those few who had been fortunate enough to buy one at Jordan Marsh were, for a while, special people, like the first ones on the block to have a Dumont television.

The next marketing mini-blitz took place in Miami in January of 1949. This was only the first of several Polaroid new-product introductions in the south Florida resort city. The logic was that since a good percentage of the people in Miami at any given time were vacationers with a fair amount of pocket money on hand, they would provide a receptive market for a new luxury item. And of course the fact that they were travelers was of at least equal significance, since they could be expected to be taking a lot of pictures and, when they returned home, would rapidly spread interest in the camera to all parts of the country. In that way, each community would be "seeded" with cameras to build up anticipation for the time when the product could finally be distributed on a national basis.

Booth's next step was to select one major store in each target city, and offer that establishment a 30-day exclusive on selling the camera in return for certain considerations to Polaroid. One was to provide advertising and promotion in that city, something Polaroid did not have the money for itself. Another was to have sufficient floor space and trained personnel to give the camera and film maximum presentation in the store. And having the camera sold in but a single store in each city would further contribute to the image of exclusivity and desirability Polaroid was after.

From this strategy it was already possible to determine the direction of Polaroid's long-term marketing plan. With the exception of the mass-oriented, low end of Kodak's product line, most consumer photographic products had been sold primarily in camera specialty stores. While Polaroid did not ultimately wish to ignore this outlet altogether (to do so would have been to risk never reaching the small

army of professional photographers), it saw its own greatest
potential in quality department stores, and later in the large
discount houses. This attitude on Polaroid's part led to years
of tension between the company and the ranks of camera
store owners, a rift that did not begin to narrow until well
into the marketing of the SX-70.

R. H. Macy was the company chosen to offer the Land
camera and film first in New York City, the nation's largest
single market for photographic supplies. In keeping with its
agreement with Polaroid, Macy's removed the glass from its
show window at Thirty-Fourth Street and Broadway, and set
up a display into which passersby were invited to step and
sample the camera.

Not wanting to be outflanked on the merchandising coup
of the year, arch-competitor Gimbels quietly secured Polar-
oid cameras and film from an unnamed out-of-town supplier,
and announced that it too had the new magic camera.
Realizing it had been manuevered around, Macy's dispatched
a raiding party of conservatively dressed store employees over
to Gimbels with enough cash to buy up every single camera
the other store had to sell. Once the mission was accom-
plished and Gimbels was completely cleaned out of Polaroid
stock, Macy's immediately took out huge ads in the *Times*
and *News* proclaiming their exclusive sales of the cameras
and film.

In the first week of its 1-month agreement, Macy's moved
about 4,000 cameras, which represented almost half of
Polaroid's monthly production capacity at the time. It was
many months before the company could begin to meet full
demand.

The names "Polaroid" and "Land" were at once paired in
the public's mind, although few people knew exactly what
the second name referred to, and some even thought it was
meant to distinguish this model from an underwater or aerial
camera they thought Polaroid must have been putting out.
This was just about the way Land planned it. Land was
fortunate in having a name that easily attached itself to a
consumer product of mass appeal. "Polaroid Land Camera"

has a nice ring to it, even if you might not associate the second name with a person. Had the inventor been saddled with a name such as Poretsky, say, or even Jones, it is an open question whether he would have been as anxious to associate his name with the product.

Even after the initially enthusiastic public response to the Land camera, the "experts" were not convinced. This had little effect on the mass of consumers who shopped at Macy's and other outlets, but it did cut back sales to the professionals and serious amateurs who bought their photographic products at the camera stores. Most professionals and magazine critics who publicly commented on the system regarded it as a toy or a gimmick. Some even went so far as to suggest that the waiting was one of the prices an individual should have to pay for his "art." (If it was so easy, how could it be worthwhile?)

Land had apparently prepared for this criticism. He was, he said, willing to reeducate the public to what they had in his camera, so that once the novelty wore off, Polaroid cameras would be thought of as more than a mere passing fad. He had too much of his company's resources and his own life tied up in the venture to allow that to happen.

Years later, Land set out his ideas on the nature of such inventions in an interview with *Forbes* in 1975:

Over the years I have learned that every significant invention has several characteristics. By definition it must be startling, unexpected and must come to a world that is not prepared for it. If the world were prepared for it, it would not be much of an invention.

The second great invention for supporting the first invention is finding how to relate the invention itself to the public. It is the public's role to resist. All of us have a miscellany of ideas, most of which are not consequential. It is the duty of the inventor to build a new gestalt and to quietly substitute that gestalt for the old one in the framework of society. And when he does, his invention calmly and equitably becomes part of everyday life and no one can understand why it wasn't always there.

It took us a lifetime to understand that if we are to make for every man a new commodity—a commodity of beauty—then we must be prepared for that extensive teaching program needed to prepare society for the magnitude of our invention.

Land's attitude toward the users of his new camera provided an interesting example of the unity of his vision. He had founded his company basically as a commercial institution of scientific research, and carried over into the corporate sphere the experimental approach of science. "Lots of companies put a great premium on avoiding making mistakes," he commented. "Here we put a great premium on being able to make mistakes."

He elaborated on this premise in a 1972 interview with *Life* magazine:

An essential aspect of creativity is not being afraid to fail. Scientists made a great invention by calling their activities hypotheses and experiments. They made it permissible to fail repeatedly until in the end they got the results they wanted. In politics or government, if you made a hypothesis and it didn't work out, you had your head cut off. The first time you fail outside the scientific world you are through.

From the beginning, this is what Land had been striving for with his company. It may, in fact, explain why it took Polaroid a relatively long time to achieve solid profitability; Land preferred having everyone who worked for him try whatever seemed interesting to them.

And when the Model 95 came out, this is exactly the concept that the advertising and Polaroid product literature stressed: with the Land camera the ordinary amateur photographer became an aesthetic experimenter. Or, stated plainly, *trial and error!* If the first picture didn't come out the way you wanted it, you kept taking pictures and comparing them to the actual subject a minute later until you came up with something you liked. Under normal circumstances, an average photographer tends to become discouraged if his first

several rolls of film back from the drug store turn out disappointingly. But with an instant camera, Polaroid seemed to be saying, you immediately know if you have what you want.

With the Land camera, you could certainly take simple snapshots if that was what you wanted. But you could do more. With this new capacity for instant response, you could develop your own aesthetic ideas and creative vision on the spot, rather than looking at a mediocre shot later on and trying to remember back to what it was you were trying to capture. By stressing the essentially creative nature of this form of trial and error, Polaroid got its customers out of the habit of thinking of their "failures" as something to be ashamed of and at the same time probably avoided a great deal of potential complaints about a film that was admittedly less than technically perfect or procedurally foolproof.

To the company's credit, it should be stated that Polaroid was established so that difficult photographic questions could tomer service. As Land said, he was trying to "build a new gestalt," and he realized that there would have to be a fair amount of teaching involved. A collect telephone number was established so that difficult photographic questions could be answered on the phone. Easier questions were dealt with by form letters. If there was no form letter in stock to address a particular photographic problem, a personal letter from whomever in the company happened to know the answer was quickly dispatched. To get customers in the habit of shooting film, plus trying to make them think kindly of the new photographic company, Polaroid offered a free roll of film by mail to anyone sending in a camera warranty. This policy lasted for the first several years of the camera's marketing. Polaroid was saying, in effect, that it would share the burden with the consumer of learning how to deal with the new product. This solicitude toward anyone buying a Polaroid camera might also have been an indication of Land's cognizance that the average amateur photographer, not terribly well-heeled and rather tentative about his new avocation, represented his true constituency.

Land also sought out the acknowledged experts in the photographic profession in an immediate effort to make the Polaroid film better from a qualitative standpoint. The most significant of Land's initial contacts was with the masterful Ansel Adams, whom Land met at the 1949 meeting of the Optical Society of America. Adams, who is best known for his monumental and ultrasharp black and white panoramas of the American West, is at the same time a photographic romantic and an acknowledged expert of the technical side of picture-taking. During his long career, which goes back to the time of such masters as Steichen and Stieglitz, Adams devised a method of previsualizing the tonal range of photographs before the photographer takes them, known as the zone system. It became the basis for a multivolume series Adams wrote.

Adams signed on as a paid consultant to Polaroid and became famous within the company for his long memos, which were as detailed as some of his photographs of Yosemite Valley, suggesting ways in which the tonal value of Polaroid film could be enhanced, as well as new applications for Polaroid photographic technology. Adams was credited with several Polaroid product innovations, including providing the impetus for the marketing of 4-by-5-inch sheet film, an essential to the professional photographer. In the process, Adams also became one of Edwin and Helen Land's closest personal friends. An intense, yet strangely peaceful and casual photographic portrait of Land, taken in 1958, appears in the Ansel Adams monograph published by Morgan & Morgan. And Adams dedicated his compendious volume, *Images 1923–1974*, to the Lands.

Even without the prompting by such artists as Adams, Land was well aware of the need to improve the basic quality of his film and the camera. It had a tendency to show spots, particularly near the middle ranges of tone; and if the reagent pod did not burst the right way, it would spread unevenly, and the user would only get part of a picture. And Land was always interested in improving the sharpness of the overall print.

To help him with this, Land had hired a Smith College arts graduate named Meroë Morse soon after he began doing serious research in instant photography back in 1944. Morse herself came from a scientific background, which Land appreciated. Her father, Marston Morse, was a professor of mathematics at Princeton's Institute for Advanced Study. Meroë began as Land's personal lab assistant, and before too long was promoted to manager of black-and-white film research, a position she held until her death in the late 1960s.

Her equal number in another phase of film research was Howard Rogers, who, like Land, had spent some time at Harvard before becoming a member of the Land-Wheelwright research team. He has remained with the chief ever since.

When Land announced the instant camera in 1947, he had stated that the process was inherently adaptable to color, though this type of in-camera development would involve a far more complex chemistry. As soon as the marketing of the initial camera and film was firmly underway, Land assigned Rogers to head up a color film research team. In traditional Polaroid style, this color work (which went on for years) was subsidized by profits from the black-and-white film. The color film, in turn, once it was perfected, would pay for the next company development.

The national distribution of the Land camera placed Polaroid among the ranks of the major consumer product producers. It was, however, still a small company in terms of employee population and still had severely limited financial resources. Land had founded his company as a place to conduct research, and this research had eventually led to a consumer product with overwhelming potential. But this did not mean, in Land's view, that the character of the corporation should change. Consequently, nearly all of the actual manufacturing functions associated with the camera's production were farmed out to vendors. Polaroid's resources continued to be directed toward research, marketing, and managing the operations of the companies acting as vendors

for what was high-volume, repetitive work; but the "innovation" had already been taken care of. Said Land, "Never do what others can do for you just as well."

Manufacture of the early cameras was assigned to a small company in Rochester, which produced them until it went out of business a year later. Production was then shifted to the sizable U.S. Time Corporation of Waterbury, Connecticut, which is most famous for its Timex Watches. Responsibility for certain cameras and components was awarded to Greist Manufacturing Company of New Haven, Connecticut, which was in the business of producing sewing machine parts and accessories. The lens for the new camera was designed by Polaroid engineer David Grey, and turned out in quantity by a number of contractors. Most notable among these was Eastman Kodak, continuing an interrelationship between these two companies which was of major significance to both. It would become even closer in the early 1960s, which only served to deepen the rift when all-out corporate war was declared a decade later.

While Polaroid had neither the funds nor the interest to handle its own manufacturing, Land did not completely trust the vendor companies to turn out the quality of product he required. Because of the precision nature of photography in general and the instant-developing camera in particular, tolerances on parts produced for Polaroid had to be extremely narrow. This, in part, explains why Land went to a watch-making company on behalf of his camera. So under the direction of General Manager David W. Skinner, Polaroid dispatched engineers to remain on the premises of each vendor to make sure the job was being done consistently to Land's liking.

The Polaroid Experience

Polaroid photography quickly became part of the American way of life.

About a half-million Model 95 cameras were sold in the first 5 years, during which time more· than 200 million Polaroid pictures were taken. Americans have never been regarded as a particularly patient group as a whole (if one could be so presumptuous as to generalize about what was then 150 million people), and the instant gratification engendered by Polaroid photography certainly appealed to the insatiable national quest for speed in all things. Polaroid has built an industry on instant gratification.

But there had to be more to it than that.

There were, of course, certain specialized advantages in the Polaroid process that appealed immediately and mightily to particular segments of the population. Those wishing to take "art" photos of lovers or spouses were now able to do so without fear of the censoring eye of the local druggist or the ogling leer of the film laboratory technician. During the socially repressive 1950s, many young people saw this as enough of a boon to single-handedly assure Edwin Land's spot in photographic heaven. The technique has become a part of popular culture and has figured in a number of movies and books, such as Michael Ritchie's film, "Smile," and Calvin Trillin's novel, *Runestruck*. The idea has since seen far more sophisticated incarnations. One honeymoon cottage in the Poconos will rent visitors a video tape system, which is set up at the foot of the bed and which records the high spots of the honeymoon night—a lasting memento which the newlyweds will presumably want to refer to again and again.

In the main, though, the Polaroid camera had a more general and more lasting effect on the public which began the second half of the century. Americans had already become attuned to the world of recorded visual information through films, picture magazines, and photojournalism. They had become enthusiastic practitioners of photography through the trend toward ever simpler and more convenient cameras, which began with George Eastman. And by letting them not only record their perceptions but also perceive the results almost immediately, Polaroid brought people that much more intimately into the creative process as it applies to the visual senses.

Creative perception (or that which comes closest to it in most of us) has at its base the principle of cause and effect. The initial moment of creativity is a previsualization of what the "aesthetic" result will ideally turn out to be. In the photographic realm, gifted and experienced men such as Ansel Adams can achieve this on their own. The average individual taking pictures cannot. The Land camera brought the previsualization and the result back into a meaningful proximity to each other so that the result could be seen while the previsualization was still a living image in the photographer's eyes and brain.

In one sense, each picture taken with the Polaroid camera becomes for the ordinary user a metaphor for Edwin Land's own experiencing of the instant image of creative perception: One comes up with a visual idea—regardless of how beautiful, profound, or mundane—visualizes it through the camera lens, then has the results in 60 seconds to compare with the original idea. The idea continues to be honed and shaped until it can offer up the desired and hoped-for results.

This is not to suggest that a Polaroid camera placed in the hands of the average—or even above-average—photographic hobbyist is going to transform him into Ansel Adams. Land would never make that claim. Polaroid and Land have not made the camera into the great perceptual equalizer. It does not bring up (or reduce) everyone to the same artistic level. Nor does it, as some have suggested, homogenize us as perceivers in the same way the large and soulless shopping malls mold us as consumers. The fact remains: "Good" photographers will still take better pictures with the Polaroid camera than will others.

But Land would claim, with some foundation, that bringing the two ends of this visual process together can help make people more aware of what they see, and, by extension, how they perceive and what their individual feelings are about it. As he says in somewhat oversimplified form, "All that should be necessary to get a good picture is to take a good picture, and our task is to make that possible."

Ansel Adams has expressed basic agreement with the inherent value of Land's self-proclaimed task:

Land really feels that if a camera is made that is simple to operate, it liberates the person to see and express what interests him. I would question the fact that the camera would make someone an artist. It can make someone a great observer and tie him much closer to the life around him.

The principle back of it is two-fold. One, it's extremely efficient—what we call the immediate response has great value in recording the world when you want to be sure what you've got. And the other is a new aesthetic approach in photography, which is the almost immediate feedback; that while we think we can visualize the image with the controls of conventional photography, [with the Polaroid process] we can accomplish that realization to an amazing degree. In this case you actually sense a level of completion far earlier than you could before.

A look at any random sample of Polaroid pictures taken during the early 1950s also provides evidence for Land's other claim—that his product has helped people better relate to each other. In any group of these snapshots, one seldom finds more than two or three scenes or landscapes; nearly all the prints are of people, generally in small groups, and usually children. Young children are inherently curious about perceptual processes, and are super-sensitized explorers of the world around them. Land's daughter Jeffie provides the original symbol for this curiosity, and her father's invention the means toward its satisfaction.

Marie Cosindas is a Boston-based photographer of national stature who has been equally successful in the fields of artistic and commercial picture-making. Cosindas, whose speaking voice is the verbal equivalent of her quiet and calm but intense photographs, has been using Polaroid film in her professional work for years (though in the larger, 4-by-5-inch format cameras rather than the off-the-shelf cameras). She is particularly mindful of the instant-response potential when working with children during a photo session: "When you have a photograph to show your subject, there's no longer a barrier between the photographer and the sitter. They can

become very creative together and the subject will come up with all kinds of different expressions."

What is interesting in this context is that a number of photographs obtained through the interaction and feedback of photographer and subject will show that subject—particularly a child—not only in the way that the photographer saw him but also in the equally valid way he sees himself. Such pictures generally become increasingly valuable to their owners in later life, as they grow farther and farther away from being the children captured on the snapshots.

A. Kenneth Showalter, a Washington, D.C., media artist who has done extensive work with the Smithsonian Institution's educational programs, is another admirer of the instant camera for the teaching of children: "The Polaroid is excellent for teaching because you get immediate feedback. You complete the loop more quickly, so the child's comprehension of what is going on is not fragmented."

Showalter is also of the opinion that Polaroid photography has made people so familiar and comfortable with the photographic process that it has made all other forms of photography that much more a part of the normal American experience:

The American public has come to view photographic prints as miniature realities. This is particularly true of Polaroid prints, which the viewer can instantly compare to the actual scene, and so verify the feeling. In any important event in our lives photographs have become a part of the ceremony itself. It's become ritualized. Can you imagine a wedding without a photographer?

In an interview with Philip Taubman of *Time* magazine in 1972, Land elaborated on what a photograph of a person can accomplish: "If I were to take your picture, I would not be able to get into the picture everything I sense when I look at you, but I would capture enough of what I sense so that when I looked at the picture later it would bring back almost everything."

In that same interview, Land asserted that a photograph could help give permanence and meaning to a child's constantly changing and confusing world:

I remember the first picture that I developed as a child. It was a picture of our French poodle. The dog was really unavailable to me. He was always running away; there were things he had to do at night as he roamed through the countryside. Then there was the picture I took of him. There I had him. He couldn't get away.

Young Edwin Land's puppy is symbolic of one's own fleeting childhood. Like the dog, it is ultimately unreachable, even to oneself. The taking of a photograph—particularly a photograph that can be seen instantly—is an attempt to capture some material significance out of that private world in flux. Interestingly, the dog image crops up repeatedly in Land's talks and demonstrations, most recently in his introduction of the Polavision instant movie system. Perhaps it is his own central representative image of his own past. Perhaps his inspiration to invent an instant picture system was in part a subconscious attempt to help each of us preserve and order our own past. Perhaps the poodle is Land's "Rosebud."

"Photography," according to Land, "is an illustration of the use of technology not to estrange, but to reveal and unite people." Instant pictures have an effect also on those people who, like children, can be expected to have a fresh and unjaded response to the phenomenon. Visitors to African tribal villages during the 1950s reported a sense of wonderment on the part of villagers upon seeing their photographic likenesses for the first time. The visitors said that the picture immediately gave them something in common with their hosts, and showed that the newcomers saw and respected them the same way they saw themselves.

Terry and Lyntha Eiler used Polaroid cameras with similar results when they set up a Project Head Start school in 1970 for the children of Havasupai Indians in their isolated village in a valley in the western wing of the Grand Canyon. The children, who had had little if any contact with

the outside world, were withdrawn and shy around strangers and had understandable difficulty engaging in even the simplest verbal exchanges. The Eilers began using 25 cameras donated by Polaroid to have the children take pictures of the subjects around them that had the most direct bearing on their lives, such as houses, pets, local scenery, and each other. As soon as the photograph came out of the camera it was mounted on a card and discussed. Through these tangible symbols of their lives, the Eilers reported, the children were able to begin verbalizing their feelings and establishing relationships with the world around them. Since the local school could only accommodate the tribe's young up to the second grade, and since the Indian community itself was establishing increasingly greater contact with the surrounding area, it was considered particularly important to equip the children to be able to deal with situations outside their own. After the initial experience, the children began taking the cameras outside their valley and recording the things that caught their interest.

Similar types of experiments have been conducted with preschoolers and children from deprived urban areas with favorable results. The Polaroid Foundation, the company's charitable institution, distributes cameras and film along with its traditional cash grants for such programs.

Professional photographers, who had originally scoffed at the Land process, began utilizing Polaroid cameras and, more often, Polaroid film in their work. Polaroid and other companies under Polaroid license started manufacturing camera backs, which made standard professional cameras compatible with Polaroid film. Using Polaroid film, a studio photographer can make on-the-spot tests of all the possible conditions of his setup, which might be costly or impossible to recreate. When he achieves the proper conditions, he can, if he wishes, transfer back to his conventional film for the final pictures.

Marie Cosindas has been using Polaroid film for her finished work ever since she went out west in the early 1960s to study with Ansel Adams. Currently, most of her work is

done in Polaroid color film, which she loads in a 4-by-5 Linhoff view camera. "Polaroid film gives the opportunity of letting you develop an idea and working out concepts which you previsualize," she says. "You just keep pulling pictures till you get everything right—color, contrast, composition. With conventional photography you can't develop the concept as it's happening."

She showed me a 4-by-5 print she had taken of an array of handmade crafts and artifacts for a commissioned poster she was making. "The little things that bothered me here, I was able to correct immediately."

Today it is estimated that the number of photographs taken annually in the United States exceeds 5 billion. The majority of these, of course, are not Polaroid. Actually, a majority, or fairly close to it, are Kodak. It is unquestionable, however, that the wide usage of the Polaroid camera and film over the past three decades has raised the level of photographic interest and awareness to an extent that never could have been achieved without them. On at least this level, Kodak's prediction that what was good for photography would be good for Kodak proved to be accurate.

Edwin Land believes that his camera's photographs, apart from recording for rememberance what their user sees, helps people view each other more clearly and individually. He said, "I find in each new person I meet a complete restatement of what life and the world are all about." Despite his practical success, Land is still in many ways a romantic. The "Complete restatement," however, has been one of the guiding principles of Land's life, and he continues to be at least partially successful in instilling this idea— perhaps subconsciously—in a significant number of his customers.

4

Growth

The Camera Takes Hold

In the photographic business, the future of one's product is equally as important as its present. Once the scientific and technical problems have been solved—as they had been for Land's first generation of film—it was merely an engineering feat to churn out roll after roll of acceptable quality print material. But keeping it that way in the photographic business is another matter.

The sepia-toned film marketed with the Model 95 held up remarkably well in clarity and tonal quality. Many of the original prints still in existence belie their age and status as pioneering artifacts. However, to a generation used to thinking of sepia as a vestige of the turn-of-the-century about on a par with the bustle and egret feathered hat languishing in the attic, the Polaroid prints had an instant anachronistic quality totally out of keeping with the image of a technological leader. What is more, the sepia image seemed inferior in sharpness compared with the quality of the best prints then being offered by Kodak.

Land and his chemists came up with a workable formula for a type of black-and-white film almost as soon as the Model 95 was introduced, and had it ready for the marketplace by 1950. But within 6 months of the initial sales of

this Type 41 film, Polaroid had a more serious problem on its corporate hands: print fading.

Each industry has its own pet bane. The building industry's is snow or heavy rain. The produce industry's bane is drought or early frost. And for any film manufacturer, it is print-fading: loss of color, brightness, or tonal quality over a period of months or years.

A certain amount of fading is unavoidable in even the finest products. For years it was virtually impossible to assure constant color in any sort of color prints, even with all the resources of industry-leading Kodak attacking the problem. Today, a disclaimer about color-print-fading is still included on the data sheet included in each little yellow box.

But black-and-white prints were not supposed to fade with age to any appreciable extent, which partially explains why so little important—historically or aesthetically—photographic work was done in color until quite recently. Land was well aware of the dilemma Polaroid faced as soon as it became clear that Type 41 prints were fading. Polaroid was now staking its corporate life on instant photography. And most major American photographic companies make their significant profits on film and not on cameras. If Land could not solve the problem, his camera would go down in business annals as another mere passing consumer fancy.

Time was of the essence. Land realized that, in any consumer-oriented field, early negative publicity is difficult to shake. And it is a fact admitted privately by a number of Polaroid personnel that, more than two decades and several generations of film after the problem surfaced, a great many people still associate severe print-fading with Polaroid pictures.

Land's response to the problem was characteristic. He headed for his laboratory, the place where he felt he was most in control and where, if sufficient attention was paid, a solution would be forthcoming. Land has said, "If you are able to state a problem—any problem—and if it is important enough, then the problem can be solved." Many intelligent

people, particularly in the social sciences, would dispute this assertion with good cause. It is not, however, of paramount importance whether Land was right or wrong. What is important is that he believed the statement accurate and was able to act accordingly.

After numerous tests on Type 41 prints, Land discovered that the image was being degraded from both top and bottom by contaminents present in the air. Based on this observation he decided that the positive print material had to be reconstructed, and that a protective coating of some sort had to be devised for the top. He asked Meroë Morse to work with him on the positive, and placed Elkan R. Blout, associate director of research, in charge of a team developing the protective coating Land envisioned. Land at this point could specify what he wanted functionally and chemically; and he knew that a certain kind of polymeric material could take care of his problem. As the years went by, Land would often use this method to further the development of new products, committing ever-increasing amounts of manpower and research resources to the outcome of projects that he knew for sure were actually workable.

Land had several requirements for the coating. It had to dry quickly and form a water-resistant, completely transparent, flexible surface, which, of course, would not discolor with age. Blout's group went through numerous materials and synthesized more than 200 new polymers before coming up with a coating Land felt was workable. He put it together in his laboratory with the new positive stock he and Morse had developed. The resulting film, which included a felt and plastic print coater with each roll, proved to be as permanent as the best Kodak conventional film. And this type of bravura scientific performance, the technological equivalent of calling a triple bank shot on a pocket billiards table, established an aura of confidence around Land in his own company so that in the future, though all the outside world might scoff, if Dr. Land said it was so, it was.

The outside world was, by this time, beginning to

recognize the insights and achievements of the Polaroid chairman. On May 9, 1951, Land was elected president of the American Academy of Arts and Sciences at its annual meeting in Boston. And a year later in June, he was awarded his second honorary Doctor of Science degree, this one from the Polytechnic Institute of Brooklyn. His first—bestowing on him the title of "Dr."—had come from Tufts College shortly after he announced the instant picture camera in 1947.

With the original research and development costs of the camera and film now behind the company, and the product building on its own consumer momentum and generating income, Polaroid finally had the funds to give that momentum an extra push. The services of Doyle Dane Bernbach, Inc., a New York advertising agency, which had been founded about the time the Land camera first came on the market, were enlisted for this effort. Doyle Dane became known in the 1950s and 1960s as one of the most innovative companies in the advertising business, coming up with many—if not the majority—of the campaigns people remembered. Among their most notable were El Al Airlines ("My Son the Pilot"), Levy's Rye Bread ("You Don't Have to be Jewish to Enjoy Levy's"), and Avis Rental Cars ("We Try Harder"). The agency reached its summit with the Volkswagen campaign, begun a couple of years after Polaroid signed on. The Volkswagen magazine ads were simple, uncluttered, extremely low-key, and riveting. Probably not one person in a hundred passed them by without taking a look.

Doyle Dane's other accounts represented companies competing head to head in the marketplace, while the Land Camera occupied a unique position. It is therefore an open question as to how much any particular advertising strategy did for the company. But the agency's Polaroid campaign was intelligently structured to make best use of the still relatively new medium of television. The American public had not yet become jaded by the inundation of mindless programming and advertising which now most frequently represents the

medium, and the association with the most exciting visual and technological breakthrough of the age was quite beneficial to Polaroid.

The Land camera was ideally suited to television advertising. Since communicating the camera's uniqueness involved showing the picture being taken *and* the print being lifted out of the camera 1 minute later, the static form of the print ad—which Doyle Dane would soon use so effectively for Volkswagen—could not really show off the product's capabilities. Realizing this, and also realizing that at that time people watching television would naturally be the most likely to want the camera, Polaroid became one of the first major network-level sponsors in the mid-1950s.

Personal endorsements by celebrities was far from a new idea, but it was just coming into its own in television, and so still had somewhat more swaying power than it does now. And Polaroid handled it in a credible way. Millions of people became aware of the existence and operation of the Land camera, seeing it demonstrated in the hands of "Tonight Show" host Steve Allen. Allen would take a photograph on the live program, then display the results to the studio and home audience 60 seconds later. The camera, at that point, was far from foolproof, and the pictures did not always turn out the way Allen and Polaroid expected. Occasionally, they did not turn out at all. But seeing the camera used by a sophisticated master showman such as Allen gave people a sense of how much fun it was to use it, plus an inkling of the drama of seeing the picture revealed right after it is taken. A simple, competent series of print ads written by Doyle Dane's William J. Casey backed the television plugging. Seeing the camera in actual use by people on TV, however, is what Polaroid executives credit as the chief media push of the 1950s. And though Land has long believed that a superior product will tend to find its own place in either the existing marketplace or a new one, many Polaroid people believe that his camera could never have caught on as quickly or completely as it did in the United States without television.

Steve Allen received much of his promotional payment in

the form of Polaroid stock. He is today substantially wealthy as a result.

It was around the time of Polaroid's plunge into national advertising that the majority of camera store owners finally seemed to have concluded that the Land camera was here to stay as an integral part of the American photographic market. Despite what the experts had predicted, The People—on whom Land knew he could rely—were making his invention one of the major consumer phenomenons of the century. In a signed ad in the June 13, 1954 issue of *The New York Times,* the president of Willoughby's, one of the largest camera stores in the country, admitted having predicted the original Land Camera "would be a thing of the past in six months."

"How wrong I was!!!" he magnanimously confessed. Confession, in this case, might have been good for the soul. It was even better for the cash register, as the ad coincided with the introduction of the Polaroid Model 80 "Highlander." The Highlander, which represented 4 years of research and about $1.5 million worth of design costs, was the first moderately priced Polaroid camera. The original Model 95 and its slightly updated successor, the 95A, had captured a good percentage of the well-heeled and/or terribly enthusiastic picture-taking sector. The camera's owners and the advertising campaign had also created interest in a large number of other people who could not quite manage the $90-plus retail price tag. The Highlander retailed for $59.97, and continued Polaroid's master plan of offering increasingly lower-priced models as the company's technical competence to do so grew and the market for them expanded.

Once any photographic concern (as opposed to a strictly camera-manufacturing company) can economically do so, it is generally only too pleased to lower camera prices as much as possible: for any firm that makes both photographic equipment and film—such as Kodak, Polaroid, and, until recently, GAF—the largest profit margins are in the film. Profit margins on a well-established line such as Kodachrome will be well over 60 percent. Some cameras can almost be given away if they can assure heavy film usage by their owners. It is

analogous to the shaving industry, which will often give away a sample safety razor with the purchase of the newest line of blades.

Though Willoughby's original skepticism of and hostility toward the Model 95 was undoubtedly genuine, the embarrassment of public retraction was eased somewhat by the prospect of thousands of dollars worth of sales. But left unstated publicly was that a level of tension continued to exist between Polaroid and the photographic specialty dealers ranging from the tiny corner camera store up to the giants like Willoughby's. Land clearly knew he had something extraordinary on his hands as soon as he could get the instant camera to market. For the many who wanted it, it was the only game in town.

Many dealers accused Polaroid of playing this position for all it was worth with a high-handed "take-it-or-leave-it" attitude. At first, no returns of merchandise were accepted by the company, a relatively unusual practice in the photographic industry. More important, Polaroid cameras, which are sold wholesale generally for about two-thirds of the suggested list price, are often greatly marked down by large-volume discount and department stores in an effort to entice customers in the doors with this attractive item. The camera store owners felt they could not compete with those volume-based or loss-leader prices, but had to keep the cameras and film on their shelves anyway. It would often happen that a customer would come into a camera store at which the clerks were well-versed in the product line, look at a Polaroid camera, have it fully explained, then go out to a discount store and buy the same camera, now that he understood how to use it. The dealers also remembered well that when Polaroid first began to market the Model 95, it chose such outlets as Jordan Marsh and Macy's for its retail vanguard, and not the stores traditionally associated with photographic sales.

Polaroid eventually became sensitive to this attitude, though probably not sensitive enough and not soon enough. Perhaps they became self-satisfied, believing they had some-

thing that no one else had, and that the public wanted. But Polaroid also came to realize that this type of antipathy from the rank and file of the retailers in the industry is a heavy burden to bear, even if they did not represent the prime source of income.

Though the specialty stores do not hold nearly as much sway with the type of consumers who buy Polaroid cameras and Kodak Instamatics as they do with the 35-mm market, they hold considerable sway among professionals. And for Polaroid to have its cameras accepted as more than mere toys or gimmicks, it was necessary to establish a reputation with professional photographers. To some extent this could be accomplished by personally encouraging such giants as Ansel Adams and Walker Evans to use the product. But to reach the rank and file of professionals and serious amateurs, these people had to see Polaroid products in the shops where they did business.

New Products, New Images

While Land continued to spend most of his time on perfecting the instant process, he still apparently found a few moments to keep turning out the "sidelight" inventions that had marked his career since the early days. Near the end of 1953, Land produced a microscope, employed in cancer research, using light not visible to the human eye. Land developed the microscope under contract to the American Cancer Society and the U.S. Office of Naval Research, and it was first installed at the Cancer Research Institute of the New England Deaconess Hospital.

The design of the microscope benefitted from much of Land's previous research in optics and photography. A series of lenses reflected ultraviolet light through a sample of

human tissue onto a roll of black and white film. Three specific wavelengths of ultraviolet light were selected to take best advantage of the fact that various components of tissue absorb certain wavelengths but transmit others. A monochromator was adjusted to provide the first such wavelengths of ultraviolet light and the exposure was made. The monochromator automatically provided the second wavelength, the second exposure was made on a fresh frame of film, and the procedure was repeated a third time. The 3 exposed frames were advanced a short distance, and a thin film of developer was squirted onto them. A few seconds later another liquid was applied. Moved to a viewing station, the records thus developed were simultaneously projected through red, green, and blue filters onto a single screen. The 3 images formed by invisible ultraviolet light were thus transferred into 3 images in visible colors that combined to form a multicolor image the scientist could interpret.

In August of 1954 Land patented a radiation detector that was to be worn as a badge. When he wanted to find out how much radiation he had been exposed to, the wearer would press on it to burst a pod of developer inside. Then the badge was opened by pulling two tabs, and the degree of radiation exposure could be instantly seen on the sensitive film.

On the optical front, the company had substantially supplemented its income by churning out about 6 million pairs per week of the cardboard-frame 3D movie glasses by the middle of 1953. Outstanding orders for the glasses totalled more than 70 million pairs. However, by the next year it was difficult to give the viewing devices away.

The steadily increasing production of Land cameras and film offset the revenue loss of 3D viewer sales. During the crucial pre-Christmas buying season, Willoughby's in New York reported that the Polaroid Land Highlander was the top seller of all cameras offered in the store. In November of 1955 Land announced that Polaroid would begin selling film that produced 60-second transparencies, a

more complicated technical accomplishment than prints.

Though the commercial application for these black and white transparencies has eroded over the years with the increased sophistication of audio-visual techniques, at the time such lantern slides were the standard medium for use in such areas as business and scientific meetings. Not only did this continuous-tone film display greater light range and light-responsiveness than the conventional transparency film on the market, it also had the obvious advantage of allowing an entire day's worth of charts, photographs, diagrams, and cross-sections to be prepared shortly before a conference was to begin. By this point, the Polaroid Corporation had long since established its reputation—in both the scientific and industrial communities—as one of the most advanced out-posts in the field of optical research and technological applications.

And on the last day of December 1956, Polaroid marked the occasion so cherished by every industry and manufacturer in the volume-oriented American business society. A Model 95A Speedliner camera, sold at the Village Camera Shop in South Orange, New Jersey, was proclaimed the millionth Polaroid Land camera in existence, having been produced some months earlier by one of the company's subcontractors. One can conjure up the image of Polaroid sales executives sitting around a conference table waiting impatiently for the Big News, much as Walt Disney must have waited for the millionth paying customer to push through the turnstiles at Disneyland, or Henry Ford anticipated the sale of the millionth Model T. In America, selling a million of any-thing—cameras, record albums, cars, or amusement park admissions—lends a certain credibility to the item and a solidity to the company that produces it. The milepost means nothing other than to those who mark it. But it is no doubt true that as of January 1, 1957, the Polaroid Corpora-tion and Edwin Herbert Land himself must have felt a bit more secure with their integral involvement with the contem-porary American scene.

The next several years saw a steady development of

products to fill out the Polaroid instant picture line: A number of improved cameras known as the Model 150, the Model 700, and then the Model 800 came out in 1957. In the fall of 1958, Polaroid introduced the 4-by-5-inch pack film holder for professional and scientific use. It could use either Type 55 P/N film with reusable negative, or the normal paper-base Type 52 film. In 1959, Land introduced a line of black-and-white films rated at 3000 ASA.

A film's ASA rating (American Standards Association) or "speed" refers to its light-gathering ability. The higher the ASA number, the less exposure is necessary for the film to absorb the necessary amount of light. The standard high-speed Kodak black-and-white film is ASA-rated at 400. Generally, to go much higher than this under normal circumstances without specialized procedures, equipment, or knowledge involves a trade-off of increasing "graininess" of the photographic image. The grain, of course, increases as a negative is enlarged for positive printing. The virtually grain-free 3000-speed black-and-white film Land brought out, therefore, was considered a major photographic achievement even outside the field of instant pictures. It is the standard Polaroid still uses almost 20 years later for its entire range of amateur and professional black-and-white films.

At the same time the 3000-speed film came out, Polaroid marketed what turned out to be the highly popular "Wink Light," a mild electronic flash that attached to the camera and filled in shadows, which often could be seen on indoor pictures. The Wink Light, which sold in 1959 for $17.95, employed a "fill-flash" concept later used with the SX-70: obtaining an image by the combination of available light and flash, rather than one or the other by itself.

While Polaroid was making public financial progress with the Land camera and the expanding (and improving) line of black-and-white films, subsurface rumblings continued to be heard and felt that progress was being made toward the introduction of instant color. A number of chemists and photographic experts stated flatly that such a system was not possible under the current state of knowledge in chemistry.

But as early as the annual Polaroid shareholders' meeting of 1959, Land was saying he was "well satisfied" with the progress being made in color film research, although "it [was] still too early to predict when this development [would] be ready for commercial production."

Land applied his traditional gift for superlatives by describing his lab's color test prints as "pictures of really spectacular beauty." He gave vent to his other gift for involving an audience by announcing, "The closer we get to color, the less I'm going to say to you about it. When you come to the meeting and I don't even mention color, you'll know it's just about in the store around the corner." Land wanted to fill in his "partners" sufficiently to excite them about the endless possibilities for creative and fiscal achievement engendered by instant color film, but not sufficiently enough to let them get in the way.

Though the color film would not actually be marketed for 4 more years, the first breakthrough in color research at the Polaroid laboratories had come 6 years earlier, in the spring of 1953. It was achieved by Howard Rogers, who at that point had already been heading up the color research team for some time. According to one company story, Rogers, who was then working on plastics for use in optics, saw a list of corporate priorities in Land's office and, noticing instant color film near the bottom of the list, asked to have the assignment. Land agreed and came to glory in his decision.

Rogers' work is a prime example of the institutionalization in a company of one man's personal modus of discovery. The circumstances under which Rogers achieved his major breakthrough with instant color parallel almost exactly the moments of "instant image" of the man who hired and trained him.

Rogers pursued the scientist's traditional course of formulating basic hypotheses and then testing them in the laboratory. And his insights and experiments produced many significant inventions in both materials and film structures for color photography.

In color processes then in use commercially, each of the

colored image components was a dye created during process-
ing by color development—a color-forming reaction between
a "used" developer and a colorless compound. Rogers
proposed instead the utilization of dye-developers—pre-
formed image dyes that were at the same time photographic
developing agents. The dye-developers resided in the nega-
tive, not in the pod. Initially insoluble, they would be
solubilized by the alkaline viscous reagent released from the
Polaroid pod. In areas of the negative that had been exposed
to light, development would result in immobilization of the
dye-developer molecules, whereas in unexposed areas the still
soluble dye-developer molecules would transfer freely from
layers of the negative to the positive image-receiving layer.

Rogers' early dye-developers produced excellent transfer
images, but they were subject to unwanted color shifting as a
result of changes in the state of oxidation of the developer
part of the molecule and its response to changes in the
alkalinity of the system. An invention of Rogers and Dr.
Elkan R. Blout, then associate director of research, provided
dye-developers that included insulating groups between the
dye part of the molecule and the developer part of the
molecule, thus eliminating the unwanted color shifts. The
dye developers used in the early Polacolor negative and the
metallized dye-developers used in Polacolor II and SX-70 all
include insulating groups.

The breakthrough came in the spring of 1953. The way in
which it occurred is nearly as significant as the achievement
itself. As Rogers explained to *Newsweek* magazine 10 years
later, the concept came to him at once: "The idea sort of
welled up as an integration of all the things I knew up to that
point. When an idea comes that is that sure, the feeling is
one of subdued elation."

The sound and tone of Rogers' statement parallels the
ones Land made upon coming up with the instant-picture-
camera idea a decade earlier in New Mexico. Again, Rogers'
color breakthrough was neither the beginning of his tech-
nological search nor its conclusion. It was merely the moment
in which the problem itself became clear; and from the
conscious and unconscious preparation he had had for the

challenge, Rogers was receptive to the instant imagining of the solution. Like Land's original invention, there would be several more years of concentrated research and experimentation before the product was ready for public use, but this one morning in 1953 had set the course that was to be followed.

That one of Land's top assistants should solve his scientific problem in the same fashion in which he himself had continually solved his own is not overwhelmingly surprising. By the time of Rogers' invention, Land had taken pains to assure that the moments of instant image he expected from his associates would not be lost. Believing that people express their ideas and discoveries best at the moment of inspiration, Land had set up a recording device in his outer office. When he was away from his office, in his laboratory or otherwise unavailable, anyone with an idea was encouraged to rush over to this machine and record their thoughts for Dr. Land, who would then have the benefit of hearing the idea in its natant moment at his own convenience.

Once the dye-developer concept had been worked out, there still remained the arduous task of selecting and synthesizing the specific molecules of developer-linked-to-dye. Altogether, the group of chemists working with Rogers and Blout created more than 5,000 completely new compounds in the course of searching for the ones which would react as desired for the development process to take place. One comes away with an image similar to Thomas Edison's Menlo Park researchers trying substance after substance before coming up with the workable material for the incandescent lamp filament. A slight modification would be that at its peak, the Rogers-Blout team contained more than 30 Ph.D's.

At the 1959 annual meeting at the company's facility in Waltham, Massachusetts, the progress being made in instant color photography was not the only topic discussed. Polaroid announced that as of the first of that year, it held 238 U.S. patents in the field of one-step photography, 122 of them awarded personally to Land. As might be expected, Land is one of the major supporters of the American patent system.

His type of work essentially involves marketing the results of new scientific and technological breakthroughs. The application, though generally skillful, is not nearly as difficult as the breakthrough itself. Land therefore sets great store in the protection of the innovator with regard to his own ideas, which, at its best, the patent system represents.

In inducting Land into the National Inventors Hall of Fame in February of 1977, Arthur H. Seidel, president of the National Council of Patent Law Associations, stated,

"Edwin Herbert Land, scientist and inventor, provides a unique example of the success of the American patent system carrying out its Constitutional charter 'to promote the progress of science and useful arts.' The limited exclusive rights given for Dr. Land's inventions permitted him to organize Polaroid Corporation and permitted Polaroid to grow and to support the research and development necessary to bring succeeding inventions to the marketplace."

Throughout his career, Land has defended the system and tried to explain it to those who did not understand or would abuse it. He discussed the role of the patent system in a speech he gave before the Boston Patent Law Association in 1959, making the distinction between the types of individuals and business concerns whom patents protect and the ones to whom they are a roadblock:

To a large and fundamentally uncreative company patents are a threat and a nuisance. . . . For such organizations innovation elsewhere represents a dangerous threat rather than a wholesome challenge. Moreover, it is in the short-term interest of such firms to have a very weak national patent system so that innovation of great significance will not thrive, and also so that they may acquire at low cost the results of any innovation elsewhere which happens to become significant.

In the same speech, Land went on to reaffirm his faith in the individual innovator. He implied that only the individual, and not the large group, can see a part of the world in a totally new and different way—as he himself had:

Spontaneously and unpredictably individuals arise here and there in the world, here and there in time, who introduce great clarifications, new words, new language, and fresh statements which cause the rate [of scientific progress] to jump ahead by 10, 20, or 100 years. We accept these men by paying tribute to their names—Ptolemy, Copernicus, Galileo, Newton, Faraday, Maxwell, Einstein—but then we fail to learn the lesson that their names teach.

Just as the great steps in scientific history are taken by the giants of the centuries when they slough off the tentacles of the group mind, so every significant step in each lesser field, in each single field, is taken by some individual who has freed himself from a way of thinking that is held by his friends and associates who may be more intelligent, better educated, better disciplined, but who have not mastered the art of. the fresh, clean look at the old, old knowledge. If these individuals whom we call creative are in the domain of pure science in a university, their reward and encouragement will come naturally from their scientific peers. If, however, they are working in the domain of applied industrial science, then they themselves and the industry that supports them must be encouraged to disseminate that knowledge promptly in this era when pure science and applied science are almost indistinguishable.

It is interesting to note the connection Land makes between the industrial and academic spheres in his speech. He seems willing to separate them—but not too far.

Concluding, Land said that the patent system represented the repository in which the individual innovations could be recorded for others to build on—public, yet protected. It is interesting to note that the wealthier most businessmen and corporate leaders become, the more they proclaim the need to protect and increase their holdings. The petroleum companies uphold oil-depletion tax credits. Builders tenaciously defend the savings they accrue through property depreciation. As a corporate leader, Land has been doing the same sort of thing over the years, but from his own frame of reference. The normal businessman, who operates for the main purpose of amassing capital, wants to protect that capital. Land, while certainly interested in financial

success, has been primarily concerned with a different sort of currency—the currency of ideas. So, at its base, the patent system is his "oil-depletion allowance." It is the incentive and protection for his stock-in trade.

At the 1976 Polaroid annual meeting, the first at which the direct threat from the new Kodak instant cameras had to be faced, Land commented on the company's patent-infringement suit against Kodak: "The only thing that keeps us alive is our brilliance, and the only thing protecting our brilliance is our patents." The tendency toward superlatives does not mask the simplicity and directness of his thinking on the matter.

Expansion and Simplifications

The 1959 annual meeting was surely a source of unprecedented corporate pride and shareholder satisfaction. There was the report on color progress and the gratifying patent tally. Then, Dr. Land stood before a large map of the world, gestured toward it as if to welcome the rest of the earth into the Polaroid sphere, and stated, "In this whole world we have endless opportunities to go ahead and do what we have done in the United States."

Obviously, Polaroid was following the trend of just about every other major American corporation—to send its products overseas and collect the profits in an ever-expanding western-oriented world market. It is also safe to say that Land saw no reason why his camera should not be enjoyed and appreciated by peoples everywhere. If he genuinely felt—as he undoubtedly did—that the instant camera could bridge gulfs of language and other forms of communication and understanding, then, in his thinking, Polaroid had a sort of manifest destiny to spread the "Good News" as far as possible.

There is, of course, another view of the question of corporate multinationalism. At best, there is no reason to impose western merchandizing on nations whose cultures have progressed quite satisfactorily without it. And at worst, it is a force that can leave a nation socially and economically plundered. The first case is what some social critics have referred to as the "coca colonization of the world." The second case can be represented by International Telephone & Telegraph's exploitation of Chile.

Polaroid is not really in the same league as such marketing giants as Coca-Cola or, more recently, McDonald's. There are no Polaroid billboards or Plexiglas storefronts blighting the landscape. Taking instant pictures hardly robs a country of any of its cultural traditions (except in certain middle-eastern countries where any sort of photograph is religiously frowned upon). Polaroid will never be large enough to exert political influence in a host nation, and as long as Edwin Land's views are followed the company would never presume to try. And it is just possible that to a certain degree Land may be correct that his products do contribute toward communication and understanding between people.

By and large, though, Polaroid's entry into the international market should be viewed neither as a play toward grand-scale empire-building nor worldwide cultural altruism. By the late 1950s, the corporation had reached the stage where it made economic sense to market its products and technologies to a wider audience than merely the United States. Polaroid controlled a product that no other company had, and a lot of people wanted it. In April of 1959, though, Land did state that the Russians (who do not generally pay much attention to American patents or copyrights) had managed to produce an instant camera similar to Polaroid's. But Land also pointed out that the Soviets had been unable to match the quality of Polaroid film. The story at the time was that, in typical fashion, Russia was claiming credit for the original invention of the instant camera.

Polaroid Corporation of Canada, Ltd., the first foreign subsidiary firm, was started in June of 1959. In June of the

following year, Polaroid arranged with the Japanese camera manufacturer, Yashica K. K., Ltd., to produce the 120 and 160 Land cameras for sale in Japan and elsewhere in Asia. They were produced under the supervision of Polaroid's Japanese subsidiary, Nippon Polaroid Kabushki Kaisha.

By the middle of 1960, Polaroid products were available in 45 countries, a wholly-owned sales subsidiary had been formed in West Germany, and distributors were being added in South and Central America. Five years later, Polaroid established its own European manufacturing facilities at Enschede, Netherlands, and Vale of Leven, Scotland.

In the United States, the "first generation" of Polaroid products had become a standard part of the photographic market, enough to make Polaroid the country's second largest producer of photographic equipment and film. Eastman Kodak remained the unchallenged leader, but as Polaroid pulled ahead of other manufacturers of conventional films and cameras such as Bell & Howell and GAF, it proved that the public regarded instant photography (even though still only black-and-white) with equal respect as it did traditional methods.

It can be said that while no one appreciated the possibilities of the instant-picture camera as well as Land himself, up to that point the product did not meet his optimum standards. The camera should be smaller, easier to use, and more versatile, and the film should be of better quality and develop ever faster. As William McCune commented, "Everything we've done has always been a compromise to [Land], which has been almost intolerable."

So in the early 1960s, instant-picture technology was sufficiently established to allow Land and his engineers to begin a wide-scale series of specific improvements. The reality of "absolute one-step photography" was still a decade off, but each change in design brought him closer to what he thought the Land process ought to be.

In itself, the conversion from roll to pack film greatly simplified the system. Instead of film and paper rolls, to which reagent pods were attached and which had to be fully

processed inside the camera, the pack system utilized a metal cartridge of eight individual sheets of film, each with pod and positive sheet attached. Whereas the prints from the roll film had to be lifted from the back of the camera, the pack prints were pulled out through rollers, with processing completed outside the camera. An earlier simplification had reduced development time from 60 down to 10 seconds in September of 1960. For all intents and purposes, the black-and-white print was now totally instant.

Each of the Polaroid products and technologies built on the total accumulated experience of everyone associated with them. Land recently commented, "The purpose of the company is to create a new kind of wealth—materials and processes that didn't exist before. And that's what we're here for. Then you blend those into products as you go."

Specialized films based on the Land technology and experience in scientific research came out at about the same time. Professional 4 x 5 film for studio portraits and other high-detail work was brought out in the P/N series (positive-negative). The film developed in 15 seconds and produced a normal positive and a reusable negative, which was ready for printing after 2 or 3 minutes of treatment. A 3000-speed x-ray film producing a 10-by-12-inch positive print went on the market in February 1961. The most significant feature of the film was that it required only about one-fifth of the normal x-ray exposure time, which cut down considerably on the radiation risk. And in the same year, Polaroid came out with an ultrasensitive film for specialized scientific use that could capture action lasting as briefly as a billionth of a second! This Polascope 410 film was to be used for oscillograph tracings and other similar instrument data recordings.

Other Markets

Another of those numerical milestones was reached on August 22, 1960. For the first time the market value of the 3,844,000 shares of Polaroid stock hit the billion-dollar mark, with each share reaching a record high of 261¾ and closing the day at 255½. This represented a price of more than 90 times that of earnings, a good indicator of a particular stock's desirability. Polaroid had already acquired blue-chip status and, because of its apparent stability, it had become a favorite of institutional investors. By 1967, a study by Vickers Associates, Inc., showed that Polaroid was the second most-favored issue for institutional investors. The leader was the establishment bedrock, IBM.

Polaroid had moved a long way from the late 1940s at which time money was so tight that it could not have raised the capital to manufacture its own products had it wanted to and had to arrange elaborate schemes to get other companies to pay for most of its advertising. Although the company still supported an unusually large research-and-development budget (some of it devoted to personal Land projects that were never intended for marketing or profitability), the cash flow situation was solid, and Polaroid was well up into the second level of major American corporations. What had not changed in that time, however, was Land's basic wariness over letting the financial situation get out of hand. Polaroid maintained tight control over its patents and the marketing of its products. And though it had grown enormously, Land still maintained tight control of Polaroid as chairman of the board, president, and director of research. The degree of fiscal conservatism exercised by Polaroid is as unusual for a large corporation as is the degree of Land's personal control over the company. Throughout its history, Polaroid has stayed completely out of debt, financing expansion with its

own funds and writing off the costs on a pay-as-you-go basis. But this refusal to take on outside debt is an important symbol of Land's control compulsion. Polaroid's Donald Dery explains that it was part of the chief's basic philosophy: "Land's view is that the company should be scientifically daring and financially conservative."

An example of this type of thinking was severely criticized in 1969 when Polaroid announced a 1,060,000-share stock-rights offering, which the company preferred to borrowing as a method of raising capital. The sale diluted per-share earnings by about 3 percent. At the time, *The Wall Street Journal* quoted one stock analyst as saying, "They could just as easily have borrowed the money rather than cause dilution, even though the dilution is small. It's an example of ultra-conservative financing policy."

Along with this basically conservative money-raising policy, Polaroid also realizes considerable income from a large (though the specific figures are not disclosed) holding of municipal bonds, which produce tax-free revenue for the company. This income source almost approximates the endowment concept of a large university.

While remaining fiscally conservative, Polaroid seemed ready to apply some of its "scientific daring" toward expanding the company's interests. At the 1960 annual meeting, Land had said, "The time has come when management can start turning its attention to other fields than photographic."

Specifically, it turned out that Polaroid was eyeing a move into what promised at the time to be the next important arena of technological innovation—photocopying. The market was ripe for innovation. The office and commercial environments had been muddling along on carbon paper, mimeograph, and ditto machines, and the few primitive copying devices that did exist, such as Kodak's Verifax and 3M's Thermofax. Though it at first seems a rather odd notion, the business world was finding more uses for paper and documentation of all sorts than it could handle. When the Haloid Company of Rochester came out with its so-called Standard Camera in the late 1950s, there was virtually

nothing like it on the market. Though it was designed primarily for producing offset masters, it could make single copies of documents on plain, untreated paper. When, in 1961, that same company—which by then had changed its name to Haloid-Xerox—came out with a product known as the 914 Copier, the response was overwhelming. A void was literally waiting to be filled. And as with the Land camera, a market was instantly created where none had previously existed.

This was inviting territory. So in 1961 Polaroid began considering a foray into the photocopying field as a way of diversifying, while staying with the general photographics business. At the time, a spokesman for Polaroid said they had been developing a photocopying machine for at least 10 years. This is quite believable, given the range of expertise Land had developed within the company and the amount of time Polaroid often spends developing products before releasing them.

A month before the Polaroid announcement, Doyle Dane Bernbach dropped the Haloid-Xerox account a single day after securing it, saying that servicing both Xerox and Polaroid would constitute a conflict of interest. Agency president William Bernbach explained that when he accepted the Xerox account, he did not know that long-standing client Polaroid held patents in the photocopying field and intended to use them.

During much of the early and mid-1960s, there were indications, both official and non-official, that the Polaroid copier was making great strides forward in the research lab. Optimism ran high in the copier market and the investment community. Who could be better qualified to come out with a dazzling new machine for image reproduction than Dr. Land?

And in the meantime, Haloid-Xerox dropped the first part of its name, climbed toward the upper reaches of the Fortune 500 list, and dominated the field it had created nearly to the extent that Polaroid dominated instant photography. IBM and Kodak—both of whom had the oppor-

tunity to pick up Chester Carlson's xerographic patents for a song in the late 1940s—began intensive research and development into their own plain-paper copier system. They each came out with forceful competition in the admittedly late hour of the 1970s.

Polaroid had more announcements to make. At the 1967 annual meeting, held in part of an unfinished plant at Waltham, Land declared,

We are making great progress in the paper [for the copier] itself, which is going to be as remarkable a commodity as some of Polaroid's photographic papers. It isn't the company's policy to go into any field unless we make a singular contribution and fill a need that isn't being filled. It would be stupid for us to make something like Xerox.

Land's announcement strongly suggested that the design Polaroid has working on was not for a "plain-paper" copier. And even keeping in mind Land's capacity for foreseeing and creating markets where they did not currently exist, it was difficult at that point to conceive of a market for a copying machine of the Polaroid design, no matter how technologically ingenious it might have been, when Xerox was already turning the same trick with a maximum of speed, simplicity, and quality.

Still, in the annual report published in March 1968, Land announced that Polaroid was constructing a new plant to manufacture the copier paper, which could be used only with the copying machine they were developing. Land made vague claims as to the great economy of the system, whose target release date he still did not mention, and said of the machine, "We believe [it] to be the simplest operation ever used in the document copying field except for the original thermal machines."

To date, Polaroid has not come out with a document copier of its own. A company spokesman says that the project has been relegated to "the back burner for the time being," which seems to be a way of saying that Land had deferred

about a decade's worth of research in the field. It was undoubtedly a disappointment to company personnel, though certainly not on the order of the headlights situation, or even 3D movies. But Land most assuredly wanted to conserve Polaroid's resources for the areas of its strengths—or, more precisely, its uniquenesses.

At the same 1967 meeting at which he announced substantial progress in the copier field, Land downplayed the possibility that any consumer product would come out of Polaroid's long-standing color television research arrangement with Texas Instruments. "Something good will come out of the work, but I can't say just what form it will take."

Land and Polaroid have been called to task over the years for announcing products prematurely and for ballyhooing others that never make it to the market, such as the document copier and the new form of color television. But even aside from the fact that much of the ballyhoo has actually originated with the press and the investment community (with Polaroid's usually active encouragement), it is also true that there is a certain price that must be paid for technological vanguardism. And the price is the large number of ideas that never pan out. This, of course, is true of many companies in the high-technology arena. But because of Land's and Polaroid's particular character, the expectations are high and the disappointments seem more acute.

Outside Interests

Color Vision

Through his ingenuity we can portray ourselves in 60 seconds; through his industry the life of our city becomes more abundant.

This was how the citation read accompanying Edwin Land's honorary Doctor of Science degree from Harvard in 1957. It referred to two areas of his fame and achievement—invention (specifically, instant photography) and community involvement. There were others.

Land, had, as he said, set up a company in which he could do pure research as well as have his inventions used. He had created a company in his own image, and that company's marketing of his ideas had made him an extremely wealthy man. And he had established the company in such a way that its practical economic pursuits were not out of keeping with his own personal intellectual interests, such as chemistry, optical physics, and education. The fact that he exercised such complete control over the actual workings and the imagination of the company meant that he could impose his own unified vision on its working environment and its orientation to the community around it.

Depending on whom one talked to, Land was primarily thought of as an inventor, a corporate leader, a sophisticated

engineer, a renegade academic. He has continually referred to himself as a scientist. Land had begun both his scientific and business careers with the study of the behavior and properties of light. This study created an industry. It also created in Land a lifelong interest in aspects of light from a perspective of pure science. Once he understood the basic properties of light (a feat he accomplished in his teens by going through every volume the New York Library possessed on the subject), his key interest shifted to the way the human eye and brain utilize light in the most dynamic of the senses—vision. And any inquiry into the nature of vision eventually leads into a most challenging realm—how the eye perceives color.

What we refer to as color is actually light waves of varying lengths along the visible spectrum. Colors are represented by specific wavelengths, usually measured in nanometers (one billionth of a meter). The visible spectrum runs from violet on the short-wavelength end (400 nm) to red on the long-wavelength end (700 nm). Below 400 is the realm referred to as ultraviolet and above 700, the infrared region.

At some point during the 1950s, Land was in his laboratory looking at an image projected through three separate projectors, containing filters passing the short, middle, and long wavelengths of light. When he turned off one of the projectors, there was no noticeable change in the color vibrancy of the projected image. An assistant working with Land wondered why the "appearance" of the colors remained the same: according to the accepted theory of color vision, taking away any portion of the spectrum should have removed a corresponding range of color.

Land attempted an explanation in keeping with the color theory, but it did not sit right with him. A few hours later it suddenly occurred to him that what he had seen with his own eyes indicated that the traditional theory was inadequate. In another moment of instant image, he had been able to distinguish between what appeared to be true from the body of scientific inquiry and that speculation that had preceded him.

The working theory of color vision originated with Sir Isaac Newton's discovery of the properties of the visible spectrum in 1660. Nearly all of the important research and theories relating to color vision since then have been based on Newton's principles. But what Land's experiment showed him was that, contrary to accepted thinking, the human brain and eye did not need three parameters in order to perceive specific colors. Color mixing was no longer completely synonymous with color perception. For a physicist, this realization must have been something akin to Einstein's redefinition of the mass of a moving particle, or for a mathematician discovering that three independent variables could be solved with only two simultaneous equations, or that a triangle could be constructed with only two sides! Land had reason to feel that he was looking into a new horizon of science.

Land began a series of experiments in which he recreated numerous colors of the spectrum from a mixture of only red and white light. Two black-and-white positive slides were made of a particular scene, one taken through a filter that allowed only the long wavelengths of light (red) through and a second that would let through the green range of wavelengths. From this Land produced black-and-white slides that showed the objects in the scene as varying shades of gray, with the red objects showing up as light grays on the slide taken with the red filter over it and as dark grays on the slide with the other filter. The reverse, of course, was true for the blue and green objects in the scene.

Both slides were then placed in a dual-image projector and superimposed on a wall screen so that one sharp scene appeared. The image, a portrait of a young woman, was black and white, as would be predictable according to the popular theory. But when a red filter was placed in front of the slide originally taken through a red filter, the blacks and whites (or actually, grays) changed dramatically to the true and pleasing colors of the original scene. The black-and-white scene was instantaneously transformed into a picture of a blue-eyed blond wearing a red coat with a blue-green collar. Normal

flesh tones were apparent in the woman's skin. When the red filter was taken away, the colors immediately disappeared and only the black-and-white image remained. When the filter was refitted, the colors once again came back.

To prove that the color appearance was not merely a result of psychological preconditioning as to what such a black-and-white picture *should* look like in color, Land tried the experiment again with the red filter over the short-wave portion instead of the long-wave one. Colors still appeared, but were reversed, with the blue-greens becoming red, and green replacing the woman's blond hair. Land even performed tests changing the relative intensities of the beams of light over the entire field of view to see if any change in the color would take place, but they remained constant.

Land demonstrated his experiment in the spring of 1957. Scientists, who expected to see only a single-colored image projected onto the screen were dazzled, and recalled the classical theories to try to explain what the noted color researcher Joseph J. Sheppard referred to as the "Land effect." Land repeated the experiment under varying conditions, obtaining the same full-color results with virtually any two pairs of wavelengths.

He wrote up his conclusions in a series of articles entitled "Color Vision and the Natural Image" for the *Proceedings of the National Academy of Sciences,* under whose auspices he had made his public demonstration. He explained his ideas again in a slightly more simplified form in an article in the May 1959 issue of *Scientific American.* In both journals he gave compelling evidence that the eye and/or brain are not dependent on the actual color of the light rays for the individual to perceive color. Rather, color vision is based on the relationship of longer to shorter light wavelengths. If a sufficient "variety" is present, the brain will "arrange" them into the proper color perception.

Land made the point that color wholly exists neither in the natural world nor in the mental perceptive processes, but is actually a function of the relationship between the individual and the physical environment. To Land, this

seems to be symbolic of man's general orientation to the world—a continuous interweaving—and the true function of science is to support and clarify that relationship.

Land's theory was supported by Dr. Michael M. Woolfson of England's Manchester College of Science and Technology. His verification, a mathematical analysis of the Land experiments performed in the United States employing IBM computers, set up a theoretical model by which the brain could make the necessary adjustments to properly perceive color.

Through his own work, Land concluded that the old theories did not hold up, and that a coherent new theory would have to be established. As he wrote—technically but rather elegantly—in "Color Vision and the Natural Image,"

This departure from what we expect on the basis of colorimetry is not a small effect but is complete, and we conclude that the factors in color vision hitherto regarded as determinative are significant only in a certain special case. What has misled us all is the accidental universality of this special case.

This feeling of the inadequacy of the currently held theories and the results of his own initial work ultimately led Land in the early 1960s to formulate his "retinex theory" of color vision. The retinex theory proposes that there are three independent image-forming mechanisms in the eye, which Land dubbed retinexes, corresponding to the eye's three different types of cones (the tiny receptors located in the retina), which pick up short, middle, and long wavelengths of light. Land has yet to locate the specific physiological mechanism for his retinexes. The word itself is a combination of retina and cerebral cortex, which are connected to each other by the optic nerve. He is unsure where, along this path, the actual color processing takes place.

Previous theories of color vision are based on the concept that the three color receptors of the eye (long-red, middle-green, and short-blue wavelength cones) pick up the light reflected off an object in each of their respective spectral

regions, and through a mixing process among them, colors of the entire visible spectrum are perceived, rather than just blues, greens, and reds. The amount of light illuminating an object and that object's ability to reflect specific wavelengths of light are both factors in determining the color that the eye will actually see. Leaves and grass, for example, reflect green light but tend to absorb red and blue light. This gives grass and leaves their "green" appearance.

What Land's theory states, in highly simplified terms, is that the three color receptors—cones, as they are called —only measure the ability of an object to reflect light in each of the three regions (red, green, and blue), and each retinex then takes the measurement in its region and compares it to the other two. A ratio results, which Land believes is the determining factor in color perception, and this ratio will always result in the same color. In fact, Land's theory states that color sensations can be produced even if only two retinexes compare their measured values. Thus, if the long-wave retinex registered, let us say, 10 units of long-wave light reflection from an object, the middle-wave retinex registered 2 units of middle-wave light reflection, and the short-wave retinex only 1 unit, then the ratio would be 10:2:1, or 10:2 if only the red and green retinexes are compared. This would probably result in a color quite orange or red in nature; and whenever the eye recorded this ratio in the same sequence again, the same color would be perceived.

As with most new ideas, the retinex theory began as a highly controversial scientific proposition, and it is still not clear that everyone in the scientific community has accepted it. Despite the skeptics, the fact remains that Land did show something that people had believed impossible up to that point. Dr. Jerome Y. Lettvin, Professor of Communications Physiology at MIT and himself an expert in optics, commented:

Land makes something work that shouldn't work. On actual phenomena such as this, he's a real artist. There are some people who are first-class doers. He's an artist with materials. What Land

did was to pose one very intriguing problem. He presented an image with two degrees of freedom and came out with what appears to be three degrees of freedom.

Shortly after Land's article on the retinex theory appeared in the December, 1977 issue of *Scientific American*, Hans Wallach, Emeritus Professor of Psychology at Swarthmore College wrote to him, saying:

There is no single piece of research in experimental psychology that has impressed me as much as the experiments you have reported and the theory you are proposing. . . . My work in neutral color perception has prepared me to appreciate your research, and I want to be among those who express their admiration for this magnificent achievement.

Along with his work on the specific mechanisms of color perception, Land contributed to the scientific understanding of an effect known as simultaneous contrast. This deals with the effect on the actual appearance of colors by different adjacent colors. For example, when a dark gray shape is seen next to a light gray one, the dark gray will seem even darker and the light gray even lighter. Lettvin had this to say:

Land revived the phenomenon of simultaneous contrast that had been recurring over and over again, but he gave it his own peculiar slant. He came upon it on his own, not realizing there was already a history behind it. The theory itself didn't seem to make sense. But the actual experiment worked. And the show he put on was magnificent—high art.

However one decides to define the retinex theory, its formulation is typical of Land's ability to see something in a totally different way. Essentially, rather than merely building on previous achievements as most of science does, Land came up with a principle that did not exist before. And even if parts of the theory are incorrect—as they very well may be—it opens up whole new avenues of thinking and demonstrates

Land's unique vision as well as his confidence and strength in moving outside the norm in his quest for understanding.

The retinex theory is far from an isolated aspect of Land's career. It is rather a motif for his entire life—a life whose achievements are built on departures from previous belief and practice. He has spent that life pursuing the uncommon path. Who knows what treasures will unfold along the way?

Education

The list of Land's academic affiliations is about as long as his string of honorary degrees. He was Visiting Professor in Physics at Harvard from 1949 to 1966 and then again in 1968. Since 1956 he has held the post of Institute Professor at MIT, the highest academic rank at a technological assemblage festooned with Nobel laureates in all of the hard sciences.

Land has never been a full-time teacher, or even a regular part-timer at Harvard, MIT, or anywhere else. His public appearances on the two campuses are almost as infrequent as they are in the outside world. His lectures and seminars, however, have been memorable, and it is considered prestigious to be allowed to sit in on a talk by the celebrated Dr. Land.

But if Land is seldom present at Harvard and MIT, he is very much a "presence" at both institutions. There is a curious reciprocal relationship between them and Land. Polaroid takes advantage of the schools' scientific and business expertise and in turn underwrites a number of their educational programs. Land "tries out" his new ideas on MIT students in seminars conducted for credit and/or pay at Polaroid's Vision Research Laboratory. And one finds an unusual number of academics sitting on the Land-inspired Polaroid board of directors. Both Harvard and MIT, each

known for its often overdone aloofness to any outside influence, care what Edwin Land thinks.

In the scientific world, MIT is the top of the pyramid. Numerous faculty members make many times their university salaries each year as consultants around the world. Some, such as Amar Bose of stereo speaker fame, launched their own companies based on their academic research. And though statistics do not exist on the point, it is a safe bet that MIT has the highest percentage of millionaire professors of any university in the world. It is a school peopled by technological superachievers.

Along with its reputation as one of the world's premier repositories of science, it is a school that had traditionally placed more emphasis on the sciences than on scientists. For generations students have complained that the Institute is so busy extending the frontiers of science, basking in its faculty's academic glow, and fulfilling its literally hundreds of millions of dollars in government contracts, that it treats the undergraduate as an afterthought.

This was the complaint Edwin Land had in mind when he delivered MIT's annual Arthur Dehon Little Memorial Lecture on May 22, 1957. The lecture is named for the celebrated chemical engineer who, among other accomplishments, founded the chemical engineering program at MIT. Previous speakers in the series had included such luminaries as J. Robert Oppenheimer and William C. Menninger.

Land's talk was entitled "Generation of Greatness: The Idea of a University in an Age of Science." He called for massive reforms in the role of the American university. And, with specific reference to such technically oriented schools as MIT, Land proposed the formation of the undergraduate population into small groups, each headed by a distinguished scientist who happened to be temperamentally suited to the task. According to Land's program, each student would also choose for himself an ongoing research project under the supervision of the mentor, whom he referred to as the "usher." Through this project, the student would begin to understand scientific inquiry firsthand while developing a

relationship with his usher and a confidence in his own independent abilities. Land stated this in his traditional manner—from the standpoint of the individual—and reiterated one of his great personal themes:

I believe there are two opposing theories of history, and you have to make your choice. Either you believe that . . . individual greatness does exist and can be nurtured and developed, that such great individuals can be part of a cooperative community while they continue to be their happy, flourishing, contributing selves—or else you believe that there is some mystical, cyclical, overriding, predetermined, cultural law—a historic determinism.

The great contribution of science is to say that this second theory is nonsense. The great contribution of science is to demonstrate that a person can regard the world as chaos, but can find in himself a method of perceiving, within that chaos, small arrangements of order; that out of himself, and out of the order that previous scientists have generated, he can make things that are exciting and thrilling to make, that are deeply spiritual contributions to himself and to his friends. The scientist comes to the world and says, "I do not understand the divine source, but I know, in a way that I don't understand, that out of chaos, I can make order, out of loneliness I can make friendship, out of ugliness I can make beauty."

But not many undergraduates come through our present educational system retaining this hope. Our young people, for the most part—unless they are geniuses—after a very short time in college give up any hope of being individually great.

The university, he said, runs each one through the mill, during which time he rises—or, more likely falls—to some predetermined level. Land did not advocate the abolition of lectures or course work, only the more intelligent utilization of the individuality and inherent abilities of the students themselves. To Land, science was a very personal proposition.

The types of reforms Land urged were motivated not only by his observations as a confrere of university leaders but also from his own experiences as a Harvard undergraduate 30

years before. As one close associate explained, "You have to look at what Land came from. When he was at Harvard, he needed a mentor a lot more than he needed a class schedule. In the lecture he was proposing what he would have liked to have had for himself."

Ironically, Land's "Generation of Greatness" lecture came at a historic moment in the history of American education. None of the academic heavyweights listening to him on that May evening in 1957 could know that in less than 5 months the Soviet Union would launch Sputnik I, promoting a frantic and tempestuous reevaluation of science education in the United States. What Sputnik ended up causing, however, was a predictable crisis reaction in which the volume and intensity of science courses were increased throughout the educational system with no greater emphasis on the individual student. Rather than increasing a desire for personal scientific inquiry, it equated science with national policy, making it just one more American weapon in the Cold War arsenal.

Nor was any program instituted at either Harvard or MIT, the two places that Land thought might be advanced and intellectually open enough to go for it. Commenting on the lecture, Acting MIT President Julius A. Stratton perfunctorily got his institution off the hook, stating,

While there may be practical limitations to the feasibility of some of Dr. Land's specific proposals, it behooves all of us, educators and laymen, alike, to embrace his concern for the full development of the creative powers which are inherent in each and every individual.

Land's ideas did make an impression on some members of the academic community though, through appearances such as the Little lecture and his personal informal lobbying on various university committees over the next several years. The most tangible result was MIT's Undergraduate Research Opportunities Program (UROP), which began more than 10 years after the Little lecture, in the fall of 1969. The program was initially funded with a grant of $100,000, which came

from Land's own pocket. Students were given college credit to work individually on significant research projects of their own choosing, both inside and outside the university, under the tutelage of a wide range of mentors. UROP provides money for laboratory equipment and expenses and in many cases, for modest salaries for its undergraduate participants. Since the beginning of the program, several MIT students have worked for credit each year at Polaroid's research labs, across the street from the Institute. And some have stayed on into the summer on Polaroid salaries, working on Land's pet projects. Today, the program is supported largely by MIT's general operating budget (with Land still kicking in additional funds when needed), and nearly half of the university's undergraduates are involved in UROP some time during their college careers.

According to some student participants, UROP has made them less intimidated by the prospect of scientific failure in the success-oriented high-technology atmosphere engendered by MIT and Harvard. They begin to realize that the inquiry itself is most important, and that honest failure is not only respectable but an inescapable step on the road to success. This, of course, has been one of Land's major tenets throughout his life.

In the Little address, Land also suggested a new way of handling lectures:

One proposal that interests me is to take the good lecturers at the moment when they are most excited about a new way of saying something, or at the moment when they have just found something new, and make moving pictures of them right in class. *Can the lecture with the vitamins in!*

With the movie we can capture the excitement, as well as the substance, of the best lectures. The lecturer can be freed of much of the burden of the total review of his field every year. He can devote himself to what he is excited about this year; to the new discovery, to the increment in knowledge, to correcting what he said before, to a fresh statement about an extensive new area.

Here we have the educational equivalent of the recording machine Land set up outside his office to get his associates' ideas while they were still fresh. The concept of taped or filmed lectures has taken hold to a certain extent, though the conditions are far different from those Land proposed. In some mega-universities introductory classes are televised to process an entire freshmen class through, say, basic math. The lecturers, though, by and large, are neither the most distinguished men and women in their fields nor the most scintillating speakers.

Though the academic world did not beat down his door for suggestions on how to implement his lecture concept, Land continued to play with the idea, and discussed with various professors and Polaroid employees how to carry it off. If the university would not try the notion on its own, Land would give them a push. In the early 1970s he assigned a research group at Polaroid to develop a system.

What they eventually came up with was called the Interactive Lecture System, which Polaroid introduced in New York at the Joint Meeting of the American Physical Society and the American Association of Physics Teachers in February 1976. In the system, a 1-hour lecture is recorded on an audio cassette. Additional cassettes contain the lecturer's answers to between 20 and 40 questions on the subject material.

As the lecturer speaks on tape, another unit uses a mechanical pen to reproduce the lecturer's notes, diagrams, and other pertinent material in that person's handwriting. The package also includes various forms of supplementary material, including biographical information on the lecturer. Polaroid first tried the system out at Harvard's Cabot Science Library, as well as in the Tufts University biology department and in chemistry classes at the nearby Lexington High School. The initial group of lecturers consisted of MIT's Philip Morrison ("Cosmology"), Cornell's pop astronomer Carl Sagan ("The Chances for Extraterrestrial Intelligence"), and Harvard psychologist Jerome Kagan ("Cognitive Development in Infancy"). Polaroid put a $2000 price tag on the

system, with individual lectures going for $95 each. At last count a number of university libraries had subscribed to the Interactive Lecture System with favorable student usage reported.

Like most offshoots of modern technology, Land's original proposal for filmed lectures, and the Interactive Lecture System which evolved from it, has its negative as well as positive aspects. One can foresee a learning institution—from kindergarten to graduate school—in which the student's only contact with other human beings is with the technicians who come to service the viewing machines. In many ways, such a soulless, sterile environment is not far off. But what Land was talking about was a fundamental redistribution of each institution's human resources in ways in which each person could have the most direct benefit on individual students. Instead of spending time preparing the same lecture over and over again, a professor would presumably be free to deal with students not in a large auditorium but in small comfortable rooms or laboratories, on an individual basis. Also, it made sense to Land that the best lectures of the best lecturers should be recorded for use in the same way that long-playing records capture performances of great musicians.

One question that must be confronted concerning Land's ideas on wide-scale educational reform is just how applicable they are to students substantially below the Harvard-MIT calibre. Can ordinary young people make wise use of a program such as UROP? And can competent mentors be expected to go along with them? This parallels the situation inside the corporation in general, and inside Polaroid in particular. Are Land's notions on individuality and personal satisfaction as applicable to the bottom of any group as they are to the top?

The problem is perhaps not quite so vexing in the academic sphere as in the industrial one. Not even Land's faith in the "random competence" of individuals in various fields is going to make a great scientist, artist, or writer out of the average person; and it might not even produce a competent one. But his type of approach, on whatever

academic level it is applied, and to whatever level of ability group, can put a person more experientially in touch with himself, make learning a more interactive situation, and communicate the fascination and variety of the world. It is a theme he voices—with less cause, some might argue—when speaking of the possibilities of his camera. What Land's idea does is to give the individual student the opportunity to reach his highest potential instead of inhibiting him before an attempt has been made. And at the same time, Land would continually remind the student that there is no shame in failure; rather, there is honor in the attempt.

Support

Along with his personal participation in the educational affairs of Cambridge's two "senior citizens," Land has been a major financial contributor. An anonymous gift of $12.5 million—the fourth largest in the university's history—was made to Harvard in June 1968 to build a center for undergraduate science. Speculation naturally began immediately as to the identity of the donor. Though they did not admit it publicly, sources revealed the benefactors to be Edwin and Helen Land. The timing of the gift might not have been arbitrary. It followed by only a few weeks an article in *Fortune* magazine stating that Land was one of the six richest men in America.

Land is also a close friend of MIT President Jerome Wiesner. Another friend of Wiesner's claims that Land intends to give his institution as much as $20 million. Wiesner has reportedly not pressed Land for a specific timetable for the contribution because of his personal relationship with Land and because, according to this associate, "The Institute doesn't need the money right now. He'd rather wait until we do."

At Polaroid, Land founded the Vision Research Labora-

tory, an organization involved with pure research into human visual perception. Land did not set it up with any commercial applications in mind and, so far as can be seen from the outside, none have come out of it. Much of the research conducted there has had to do with questions related to Land's retinex theory. Additional studies have been made on such subjects as color blindness under the direction of John J. McCann, manager of the Vision Research Laboratory. Among the intriguing projects lab members have recently undertaken are the uncannily lifesize reproductions of artworks.

MIT students participating at a fairly recent seminar jointly conducted over the course of a semester by Land and McCann, reported that the Polaroid chief was far more open and informal in the classroom setting than others, who did not know him well, have found him to be in any other environment. When not speaking to the class himself, he generally sat quietly toward the back of the room, but would enthusiastically enter into the discussion whenever McCann or a student brought up a point that interested him.

"When he asked questions," one participant said, "you got the feeling he really wanted to know the answer, and that we were telling him something he wanted to find out about."

Land's strong inclinations toward control apparently do not carry over into the actual realm of scientific knowledge. He is able to express doubt, a trait many leaders in and out of the sciences have difficulty with. Another student in the seminar, who generally spoke highly of McCann's abilities, commented, "I asked John McCann a question and he gave me a vague, runaround answer. Then I went and asked Dr. Land, and he said, 'We have no idea.'"

To an even greater extent than the corporation itself, the Vision Research Laboratory is a personal extension of Edwin Land. There is serious speculation inside Polaroid that after Land leaves, either through retirement or death, the Lab will be phased out. It was established to take care of Land's curiosities and pet projects, the sources say, and after he goes no one high enough in the corporate structure will want to

justify expenses that have no hope of generating income. "We already have the Polaroid Foundation for that," a company person stated.

Polaroid has continued to take an active interest in independent experimentation with Land cameras and film. The company's attitude might be something on the order of Kodak's original feeling that what is good for photography is good for Kodak. Any extension of the possibilities of Land film, the company realizes, has to be good for Polaroid. The subsidies Polaroid distributes end up costing the corporation little, and end up benefiting it, the photographers involved, and the medium in general.

Stephen Allen Whealton, an artist in Washington, D.C., became interested in photograms around 1968. A photogram is an image, normally abstract, produced by placing one or more objects or patterns on photosensitive paper, which is then exposed to light. The process, while technically photographic, does not use a camera. Whealton speculated that Polaroid Polacolor print film would have properties he wanted for his work, though no one had ever employed Polacolor for photograms before. He bought several hundred dollars worth of film, and after several weeks of experimentation in his light-secured living room, showed his results to the Smithsonian Institution's curator of photography. He, in turn, contacted an appropriate person at Polaroid and asked if the company would give Whealton free film and supplies so he could continue what was becoming an increasingly expensive activity.

Although Polaroid saw no commercial application in what Whealton was doing, people there were apparently intrigued by the fact that he was creating uses no one else had thought of. Polaroid continues to supply him with as much film as he wants, and sent him an SX-70 camera to experiment with shortly after it went on the market. The company has also purchased several of Whealton's photograms for its extensive corporate collection. Perhaps someone at Polaroid had been impressed enough by Land's personal

precepts to feel that, in a small way, Whealton was also seeing something totally new in an existing situation.

Government

Though the end of World War II marked the completion of Polaroid's extensive involvement with government contract work, Land himself continued to serve on a number of high-level government commissions and panels. From 1957 through 1959 he served as a member of the President's Science Advisory Committee and continued as a consultant to that group until 1973. While still consulting for the President's Science Advisory Committee in 1972, henchmen of the President at the time included him on their not-so-exclusive "enemies list" for his liberal views and supposed hobnobbing with Cambridge-type radicals. Interestingly, Land was listed as "Professor of Physics, MIT" under the academic section. He was not mentioned as a business leader, another of the groupings in the White House's highly organized exercise in paranoia. Richard Nixon, incidentally, also abolished the office of Special Assistant to the President for Science and Technology. Gerald Ford brought the post back in the summer of 1976.

The President's Science Advisory Committee began as a Cold War attempt to come to grips with the fact that many of the problems facing the government had now exceeded the abilities of a nonscientist or technician to deal with them. As might be expected, the majority of the issues the panel dealt with concerned defense; and the ones that did not do so directly, managed to do so indirectly. One of these was the reaction to Sputnik I.

A week and a half after the launching, President Eisenhower began soliciting suggestions from his science advisors on a national science education policy. George

Kistiakowsky, a Russian-born expert in chemistry who, in 1959, succeeded James R. Killian, Jr., former MIT president, as Special Assistant for Science, described Land's recommendations to Eisenhower in his book of journals, *A Scientist at the White House:*

> Edwin Land argued eloquently that the Russians were teaching their youth to enjoy science and focus on basic research, while "in the United States we are not now great builders for the future, but are rather stressing production in great quantities of things we have already achieved."

The most important phase of Land's government work was probably his participation on the Technological Capabilities Panel, a 1954 study of national security problems under the direction of Killian (who is now also a member of Polaroid's board of directors). According to Killian, the panel represented the first major reinvolvement of the scientific community with the government since the bloodletting of the J. Robert Oppenheimer affair. Killian speculated that the scientists were willing to serve an administration they felt had acted with grave injustice because of a genuine concern for national security and a feeling that they had a real contribution to make. At the time, the supposed superiority of Soviet missile capabilities was a significant topic of national concern, leading ultimately to candidate John Kennedy's acknowledgment of the "missile gap." Land was appointed head of the intelligence section of the study.

Among the aims of the intelligence section was to expand the concept of strategic intelligence beyond that of covert operations so that it could be used in the formulation of reasonable foreign and defense policy. The most prominent program to come out of the intelligence section's work was the development of the U-2 system. With his own knowledge of photography, Land suggested that a reconnaissance airplane capable of taking extremely detailed pictures from high altitudes would be an effective intelligence-gathering device. Once Eisenhower approved the system, Land worked with

the project director Richard Bissell, the Central Intelligence Agency's Assistant Director for Plans. The two men met frequently at Bissell's home in the Cleveland Park section of Washington, outside the normal Defense Department bureaucracy. The U-2's aerial surveillance camera was based on several Land inventions, and was the mechanism that alerted the Kennedy administration to the presence of Soviet missiles in Cuba in 1962.

The Hycon Corporation of California, specializing in optical work, came up with several camera designs from Land's original concepts. The one that was eventually used, the "B-camera," was a 450-pound device that fit into the U-2's fuselage. By moving its lens extremely quickly from side to side, the camera produced strips of photographs that formed stereo images optically combined for analysis.

Of course, it must also be noted that the Russian downing of the U-2 piloted by Francis Gary Powers on May 1, 1960, signaled an even greater chilling of the frigid relationship between the United States and the Soviet Union than existed during the extended cleavage of the 1950s. Exacerbating the crisis was the administration's frantic denials for several days after the incident. In his memoir, *Sputnik, Scientists, and Eisenhower,* Killian states his belief that the CIA was caught flat-footed, not having analyzed the increasing Russian capability to knock such planes as the U-2 out of the air.

Once the administration had come to grips with the problem, Eisenhower took responsibility for the entire episode. This owning up to the truth, whatever the costs, was an important concept to Land, who commented on it in his MIT commencement address in June 1960, quoted by Killian in his book:

It was not a question of the ineptitude that might be revealed by the truth or the possible damage that the whole program of negotiation for peace may have suffered ... and it was not a question of whether with foresight that particular crisis could have been avoided. The issue was this: Does an American, when he

represents all Americans, have to tell the truth at any cost? The answer is yes, and the consequence of the answer is that our techniques for influencing the rest of the world cannot be rich and flexible like the techniques of our competitors. We can be dramatic, even theatrical; we can be persuasive; but the message we are telling must be true.

This last part of the statement could be a commentary on Land's own public performances at Polaroid annual meetings.

Early in 1961, Land was appointed by President Kennedy to a task force on space programs. The nine-member group was headed by Jerome B. Wiesner, who went on to become president of MIT. The participation of both Wiesner and Killian on government science policy panels demonstrates the sway the Institute has for a long time held in the public arena. Before going back to Cambridge, Wiesner took over as science advisor from Kistiakowsky.

The Wiesner task force warned Kennedy that the United States was still lagging behind the Soviet Union in ballistic missiles and outer space exploration, and said that it was "very unlikely that we shall be first in placing a man into orbit around the earth," a serious point of national pride at the time. The group's report prompted the President's public assurance of a man on the moon before the end of the decade, a feat of unparalleled technological razzle-dazzle with appallingly few tangible human benefits.

But the space task force also came up with another observation, which was several years ahead of its time and went largely unheeded. An early report criticized the Eisenhower administration's emphasis on the manned Project Mercury program and stated that the United States should put greater emphasis on the unmanned aspects of the nonmilitary space effort. This critique was voiced again throughout the decade each time NASA spent millions of dollars on a manned flight by those who figured that greater scientific benefit could be attained at lower cost if one was willing to forego the exciting spectacle.

Land was one of 27 scholars selected by Professor Eric Goldman of Princeton to, in the words of *The New York Times,* "generate fresh ideas and new approaches for urgent domestic programs." Goldman was appointed by President Johnson in February 1964. The scholars, among them Margaret Mead, John Kenneth Galbraith, Clark Kerr, and Richard Hofstadter, were not constituted as a committee. Instead, each was to discuss his ideas directly with Goldman, who would relay them to the President.

The same year, Johnson appointed Land to an 11-member commission charged with figuring out how to deal with national problems of automation and technological development. Howard R. Bowen, president of the University of Iowa, headed the panel, which bore the suitably bureaucratic title of the National Commission on Technology, Automation, and Economic Progress.

In his memoir, Killian explained what Land felt was his own role in the government science establishment throughout the tenures of the four Presidents under whom he served:

Land . . . expressed the feeling that his major contribution as an adviser had been to convey to the president and other leaders something of the humanistic and aesthetic values of science. He took greater pride in this act of "teaching" the qualities and values of science than in his immense technical contributions to the strengthening of our military, intelligence and space technology.

Land's efforts in government volunteer work—much of it unheeded—were recognized by President Kennedy, who chose Land as one of 31 people to receive the newly revived Presidential Medal of Freedom, this country's highest civilian award. The Medal of Freedom had been given out sporadically since 1945 with no apparent pattern or set of standards. Then Kennedy decided it should become an annual national honors list. The awards ceremony took place at the White House on December 6, 1963—less than three weeks after Kennedy's assassination. Lyndon Johnson, who

presided at the Medal affair, added Kennedy's name to the list of award winners.

Awards of any sort, particularly those offered by any government, often tend to be long on pageantry and short on substance. Some awards, such as Sweden's Nobel Prize, tend to enhance the public reputation and professional standing of the award winner, no matter how exalted he might already be. And then there are other awards that, while carrying their own prestige, are themselves enhanced by the eminence of the people chosen as recipients. If it is proper to judge an award's value by the people chosen to receive it, the first Presidential Medal of Freedom was among the most significant honors ever bestowed by this government. Among the personages recognized at that White House dinner were Marian Anderson, Dr. Ralph Bunche, Pablo Casals, Justice Felix Frankfurter, Land, Senator Herbert Lehman, Ludwig Mies Van Der Rohe, Rudolph Serkin, Edward Steichen, E. B. White, Thornton Wilder, Edmund Wilson, and Andrew Wyeth. Never before was an award here so graced by the company it kept.

Land's citation read as follows:

Scientist and inventor, he has brought his creative gifts to bear in industry, government and education, enriching the lives of millions by giving new dimensions to photography.

Land continues his government volunteer service, though the volume and pace have been cut down with his age and the retiring of his peers back to academia and industry. He served on the Carnegie Commission on Educational Television in 1966 and saw to it along with that work that Polaroid assumed a responsible role in funding a number of educational television programs. He was elected a trustee of the Ford Foundation in October of 1967 and remained in that position for 8 years. And at least for a while during the Nixon administration, Land continued on as a member of the President's Foreign Intelligence Advisory Board, which, when

it was reconstituted by Nixon, was still looking into the question of what to do about ballistic missiles.

For most of his adult life, Land has believed that men and women of depth and vision should serve the government from time to time in whatever way they can. This appears to be an attempt to impose a further unity on his world view of cooperation. In his volunteer work he has often supplied helpful criticism as regards the way the government approaches problems within his field of expertise. To requote him: "If you are able to state a problem—any problem—and if it is important enough, then the problem can be solved." It can be difficult to get less-inspired people to understand this. It is difficult enough in a company of several thousand individuals, upon whom one man wishes to impress his personal stamp. But upon a conglomerate of bureaucracies numbering in the millions of persons, it is just about impossible.

6

The Color Era

Advent

Coincidentally, Polaroid and Eastman Kodak traditionally hold their annual shareholders' meetings on the same day every April. But though Kodak is many times larger than Polaroid, with a far greater number of public-owned shares, the Polaroid meetings are always substantially better attended than the Kodak assemblies. The reason is the eagerly awaited annual performance by Dr. Land, during which he can be counted upon to offer a glimpse of his latest technological wonder to the gathering.

The meeting of April 16, 1960, was among the most historic of these exercises—the first time Land publicly demonstrated Polaroid color film. He used a standard Model 800 roll film camera with flash attachment to take a picture of attractive models in Easter bonnets. Reports have it that the print quality was less than spectacular. Expert observers considered the contrast and color saturation poor. Land referred to the performance as a "progress demonstration," a reassurance to stockholders. And as usual for one of Dr. Land's displays, this one was met with exuberant applause.

At the meeting Land commented, "We do not regard this as the time to announce technical details about the new process or characteristics of the new film." This was a typical

strategy for Land who, despite his own fascination with the details of science, realizes that the shareholders flock to his meetings for something quite different. In nearly all cases, after publicly revealing or demonstrating a new Polaroid marvel at the company's annual meeting, Land has saved the technical details for an audience that could more properly appreciate them. After the grandstand introduction of Polavision at the 1977 annual meeting, for example, Land flew to Los Angeles to present a detailed and carefully written paper on the new medium before the Society of Photographic Scientists and Engineers.

The technical details of the instant color film, developed jointly by Land and Howard Rogers, represented the most formidable scientific challenge Polaroid had yet faced. Producing the color film was an extremely complex feat of chemistry involving literally millions of scientific facts, many of which were previously unknown. What we see as different shades of color the Polaroid scientists had to conceptualize as different molecular reactions.

Basically, the Polacolor film, which is about half as thick as a human hair, is made up of six layers plus a base layer and two spacers. There are three color-sensitive layers of emulsion, each of which reacts to only one primary color. Each of these layers is twinned with a layer of dye developer, the *sine qua non* of Rogers' invention. Next to all of this is the four-layer positive. But between the positive and the negative is the evenly spread layer of alkaline reagent, held in the normal Polaroid chemical pod until the film is pulled through rollers and the developing process beings. Though no one in the company can quite recall its origin, at Polaroid the viscous reagent has often been referred to by the highly scientific appellation, "goo." Technical inventory sheets in Polaroid labs still contain a printed column with "goo" as its heading.

Once the film passes through the camera rollers after exposure, breaking the pod and spreading the reagent across the interface of the positive and negative portions, the dye-developer molecules "migrate" to their respective color-emulsion layers, producing a negative image by reacting with

exposed grains of silver halide. Then the process becomes more complicated. In the migrating process, each dye-developer molecule can react only with grains in the first emulsion layer it reaches. Yellow dyes stop at the blue negative image. The magenta and cyan dyes pass through it and move to the positive, where they blend to produce the appropriate shades of blue. A similar sort of reaction creates each color in the positive area. At the end of the development cycle, the alkaline solution reaches the acid molecules within the positive sheet. The chemical combination of acid and alkali produces water, which "washes" the positive. This controlled neutralization provides a finished color photograph that is shiny and nearly dry when stripped from the negative.

The entire development process takes exactly 60 seconds to complete, and took Land, Rogers, and their associates about 10 years to bring to reality.

As more and more details about the Polaroid color process began to surface, the product seemed to gather its own momentum. Anticipation in both professional photographic and financial circles was much keener than it had been for the original black-and-white camera. Sensing expectations that were building out of control, Land wrote in the 1962 annual report, "We do not have the illusion that we will be able to please all our customers all the time."

At the 1962 shareholders meeting, Land announced that the color film would be marketed before another year had passed, and stopped the proceedings for 10 minutes so that each of the stockholders present could take a close look at the 150 Polaroid color photographs on display. Land then called for a show of hands as to whether the film was ready for the general market. The "motion" carried 795 to 5. He also took the time to deny publicly reports, which had been brewing for a couple of years, that the stock was about to split.

The 1962 meeting at Waltham was highlighted not only by the color demonstration but also by an angry exchange between Land and Harry Korba, a stockholder from Yonkers, New York. Korba accused the Polaroid management of not

reporting fully to stockholders on company activities. Land demanded a retraction, which Korba would not offer. Korba continued to ask questions of the chief until he was eventually shouted down by the majority of stockholders, who felt they had always been given sufficient information.

Corporate secrecy is always a touchy issue with regard to company shareholders. Since annual meetings become a matter of public record, no company wants to tip its hand to the competition, especially a company dealing in high technology in which specific knowledge is such a valuable commodity. On the other hand, the system of publicly held corporate meetings signifies that the stockholders are the owners of the company. And many feel that they should have a voice in the running of the business, other than the perfunctory approval of management-tied boards of directors.

In point of fact, the average stockholder has almost no say in the running of the corporation. A massive stockholders' revolt is so rare—and normally occasioned by such gross excesses of management—as to be a fascinating spectacle. And a revolt of the rank and file of Polaroid would be even rarer. Not only does one seldom come across a large corporation anymore in which one person holds such a significant portion of the stock, but in this case that one person has far greater hold on the reins than even his ownership would indicate. Since its original incorporation in 1937, Polaroid's primary corporate asset has been considered Edwin Land's brain. It is inconceivable that as long as that brain continues to function in the manner it has for the past six decades that there is any serious chance of the shots not going exactly the way he calls them. So each annual meeting will continue to fulfill its two basic requirements: It will discharge the corporation's legal requirement to meet once a year for the election of directors and transaction of other relevant business; and it will provide a marvelous show as long as Dr. Land is agile enough to climb on stage.

Though Land had set a public timetable for the introduction of Polacolor film, several small details and one major one remained to be worked out. By the summer of 1962, Polaroid

chemists working under Rogers had not figured out a way of getting around the need for having a coater for the color film similar to the one still in use with some of the types of Polaroid black-and-white film. In his continual quest to move as close to an actual "one-step" process as possible, Land was overwhelmingly interested in turning out a color film that was complete without the need of rubbing it with a messy squeegee.

Time was becoming the most critical factor. If Land's announced schedule was to be kept (which was, at this point, considered crucial to the company's credibility in the investment community), initial production would have to remain on schedule, with marketing taking place in February or March. A number of the coolest heads at Polaroid advised coming out with a film that had to be coated—which would still delight the photographic public—and worrying about getting rid of the coater when they had the time to tackle it.

To Land, this would not do. On Labor Day weekend he announced to his associates that he would have the problem taken care of before marketing would have to begin. This meant substantially redesigning the positive film layer, which itself was the product of more than a decade's work.

No one in the company or the Land household saw much of him for the next several months, except for the few assistants who worked alongside him in the laboratory above his office on Osborn Street. Land averaged 18 hours a day in the lab, often having all three meals brought in to him. By mid-December he emerged from his seclusion with the formulas for two new film layers, which eliminated the need for print coating.

Of his laboratory ordeal Land commented, "It's no more eccentric than saying you don't go to bed when you're halfway up a mountain."

This technological exploit was in many ways a repeat performance of Land's solving of the print-fading problem of the early 1950s. The problem was clearly stated—the type of challenge he likes best—and he could call on the accumulation of all his knowledge and instinct in approaching it.

When Land first walked into his laboratory in September, it probably hardly occurred to him that the problem might not have a solution.

Among all the components in Land's intellectual arsenal, the chief one seems to be simple concentration. Several years before he pulled the Polacolor stabilizing chemistry out of the bag, he told *Fortune,*

I find it very important to work intensively for long hours when I am beginning to see solutions to a problem. At such times atavistic competences seem to come welling up. You are handling so many variables at a barely conscious level that you can't afford to be interrupted. If you are, it may take a year to cover the same ground you could cover otherwise in sixty hours.

Land's comment is reminiscent of the incident involving the English poet, Samuel Taylor Coleridge. Having just awakened from a brilliant and exquisitely detailed dream, Coleridge immediately began to set his vision to paper. Less than halfway through he was interrupted by a visitor who inadvertently distracted the poet during that vital process. And as a result, "Kubla Khan" remains only a magnificent and stunning literary fragment.

One might not generally think of scientific work being subject to the same sorts of impediments as are artistic creations. It would seem that a scientific inquiry should be a logical, linear process, which, by its very scientific nature, should be orderly and regimented enough to stop and start at any point without serious consequences. But this approach does not take into consideration the intuitive process, the sudden revelation, the "instant image." Land views his work in the same light that he views Coleridge's—or, to use his own analogy, Beethoven's. Science is for him a process of uncovering individual human potential. It is deterministic insofar as there are truths waiting to be revealed. But he also believes that discoveries are not arbitrarily transferable from one person to the next any more than Coleridge and Yeats could

have written each other's poems. Nor might the same individual, under different circumstances, be able to achieve the same scientific results. Land is therefore extremely careful in optimizing his, and his associates' chances for success, by reminding them of the fragile, tenuous nature of scientific discovery or, on a more basic level, scientific "uncovery." This seems to be one of the chief tenets of his Polaroid experience.

Marketing

Polacolor was marketed first—as are most new Polaroid products—in south Florida. The promised February 1963 introduction date was kept. In 1963, color accounted for about 40 percent of all film sales in the United States. And normal color print film, under the most convenient of conditions, required 20 processing steps and took at least 93 minutes. Polacolor was fully developed 50 seconds after the shutter button was pressed. *Newsweek* claimed that no postwar product had been as eagerly anticipated as Polacolor, with the exception of the Ford Edsel.

In the excitement of the moment, Land's previous disclaimers about the film were nowhere to be heard. Instead, he was lauding his latest product by citing the rigid requirements it had to meet: "Our films must pass a test no other color films have faced before. Our customers will have a color print in hand for comparison on the spot, with the scene itself."

Polaroid's distribution people sent about as much film to Florida as they could squeeze out of the assembly line, figuring again that the inevitable shortage would heighten its desirability. But the anticipation turned out to be so strong that Florida camera dealers began receiving requests for film from all over the country. The demand for Polacolor was overwhelming. Most dealers, who were selling the film for between $4.77 and $5.25 for a six-picture roll, were sold out

of their entire initial allocations within the first few days and had to wait a month for more stock to arrive from Cambridge.

Competing with the general consumer public for available film were such groups as the Cape Canaveral Security Department, which decided that instant color photographs would be ideal for identification badges. Polaroid has since marketed a widely used system expressly for ID cards and badges. It simultaneously takes two instant pictures and superimposes the company name above the photograph.

Even after the initial film introduction hoopla in the Miami area, demand for Polacolor remained at higher levels than Polaroid could handle. The staid *Wall Street Journal* ran reports nearly every week for the first half of the year announcing the additional states film distribtution had been expanded to. By early summer, supply had just about caught up with demand, and national distribution was in full swing.

As soon as Polacolor distribution was under control, Polaroid came out with a new Land camera, the Automatic 100. This pack film model, which retailed for between $130 and $160, was intended to become the basic Polaroid camera. Improvements in design included a more sophisticated shutter whose electric eye measured and integrated available light at the moment of exposure, to control the shutter function automatically. The pack film also developed outside the camera, in what has become the standard Polaroid "peel-apart" format. This meant that the user could take a series of photographs one after another and not have the minute of waiting time before taking another shot.

Polaroid set as great a financial store in the Automatic 100 as in the new color film, announcing that $5 million would be spent on advertising in 1963 alone, an unprecedented sum for the company. The camera was manufactured by Polaroid's largest vendor, U.S. Time Corporation, at Little Rock, Arkansas.

While Polaroid was busy marketing its sophisticated new instant color film and the not inexpensive Automatic 100, Kodak was bringing out its first Instamatic camera. It was the

forerunner of a series that became the most successful line in the history of modern photography. The Kodak move also reinforced the traditional demarcation of the photographic market between the mass-oriented Rochester company and the more sophisticated, higher-priced Cambridge firm.

Both corporations had much to gain from this relationship. As long as Polaroid followed its course of improving the product while not taking away from Kodak's constituency, Big Yellow was content to leave well enough alone and not try to penetrate Dr. Land's formidable wall of instant picture patents. What's more, as of the advent of the instant color era, Kodak had become one of Polaroid's key contractors, producing the Polacolor negative material to the tune of tens of millions of dollars per year. Color negative is an extremely complex item to manufacture in large quantities, even after the basic chemistry has been worked out, and Kodak has always excelled in the field. Kodak, for its part, still thought of Polaroid as a pretty small kid on the block, even though it was now number two. Still remembering the days when young Edwin Land secured his first large contract to provide Kodak with polarizing filter material, upper-level Rochester executives continued to refer to Polaroid as "him."

The cordial truce between Rochester and Cambridge maintained itself in full force until the spring of 1964, at which time the first rumblings were heard that Polaroid might be looking to expand its marketing horizons. At the annual meeting of that year, Land announced that the company was developing a camera to sell for about $20, a fraction of their least expensive market entry at the time. Nineteen sixty-four was also the first year in which Polaroid film sales figures exceeded those of cameras, indicating that after nearly two decades the company had established a stabilized market share to sell to. This indicated too that Polaroid could finally afford to bring out a camera on which very little profit would be made, since the bulk of its photographic income (which now accounted for nearly 90 percent of company revenues) would be gained from the film camera owners would purchase.

The $14 Swinger, brought out in 1965, was Polaroid's first camera to sell for less than $50. Kodak immediately saw it as a major threat, for it signified that Polaroid could effectively compete in the inexpensive mass end of the market, which had been Big Yellow's bread and butter. The Swinger took 2½-by-3¼-inch black-and-white pictures and had no capacity for color. It was primarily manufactured for Polaroid by Bell & Howell and, unlike the other Land cameras of the period, the Swinger accommodated roll film. In the first 3 years of production, Polaroid sold 7 million Swingers!

When the Swinger was introduced in July of 1965, after much publicity about Polaroid's entry into the low-cost camera field, cameras and supplies were severely rationed. This had become a typical marketing problem for Polaroid. But it did have the effect of building desirability. By mid-1966, Polaroid announced that demand was so great that all cameras would be on an allocated basis for the rest of the year.

The Swinger had the predicted effect, expanding the range of Polaroid customers beyond fathers, well-heeled hobbyists, and serious amateurs. The most important new addition was probably the teenage market. The camera was an inexpensive gift, appropriate for Christmas, birthdays, graduations, or nearly any other occasion. And once the young people owned the camera itself, the black-and-white film purchases could be managed on an allowance or a small amount of pocket money.

But though there were few controls and adjustments in the operation of the Swinger, light conditions were a serious challenge, a much greater problem than they had been on any previous Land camera. Inside the high-impact plastic camera body, the Swinger's viewfinder spelled out "YES" if there was enough light for a picture, and "NO" if there was not. It was often difficult, however, to distinguish which instruction the camera was giving, particularly if the user happened to wear glasses or was nearsighted. With the roll film design, the Swinger also had a tendency to jam if it was knocked around, as was fairly standard treatment for a

$14 camera. Polaroid eventually redesigned the viewfinder so that it only said YES. If you could not see the word clearly, a flashbulb was in order. A Tee-bar strap was also included in later Swinger models to make the camera easier to hold while extracting the film. This eliminated numerous wasted pictures.

The film itself was quite satisfactory, though, just as the Polacolor film was proving to be. This was the area where Polaroid left the least to chance, rightly figuring the initial bad experiences with a pack or roll of film would sabotage the camera's chances for success and downgrade the company's name. Every type of Polaroid film is continually tested in a variety of situations for such factors as contrast and color balance. One of these situations is a fabricated typical middle-class living room, similar to a movie set, in which the company figures a good percentage of amateur photographs are snapped. In Polaroid's test studio, full-time models do nothing all day except pose in supposedly normal photographic situations. Unlike most models, who are hired on the basis of winning smiles or how sensational they look in designer clothing, the Polaroid models are selected for the particular reflecting qualities reading of their skin.

While the Swinger was still on allocation in January of 1967, Polaroid brought out four new Colorpack cameras, known as the 200 Series, to replace the 100 Series of a few years earlier. The top of the line sold for about $180, commensurate with the company's prior pricing. But the low end of the line sold for only a little more than $50. Polaroid color cameras were not yet quite in Kodak's backyard, but they were moving closer. A number of dealers complained that the new series was being issued when they still had a large inventory of 100 Series units they would be unable to unload, but the majority of retailers were pleased with the timing of the January introduction, since the post-Christmas quarter is normally the slowest time of the year for luxury items.

During these years of intensive marketing for Polaroid and an unprecedented number of new product introductions,

Land was still finding time to pursue his scientific interests and continuing to garner his normal share of awards. In June 1965, he received the Charles F. Kettering Award—named for the inventor of the self-starter—at a conference in Washington sponsored by George Washington University's Patent, Trademark, and Copyright Institute and the committee celebrating the 175th anniversary of the American patent system. The award coincided with the granting of a patent Land received jointly with Howard Rogers for work relating to the transfer of dyes from the negative to positive layer of his color film. The patent was Land's 291st.

The following year Land picked up the Albert A. Michelson Award at Case Institute of Technology in Cleveland. The honor, named for the Nobel Prize-winning physics professor, covered most of Land's bases, calling him "a pioneer in optical research for the invention of Polaroid and its wide application in science and technology, the design of the Land camera, his contributions to color vision, color photography, three-dimensional motion pictures, and for many innovations in basic and applied optics." That same month, *Popular Science* magazine bestowed on Land and the Polaroid Corporation the Popular Science Award for many of the same reasons.

Yale University followed rival Harvard's lead that year by granting Land his ninth honorary degree. Columbia and the University of Massachusetts would follow suit the following spring, a couple of months before the White House named Land one of 12 recipients of the National Medal of Science, the government's highest award in that field. Other winners in 1967 included Dr. Harry F. Harlow, Igor I. Sikorsky, and Land's old associate from the President's Science Advisory Committee, George Kistiakowksy, who among other things was being honored for developing the implosion method, which triggered the first atomic bombs, and the concept of chain reactions in chemistry.

Aside from being among the most honored men in America at the time, Land was also among the richest. The May 1968 issue of *Fortune* listed Land as one of the eight

wealthiest men in the country, with assets totaling at least half a billion dollars. *Fortune* recounted Polaroid's shaky financial plight at the end of World War II: "What has happened since is one of the great miracles of business, fully documented and widely publicized, but still awesome to contemplate." Land probably agreed with the "awesome" part of the statement, but given his own abiding faith in himself and his company, he considered the outcome something less than miraculous. Land attributed Polaroid's success to the basic human assets of the company's employees, but realizing his own gift for overstatement, quickly added, "Virtue and a good product are invincible!"

Since the article appeared, the paper value of Polaroid stock has considerably eroded the half-billion-dollar figure, though one does not anticipate that Land or any of his descendants in foreseeable generations will be financially wanting for anything. It also bears remembering that the bulk of this money is largely an abstraction, and depends for its existence on the irrational fluctuations of the stock market. Even so, such figures are dizzying, especially when we consider that on a *single day* in February of 1968, Land and his wife lost more than $42 million in stock value!

The Polaroid stock at that point was still considered the bluest of the blue chips, with a single share selling in the three-figure range. At a special meeting on February 23, 1968, company stockholders took a long-awaited move and voted another two-for-one stock split along with an increase in the quarterly dividend. Company spokesmen denied that the newly created shares were being eyed for any sort of capital financing.

Polaroid has always been something of an enigma on Wall Street. At first, with the exception of a few hearty financial souls, no one wanted to touch it. By the time Edwin Land finally proved to the skeptical group that the public realized he and his products were for real, brokers began falling all over each other buying Polaroid stock for their most careful, conservative clients, as well as those who became enchanted by the soaring share prices and even

higher soaring price-earnings multiple. Polaroid achieved the reputation as a "glamor stock," a grouping reserved for such performers as IBM and Xerox, and the reputation stuck.

In spite of all of this, Polaroid has never delivered consistently on the Market. Earnings results have never been consistent with what Wall Street optimists continually expect; and as a result, there seems to be a cyclical series of articles every few years speculating on what has "suddenly" happened to Polaroid. The company does carry a heavy research-and-development burden that supports a fair amount of products which may be years off. It also maintains an internal accounting policy of writing off costs as they are incurred rather than spreading them out over several years of the product's life. This means that expenses might seem high even in years in which sales approach record levels. And it is also possible that the charismatic nature of the corporation's stock in trade caused an inflation in stock prices out of all reasonable proportion to their performance ability. The stock market is, after all, as much an emotional as a financial forum.

Around Wall Street, the word glamour is meant to refer to a particular security's income-producing ability. But in the case of Polaroid, a number of investors were unmistakably interested in the issue because of a different kind of glamor. In 1973, Robert Metz wrote in his *New York Times* "Market Place" column:

Polaroid and its scientist-founder, Dr. Edwin Land, continue to dazzle Americans, who clearly regard him as something of a latter-day Henry Ford. In view of the uneven course of earnings over the years, it is clear that some who bought stock do so more because its founder is an original than because of the results.

At least some of the growth in Polaroid stock during the boom years of the mid-1960s was due to the ever-surfacing rumors that Polaroid was about to break into the color television market through its joint project with Texas Instruments, and into the document copier field through the work

with Litton. Much of the financial community lives by the herd instinct, and these two products represented the most glamorous "movers" of the era. Their production by the already-glamorous Polaroid Corporation was enough to send even the most conservative investor to the phone to beat the rush. The fact that neither of these products reached the market is also in part responsible for the dramatic nosedive in Polaroid stock prices when things began to flatten out in the early 1970s.

The founder addressed his stockholders on April 23, 1968: "I feel that the company is in one of the most vital creative stages of its entire history." Speculation was high as to what he was specifically referring to. He had demonstrated instant color transparencies (slides) to the 3000 guests, customarily announcing that the process was a number of years away from marketing. He also demonstrated a prototype document copier and said nothing about its possible sales date. The item he specifically had in mind was still years in the future, and would not even be announced for some time. But it was something Land had been thinking about since that day in New Mexico with his young daughter Jennifer.

In the meantime, Polaroid stepped up its marketing offensive, bringing out new products in the photographic line at least on a yearly basis. Early 1968 saw the introduction of the Big Swinger, a camera with the same target audience as the old (or little) Swinger and selling for $5 more. It used the standard Polaroid 3¼-by-4¼-inch pack film—still black and white only—and was selling in stores for under $20. The Big Swinger's first impact was to kill the market for the little Swinger. After that it held its own until Polaroid released the Colorpack II in March of 1969.

The $30 Colorpack II—which came out the same month as the $200 Model 360—was Polaroid's first effort to completely entrench itself in the market the Swinger had served as "point man" for. It took black-and-white or color film, had an electronic shutter for automatic exposure control, an

electric eye, a reasonably precise lens, and a built-in flashgun, which used four-shot flashcubes. Polaroid spent more than $2 million in the first 10 days to promote the Colorpack II, which physically resembled the Big Swinger. It took little marketing imagination to realize the "back-up" effect on Polaroid's low-end product line. The Colorpack II finished off the Big Swinger, just as the latter had devoured the little Swinger. Polaroid unloaded its remaining stock of both kinds of Swingers to A & P and Sears, Roebuck, which sold them for under $10 each.

More than any previous Land camera, the Colorpack II represented Polaroid's new marketing aggressiveness. The company understood that to lock into the Kodak territory, Polaroid would have to come out with a camera that competed adequately with anything the average Kodak color camera could do, while maintaining a price range that was not much above the black-and-white Swinger. To accomplish this, Polaroid accepted a substantially lower profit margin on each unit, and forced retailers to bite the same bullet. They complained, but the $2 million worth of advertising generally made them too busy to write any long letters of protest to the company.

The Model 360 was one of six new cameras replacing the 200 Series. The introduction ritual pretty much followed the protocols and procedures of the 200 Series initiation 2 years earlier, with the public clamoring for the latest model and many of the dealers griping that customers who had bought older cameras during the heavy Christmas buying season would come in and complain that their newly purchased units were now obsolete.

Of course there are two ways of looking at this continual replacement of new models with newer models. One is from a perspective of planned obsolescence, akin to the policy so effectively followed for years by the American automobile industry. The other approach—which the company would obviously favor—is a policy of bringing out a new model whenever improvements are achieved or lower costs become possible. In the course of these new-model introductions,

those existing Polaroid customers with sufficient interest and funds went out and bought each latest improvement, and the rest remained well served by what they already owned. Thirty years after the introduction of the original Model 95, Polaroid will still repair and supply film for every camera it has ever marketed.

Polaroid was in the mass market for keeps as of the Square Shooter, brought out in June of 1971. It was not a quantum leap technologically over the Colorpack II. Its essential difference lay in its acceptance of the new Type 88 square format (hence the name) film, which was smaller and cost less than the standard Polacolor stock. At the time there was no comparable black-and-white format (there is now), and so the Square Shooter was strictly a color camera.

By this point the company was already incurring massive costs associated with the SX-70 project, and the Square Shooter was looked to as a way of offsetting some of these costs. But to keep the Square Shooter and the other second-generation Land cameras selling, it was necessary to keep details about the SX-70 as tightly under wraps as possible. The most important detail was the date the new camera would be ready for the public. As long as Polaroid officials could remain vague about this, they felt people would not stop buying the current cameras.

One final Polaroid consumer product that hit the market in 1971 was not really a continuation of the Swinger-Big Swinger-Colorpack-Square Shooter line. It was called the Big Shot. Retailers had a hard time finding a classification for it, and consumers had an equally hard time finding a reason to buy it. The Big Shot was a gawky, gray plastic affair, which resembled a periscope turned on its side. It had a fixed-focusing distance of about 4 feet, used only the more expensive Type 108 color film, needed bright light to function well, and took nothing but head-and-shoulders portraits.

At the 1971 annual meeting, Land carted onstage the absolutely surefire combination of two babies and one dog and then had two attractive young women snap pictures of

them, which were projected on a large screen for the approval of the assembled audience. Subsequent advertisements touted the Big Shot's capacity for cranking out fetching portraits. This single function the Big Shot performed quite well, but almost no one had enough of a need for this type of picture exclusively to warrant the purchase of a separate camera, especially when any of the other Land cameras could obtain pleasing results with the proper setting. Overspecialization of consumer products is not an unheard-of phenomenon in the luxury field. Polaroid obviously figured it could slip another product in on the market with no additional research-and-development costs, and jumped at the opportunity. But so far, it appears that the company has learned its lesson from this misguided campaign, and the accent on all subsequent models has been on versatility rather than specialization.

Looking Ahead

Polaroid's product line of the late 1960s clearly documented the company's intentions of universalizing itself among all levels of the consumer photographic market. Eastman Kodak then began feeling the need to take a bigger part of what was becoming a bigger and bigger action. Realizing that there would be no way of keeping a giant of Kodak's resources out of virtually any market it wanted to penetrate, Polaroid decided that some increased cooperation was in order. Kodak had been supplying Polaroid's color negative material since Polacolor went into production in 1963. In 1969, Polaroid and Kodak signed a supply agreement that would have the Rochester company continue to produce the color negative for an additional 5 years. Polaroid needed the supply, and also theorized that keeping Kodak on board in this fashion might prevent it from trying to break into the instant-picture market with its own line.

Polaroid had been marvelously successful with its Land cameras and film for 20 years. But part of that success had to be attributed to the fact that no one else could legally compete.

The 1969 agreement offered a further concession to Kodak. As of 1976, it would be allowed to sell color film packs for Polaroid Land cameras under its own name. Under the new agreement, Polaroid retained the right to terminate the Kodak license if its royalties did not reach $10 million by 1980. The agreement appeared to be a further peaceable carving up of a lucrative hunting ground. But the announcement contained ominous indications from both sides that the agreement might be short-lived. Kodak stated that its researchers were already working on their own system, and Polaroid said at about the same time that Land was developing a new camera of a different sort from previous Polaroid entries, whose pictures would be of "unprecedented brilliance and depth of color."

Less than 3 years later, on November 17, 1972, Kodak announced that it was abandoning plans to make film for Polaroid cameras. They saw no point in manufacturing film for the second-generation cameras that would eventually be rendered obsolete by this new third-generation Polaroid line. This was, in effect, the final blow to peaceful coexistence between the two photographic kingpins, and from this point on, the battle was joined.

Kodak, which had pioneered standard-process color film, was for years able to keep way ahead of the pack by continually refining its product and expanding its uses, much as Land had done in the instant-picture sector. But by the late 1960s, the product was so refined that there was not that much more they could do to it year after year. And a host of competitors, such as GAF, Ilford, and Fuji, had begun making inroads in this most profitable of all Kodak enterprises. The self-fulfilling law of the megacorporation is that lack of sufficient yearly growth is equivalent to slow death, and so Kodak was looking for other avenues to pursue. Instant photography was the most obvious.

Though Polaroid's strategy people were undoubtedly rattled by Big Yellow's slow advance toward their own ramparts, Land expressed little outward concern. In 1970 he declared that if Kodak thought it could catch up with Polaroid, they would be "understating the power of our imagination." It is both significant and characteristic that Land would base his confidence on something as ethereal as imagination.

By the late 1960s, Land was already having trouble containing his obvious delight over the new camera system, which he had taken to calling the "Aladdin." In one pronouncement he explained that the camera was "more than anybody ever dreamed of having in the mass market." Land has a habit of announcing the rough details of new developments long before they are ready to be marketed, even though he also has strong proclivities toward secrecy. He had announced, in 1958, that Polaroid was working on 60-second color film. The film was not sold until 1963. Land's sudden bursts of enthusiasm appear to be hardest on the Polaroid legal minds, who are often afraid he is going to spill something that they want kept under wraps.

Land held his first formal press conference since 1947 at the annual meeting held at Norwood on April 27, 1971. He displayed, but did not demonstrate the SX-70—the end result of years of technological struggle. At the gathering held in the then yet-to-be-occupied $50-million SX-70 factory he referred to it simply as a "complete restatement" of photography. At the meeting, Land said he called the camera Aladdin because "Aladdin in his most intoxicated moments would never have dreamed of asking for it." It was a rather hokey and unsatisfying explanation coming from Land, who normally has better control over his literary metaphors. But in another sense, it was a typical response from Land, who answers only the questions he wants to, not necessarily matching his answer to the question that was posed. Land also said that the Aladdin would become the "basic camera of the future."

Polaroid was on the verge of a self-proclaimed new era,

which instantly gave the journalists and financial analysts who followed the company the perfect excuse to look back. The numbers alone were certainly impressive. If 1938—the company's first full year of operation—is used as a base, the index value of Polaroid stock grew from 100 to 357,500 in 1971, which helps explain the astounding wealth of the Land family. If 1961 is used as a base year, the index value of the stock during the agressive marketing years of the 1960s reaches 475 in 1971.

But Land had established more in those 23 years than impressive capital gains for himself and his investors. He had established an industry, affected a way of observing and visually reacting, and—for both better and worse—he had intensified the American public's almost religious enchantment with immediacy. Now, for the first time, the public would get to see the concept that Land had envisioned all along, and he was convinced they would be as continually fascinated by it as he was.

Before that, however, forces within his own company would be trying to tell that public something else about the founder and his magic camera, something that challenged the capable Dr. Land and Polaroid in a way they had never been challenged before.

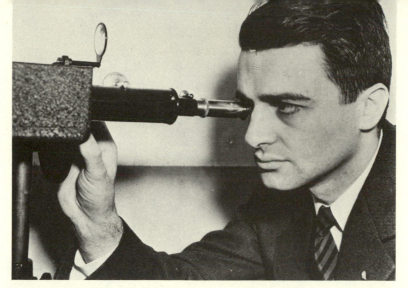

Edwin Land, not yet 30 years old, at his Cambridge laboratory in 1940. At that stage, the Polaroid Corporation was existing on applications of Land's polarizing sheets. War production would keep the company in the black for the next five years. *(Wide World Photo)*

The effect of light polarization. The photograph at left was taken of a shop window on a day of no more than average sunlight. The window reflects the scene facing it to the extent of obscuring the display. When the same scene is photographed through a polarizing filter, most of the glare and reflection is eliminated. This is a current application of the polarizing sheet. *(Photos by Marvin Ickow)*

The beginning. At the 1947 meeting of the Optical Society of America, 37-year-old Edwin Land demonstrated his instant picture process, employing an 8x10 studio camera fitted with a special back for the new film. Less than two years later, the first Polaroid Land cameras went on sale in Boston. *(Wide World Photo)*

Edwin Land peels off a picture of Charles B. Phelps, President of the Photographic Society of America. The Society's 1948 annual convention was the first public demonstration of the Land camera. *(Wide World Photo)*

The original model 95 Polaroid Land camera goes on sale for the first time at Boston's Jordan Marsh department store in November, 1948. *(Photo courtesy of Polaroid Corporation)*

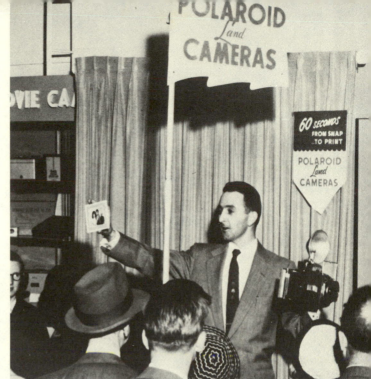

Edwin Land receiving the Presidential Medal of Freedom from President Lyndon Johnson at White House ceremonies, December 6, 1963. Attaching the medal is United States Chief of Protocol, Angier Biddle Duke. *(Photo courtesy of Polaroid Corporation)*

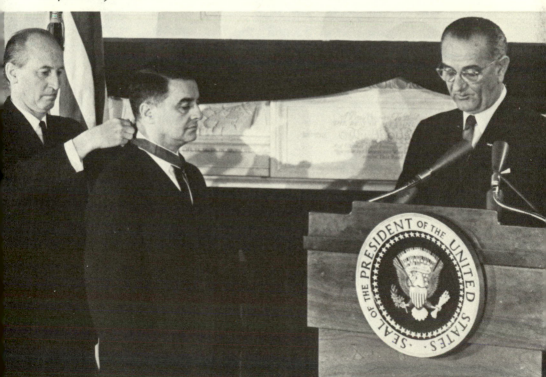

Edwin Land demonstrating the SX-70 at Polaroid's annual meeting, 1973. *(Photo courtesy of Polaroid Corporation)*

Chairman Edwin H. Land and President William J. McCune outside Polaroid headquarters at 549 Technology Square, 1975. *(Photo courtesy of Polaroid Corporation)*

Patent Commissioner C. Marshall Dann awards Edwin Land his 497th through 500th patents at ceremonies marking Land's induction into the National Inventors Hall of Fame at the United States Patent Office in February, 1977. *(Photo courtesy of United States Patent Office)*

Technology Square in Cambridge. The low, square building is Polaroid's corporate headquarters. *(Photo courtesy of Polaroid Corporation)*

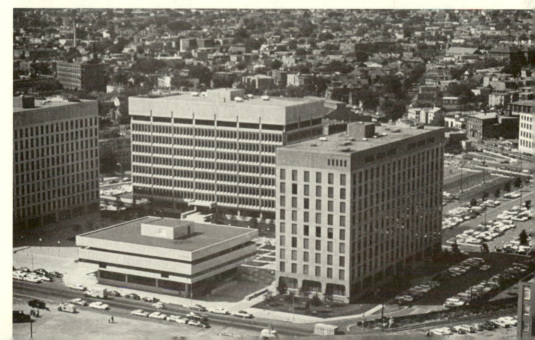

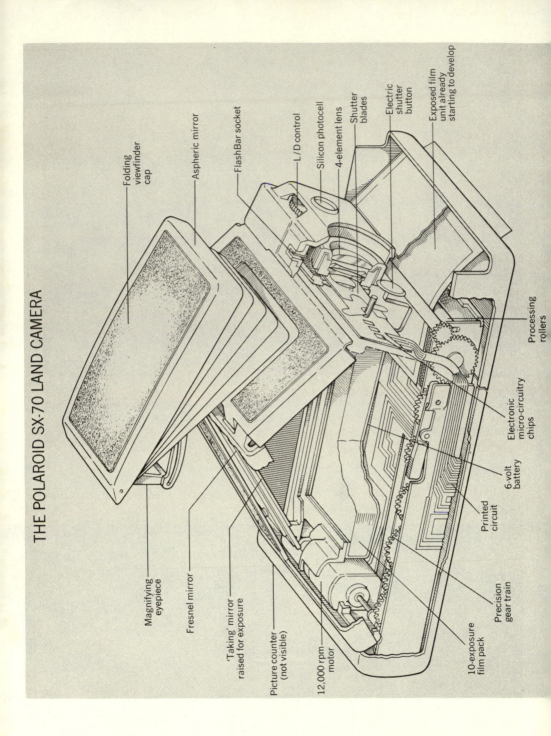

THE POLAROID SX-70 LAND CAMERA

Folding viewfinder cap

Aspheric mirror

FlashBar socket

L/D control

Silicon photocell

4-element lens

Shutter blades

Electric shutter button

Exposed film unit already starting to develop

Processing rollers

Electronic micro-circuitry chips

6-volt battery

Printed circuit

Magnifying eyepiece

Fresnel mirror

'Taking' mirror raised for exposure

Picture counter (not visible)

12,000 rpm motor

10-exposure film pack

Precision gear train

Cutaway drawing of the SX-70. *(Diagram courtesy of Polaroid Corporation)*

Eastman Kodak President Walter A. Fallon with the EK4 and EK6 instant cameras, with which Big Yellow hoped to take a sizable share of the market that had been Polaroid's alone. *(Photo courtesy of Eastman Kodak Company)*

Howard G. Rogers, Vice President, Senior Research Fellow, and Associate Director of Research. For much of the company's history, Rogers has been Edwin Land's right-hand man in the laboratory and the primary force behind the invention of instant color film. *(Photo courtesy of Polaroid Corporation)*

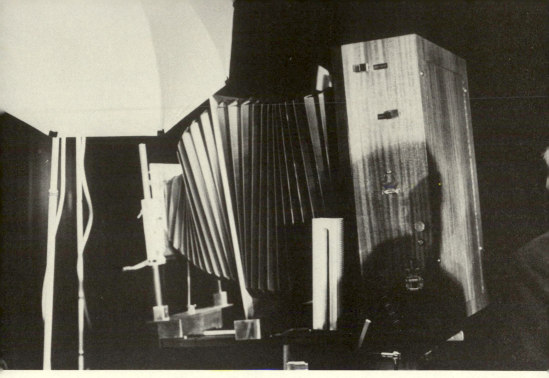

Land and his associates have been experimenting with large format instant photography. At a 1978 press demonstration in New York, artist Andy Warhol posed for a Polaroid camera that produced instant 20 by 24 inch prints. *(Photos by Mark Olshaker)*

The subject.

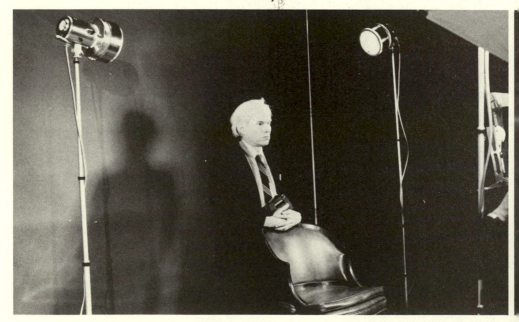

A representative sampling of Polaroid Land cameras through the past three decades. *(Photo by Kenneth Showalter)*

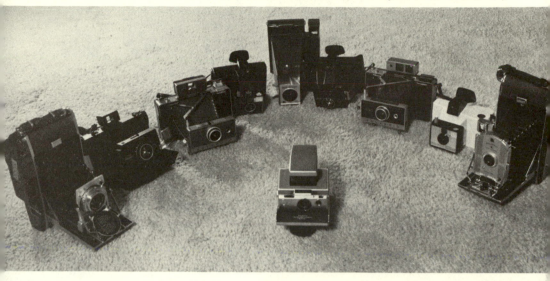

The result.

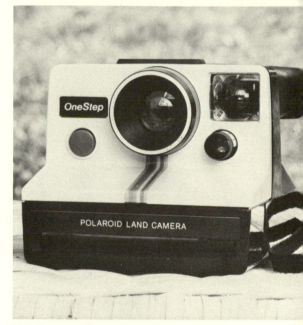

The One-step, an inexpensive, fixed focus SX-70 camera built on a Pronto body, became the most popular instant camera in Polaroid's history.

(Photo courtesy of Polaroid Corporation)

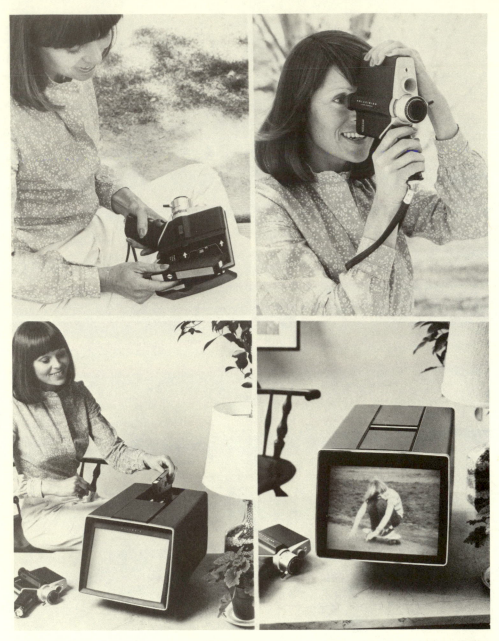

"Living images." Polavision cassette is inserted into camera, almost 3 minutes of film are shot, cassette is placed in viewer, and 90 seconds later the film can be watched. The Polavision system was introduced at the annual meeting in April, 1977 and went on sale in California later in the year. National distribution was under way by mid-1978. *(Photos courtesy of Polaroid Corporation)*

7

The Third Kingdom

Confrontation

On October 5, 1970, Dr. Edwin Land arrived at his office to find leaflets pinned to company bulletin boards proclaiming, "Polaroid Imprisons Black People in 60 Seconds." A closer look informed· him that the leaflet charged the corporation was guilty of grave moral offenses for its involvement—through the sale of identification equipment and other Polaroid products—with the white supremacist regime of South Africa. The declaration was signed by the Polaroid Revolutionary Workers Movement, a group the company founder had never heard of.

The following day an assistant secretary of the corporation, G. R. Dicker, addressed a Memorandum of Legal Matters to all Polaroid employees, denying that film, cameras, or an indentification system had been sold directly to the South African government. The memo admitted that the Polaroid ID-2 system had been sold in South Africa through Polaroid's distributor there, Frank and Hirsch, Ltd., but denied that it had ever been resold for government use. Moreover, Dicker went on, Frank and Hirsch had taken a public stand against apartheid, the system through which 3 million whites rule over 16 million nonwhites.

A day later, the Polaroid Revolutionary Workers Move-

ment (PRWM), under the leadership of 41-year-old company photographer Kenneth Williams, staged a protest rally in front of Polaroid's Technology Square headquarters. The Movement's demands were clear-cut: an immediate stop to all sales in South Africa, a severing of all company ties with that nation, and the turning over of all profits earned there to groups combatting the racist system of apartheid.

Of the approximately 1000 Blacks employed by Polaroid, which then maintained a total work force of about 10,000, only three identified themselves as being members of the PRWM. Nevertheless, the Movement obviously was significantly stronger than this, and community attention was intently focused on the brewing confrontation. PRWM leader Williams stated in an interview, "We see South African apartheid as a symbol of the many inhumanities in the United States. We cannot begin to deal with racism in Polaroid or in the United States until Polaroid and the United States cease to uphold apartheid." On October 9, Williams resigned from the company "rather than accept blood money."

It is extremely difficult to "get to" a man or woman who has millions of dollars, control of a major corporation, national reputations in several distinct fields, the ear of presidents, and policy-making influence at the most high-powered educational institutions in the country. But in a way nothing else ever had before, what became known as the "South African problem" got to Land. Since its founding, he had run Polaroid as an extension of himself, in an atmosphere in which the individual was encouraged to reach his full potential. Kenneth Williams himself, Land noted, had begun at Polaroid as a custodian and left as a professional photographer. The nonunionized company had never suffered a crippling labor action, and Polaroid employees' salaries and benefits were in the forefront for industry throughout New England. And Land personally seemed to embody the concept of the liberal imagination as well as any modern corporate leader possibly could. Land was clearly unprepared for this public show of disaffection, and more

than this, by the almost unimagined level of bitterness coming to the surface. This was not, after all, George Pullman's company town or Henry Ford's Rouge River plant. This—as Emerson might have phrased it—was Polaroid!

To many, the most repugnant feature of apartheid is the Pass Laws, which have been around since the early days of white settlement, and which were revised and codified in 1952. Under the Pass Laws all nonwhite citizens of South Africa over the age of 16 must carry identification books with them at all times, showing where the holder is permitted to live and work. Essentially, it is a "passport" the nonwhite needs to carry anywhere in the country, even in the home of his white employer. Each passbook contains a photograph of the bearer; and though Polaroid was initially unaware of the fact, its film and equipment were being used to take many of the pictures.

Though the income generated there had always been small—less than $2 million in 1969—Polaroid had been selling products in South Africa since 1947. But unlike the course it followed in many other foreign nations, Polaroid never made an attempt to establish a subsidiary company there. Instead, Polaroid sold to a distributor, Frank and Hirsch, Ltd., which employed about 210 whites and 155 nonwhites. In addition to instant cameras and film, Frank and Hirsch sold sunglasses manufactured with Polaroid lenses shipped in from Cambridge. As far as anyone could tell, Frank and Hirsch did not sell directly to the South African government. The feeling among observers in both Cambridge and South Africa was that had the company desired to do so, Polaroid could have enjoyed much greater sales among the affluent white South Africans.

Helmut Hirsch had been a refugee from Nazi Germany before co-founding Frank and Hirsch in Johannesburg in 1935, and so was somewhat sensitive to the charges of discrimination. He claimed that his firm had an exemplary record regarding nonwhites by South African standards, and that he offered them as much in the way of salary, benefits, and responsibilities as the stringent South African laws would

allow. In 1969 his company had organized an African staff committee, which was supposed to represent the views and problems of nonwhite employees to management.

The leafletting and subsequent demonstration by the PRWM took Land and Polaroid by surprise, but this was not actually the first time the question of Polaroid in South Africa had been raised. It had first come up 2 years earlier, in 1968. Polaroid executives did not deny this, and Thomas H. Wyman, vice president for sales, told a *Boston Globe* interviewer, "We recognized that our film, indirectly was being used in this identification program for Blacks and whites and I think there was some discomfort about it, but the issue did not crystalize to a point where now we wish it had." Wyman went on to admit that he found Polaroid's previous inaction on the subject "embarrassing," and said that the PRWM's actions were effective in bringing the South African issue back into people's thinking, "if I thought that were the issue that is on their minds."

Land, who had often asserted that a successful corporation must be a cooperative effort, said that he would not be intimidated into precipitous action. So after G. R. Dicker's initial clarification of Polaroid's sales situation in South Africa, the only statements immediately forthcoming from the company's top management concerned specific facts. No mention of policy intentions was included. And while the management was publicly stressing its totally antagonistic stance toward apartheid, Polaroid insiders were quietly rechecking every phrase of possible interaction with the South African government, and particularly with the administration of the Pass Laws.

The tension around all Polaroid facilities during these first weeks was unprecedented. It was a passionate issue, each side feeling a degree of unreasonableness from the other. No one favored the apartheid system, but there was no such unanimity as to what to do about it.

So hostile was the feeling that for the first time Land hired 24-hour guards for himself and his family. According to

one participant, "During that period Land probably felt terrorist groups were trying to kill him."

Following a meeting of Polaroid's board of directors, an announcement went out over the signature of Senior Vice President Arthur Barnes to the effect that the corporation would not continue "the sale to South Africa of its products which could be used in that country's apartheid program." Sales of regular film, cameras, and sunglasses were not affected. Two marketing people, Hans Jensen and Kevin Thompson, were dispatched to South Africa to officially inform the government of the Polaroid decision and to work out the details with Helmut Hirsch.

The two envoys reported back in positive, enthusiastic terms that the Polaroid move "has made considerable impact at the governmental level, as well as the consumer and dealer levels because it is an unprecedented statement of a position by an American company." Though several of the South African newspapers gave the story heavy play and made the Polaroid ban into a major issue, it is doubtful that any of the company's executives in Cambridge could have set much store in Jensen's and Thompson's report or harbored much faith in the effectiveness of the Polaroid gesture.

Those same executives realized that the issue had taken on its own momentum, and that further action had to be forthcoming quickly. Being the actual decision-maker, however, was not an enviable position. Polaroid's Don Dery commented, "The South African issue was such a hot button in the community that the company and Land decided not to make the decision on what to do by themselves." To mean anything in the eyes of the Polaroid executives, the decision of further action had to come through the process of cooperation Land had spoken of.

So during the later part of October, Executive Vice President William McCune set up a 14 member *ad hoc* committee consisting of seven Black and seven white employees. They met for the first time on October 28 to discuss the South African situation in general. The day before the

PRWM had called for a worldwide boycott of all Polaroid products in a sizable demonstration at Technology Square. Most of the demonstrators were not Polaroid employees, which meant either that the PRWM did not have wide support within the company or that it had even wider support in the community. The events began taking on added drama as other larger companies around the nation, more intimately involved with South Arica, stood by watching to see what Polaroid would do, and what would be done to it.

At the invitation of the *ad hoc* committee, Land spoke before its first session. He pointed out that he had long believed that the best way to get people to understand each other was to have them work together for a common purpose. "We think we are better than most other companies," he said, adding, "But we are about one half of what we ought to be."

And he reiterated his refusal to be intimidated by events or accusations: "I've never been pushed around in my life because I have ideals I live and die for . . . I do not want to run a company based on demands rather than participation." As Land saw it, the issue now revolved as much around the way his company was to be run and influenced as it did around Polaroid's involvement with a political system that everyone decried.

He reemphasized the company's thinking in a curious way: "When I and other members of management found out that some of our film was getting into this [apartheid] program, we said 'we are going to stop it.' And let me make one thing clear. Our decision had nothing to do with any revolutionary worker's movement, large or small." Though it is quite likely that a man of Land's moral character would have arrived at the same decision on his own, it is a fact that the uses of Polaroid equipment in South Africa did not encroach upon his consciousness until the the PRWM made its existence and demands known.

Land went on to cite Polaroid's industry-leading progress in the field of Black hiring and promotion. He said that the

way to get people to transcend their differences is to get them to work and build something together, as he felt was being done at Polaroid. Then he came to what he thought was the crux of the issue:

Would complete withdrawl—by Polaroid or other companies—have any effect? I don't know. It didn't work in Rhodesia, which became stronger and stronger and suppressed the Blacks more and more the longer their boycott lasted.

I know one thing. If we, this moment cut off all our business in South Africa, then the newspapers will be full of a vast Polaroid revolutionary movement—a movement with its two or three people. We would have a series of new demands, and there is no doubt that management would not meet them.

The world is watching us right now. Other companies are saying that "if Polaroid can't make the grade, none of us can." That word—Polaroid—is known around the world. Polaroid is considered a great and generous company. Shouldn't we use that power—the power of our great reputation—to accomplish our objectives in South Africa, or Boston, or Roxbury, or any place else? Is boycott of South Africa the right way to use that power? I don't really know. Let's examine the problem together and work together to make the decision which will prove most effective. There is a lot of hard work to be done.

Land spoke for over an hour and then stayed around for a discussion which lasted the rest of the day. The committee unanimously decided that whatever was to happen had to be an internal matter, not one imposed from the outside community. One Black member stated that, too often in the past, American Blacks had had decisions made for them. They wanted to be sure not to do this for their South African counterparts.

Two major resolutions came out of the *ad hoc* committee's early meetings. They decided to send a four-man fact-finding team to South Africa, and to consult experts in economics, African history, and other related fields to try to determine the potential outcomes of the several options they

felt were open to the company. This inquiry was to take the form of a study committee on South Africa. Land appointed an employee named Esther Hopkins chairman.

The PRWM took the stand that a fact-finding trip to South Africa—even if the South African government would admit the travellers to the country—would prove nothing since the access to knowledgeable sources would be officially limited, and those people who were interviewed would not speak candidly for fear of reprisals. The PRWM also discounted as irrelevant Thomas Wyman's claim that even if Polaroid did stop selling to Frank and Hirsch, the distributor would be able to obtain Polaroid products through other sources in Europe.

In a long article in the November 1, 1970 issue of the *Boston Globe*, reporter Donald White, who had studied the Polaroid confrontation wrote,

The impression that lingers after discussion with the black revolutionary group is one of anger, in the main quiet and controlled, but occasionally loud and unreasonable. If such anger and frustration can exist among employees of a company such as Polaroid, what must it be like in other less humanistic companies?

The *Globe* article did point out the discomfort many Black employees—who spoke highly of the company's attitude toward them in general—felt about doing business with South Africa. One member of the Black Volunteers Committee likened the situation of a Black working on products that aided the South African government to a German Jew manufacturing bricks for concentration camp ovens.

Wyman went to the State Department in mid-November to arrange for the travel group's papers. Aside from Wyman, the group included Charles Jones, an engineer, and Kenneth Anderson, an electrician—both Black—and a white draftsman, Arko Almasian. They left for London on December 2, and proceeded from there to South Africa. Once there, the groups reported that they were given a freer hand than they had expected.

After the first assault shock against Polaroid, the campaign to boycott South Africa began spreading to other American companies and was taken up by a number of church groups. Robert Palmer, Polaroid's manager of community services, saw the trend as a shift of political activity, from its previous center on university campuses, to industry. Palmer, incidentally, was one of the few Polaroid executives who personally favored outright withdrawal from South Africa, though he shared Land's fear of succumbing to confrontation tactics.

The struggle being waged was one for the respect and credibility of Polaroid's enlightened, liberal image, which, by extension, was a struggle for the personal esteem in which Land was held by the community. So in late November 1970, Polaroid began taking the public-relations offensive with an advertisement entitled, "What is Polaroid doing in South Africa." Appearing in the *Globe* and other Boston newspapers on November 25, the ad offered one explanation for why Polaroid, with miniscule investment in South Africa compared to many other American corporations, had been the first target of protest.

> Why was Polaroid chosen to be the first company to face pressure . . . about business in South Africa? Perhaps because the revolutionaries thought we would take the subject seriously.
>
> They were right. We do.

The statement continued by saying that Polaroid did not at present claim to know what was the right answer with regard to pulling out.

> Should we stop doing business there? . . . What effect would cutting off business have? Would it put black people out of work there? Would it influence the government's policies? Should we perhaps try to increase our business there to have a stronger say in the employment of blacks? Should we try to establish businesses in the nations of free black Africa?

The main thrust of the ad was that Polaroid was confronting the ethical questions in its own way and would make its final decision based on its own sense of what was right. And in the meantime, Land had agreed to abide by whatever recommendations the travel group came back with.

The travel group interviewed about 150 individuals during its 10-day stay in South Africa. They did discover rather quickly that Frank and Hirsch was paying nonwhite workers substantially lower wages for the same work than white workers, in the best traditions of South African labor policy. But they reported the nearly unanimous feeling among nonwhite South Africans was that Polaroid could do more to upgrade their economic and social conditions by staying in the country, and perhaps trying to increase its influence there. All four Polaroid representatives agreed that the company should stay, and at the same time take specific steps to improve the situation of Frank and Hirsch's nonwhite employees, and the nonwhite working community in general.

"What if the South African government would not allow this affirmative program?," they were asked. "Then we will have another decision to make," Thomas Wyman replied.

Polaroid's corporate decision was announced by Director of Community Affairs Robert Palmer on January 10, 1971. Three days later it was published as a full-page advertisement in the *Boston Globe* and such other nationally known newspapers as *The New York Times, Chicago Tribune, Washington Post, Los Angeles Times,* and *Wall Street Journal.* The company pledged to stay in South Africa through its disributor, Frank and Hirsch, but under the following conditions: salaries of nonwhite employees would be substantially upgraded, and those employees would be trained for "important" jobs; the company would make a major commitment toward the education of nonwhites at all levels through the nonwhite-run Association for Education and Cultural Advancement and through an outright grant to underwrite expenses for about 500 nonwhite students.

The size of Polaroid's presence in South Africa and the

amount of money the program had to work with (Polaroid's profits in that country) made the experimental program largely symbolic to everyone except the Frank and Hirsch employees and the students actually affected by it. It was a more complicated arrangement than merely withdrawing would have been; but after the research and recommendations of the *ad hoc* committee, the study committee, and the travel group, the program had the consensus of Polaroid management as the ethical course to follow.

It is also possible that, by this point, the PRWM's vociferous demands had made simple withdrawal the one untenable course of action. Land had said he would not be pushed around by "revolutionaries," and Polaroid's withdrawal from South Africa might have been perceived by him as a sign of caving in. So without calling to question Polaroid's high-mindedness in not leaving the country, it is conceivable that the unspoken signal from Land was that the company's response would have to incorporate something less than total withdrawal.

Land admitted to the *Boston Globe* that he had seen the effects of mass intimidation in academia and was not going to see it repeated in his company: "I have watched the university world and seen some wonderful people there destroyed . . . I have some historical preparation [for what is happening]." Perhaps his experiences in the science-intelligence community in the early 1960s gave him further historical preparation. He might have been thinking about John Kennedy's refusal to trade American bases in Turkey for Russian bases in Cuba under the glare of public confrontation during the Cuban Missile Crisis.

Within the company the plan became known as the South African experiment. Outside, it was referred to as the Polaroid experiment. It was immediately decried by the PRWM and the National Union of South African Students, headquartered near Polaroid in Cambridge. They pointed out that South African labor laws were so inherently discriminatory against nonwhites that the Polaroid experiment could not possibly bring even small-scale change if it stayed within

the present law. The NAACP called on all American businesses to boycott South Africa.

In a meeting held at the Cambridge Community Center on January 25, 1971, Kenneth Williams told followers to ask stores not to stock Polaroid products. If the stores refused the request, a white X was to be painted on the store window. He also suggested that people refuse to be photographed with the Polaroid ID-2 system, then being used for Massachusetts driver's licenses.

"They [Polaroid] don't give a damn about human life," he said. "It's capture the world at all costs." He also used South Africa as an example of what he thought could next happen in the United States: "To control the world, you have to have a means of doing it, and the ID-2 is a proven system. If it works in South Africa, it will work here."

On February 7 Williams testified before a United Nations Committee investigating apartheid. He was joined there by Caroline Hunter, a 24-year-old chemist who was the only other Polaroid employee to publicly admit being a member of the PRWM. Also testifying was George Houser, a Methodist minister and director of the American Committee on Africa. All three called for an international boycott of Polaroid products so long as they continued doing business in the racist nation. Houser stated that the greatest danger of the Polaroid experiment was that it would be copied by other American corporations (many certainly were watching it closely), and this would only strengthen the South African regime. The area had been extremely attractive to American business because of the plentiful cheap nonwhite labor created by the apartheid system. Houser said that it would be impossible to remain in the country and get around the existing labor laws, and characterized Polaroid's move as a "paternalistic act of charity."

The confrontation heated up further as Polaroid became more aggressive in the wake of the continued recriminations. Three days after she testified at the United Nations, Caroline Hunter was suspended without pay, and was fired about 10 days later. Though Polaroid refused to comment publicly on the dismissal, Hunter was informed she had been

let go "for conduct detrimental to the best interests of the company." Apparently, the Polaroid management saw no reason to pay someone to malign them and stir up anticompany sentiments on the inside. But the move clearly had a damaging effect on Polaroid's public image while it was struggling to maintain its reputation as a liberal, open-minded organization.

Hunter stated, "It is just further proof of the racism that exists at Polaroid. At Polaroid they say that if my rights interfere with their products that they can suspend those rights, as they did with me. I intend to continue to work on the boycott."

Other less sensitive and emotionally involved leaders than Land might have assumed a low profile and waited for the heat to dissipate. But Land, according to company observers, was devastated by the chain of events. Regarding himself as an enlightened employer, and heading a corporation that had never been wrenched by a bitter labor strike in its history, Land felt as if he had been kicked in the teeth for pursuing what he considered the moral course of action. He was particularly bitter over accusations that profit was his paramount consideration, when he maintained that profit had never been the guiding force in any Polaroid endeavor. He felt his accusers at least owed him the courtesy of respecting his motives as he had done theirs. When the crunch came, he felt, he had been lumped with the mass of impersonal corporate leaders, and all of his past strides in the direction of individual dignity and opportunity had been forgotten.

As he arrived under heavy security for the 1971 annual meeting at the Norwood plant, Land was greeted by signs reading "Is Ed Land Adolph Hitler?" and "Polaroid Kills in South Africa." The epithets and demonstrations over the South African situation overshadowed the first public unveiling of the SX-70 and the rumblings of Kodak's impending entry into the instant-picture market. When questioned at the meeting about the South African issue, Land replied that it was costing the company more to stay in than it would to leave, and stated, "We are very proud of our record."

Support for the Polaroid experiment came from a number

of quarters, particularly the journalistic community. Ulric Haynes, Jr., a Black, and former U.S. State Department specialist on Africa, endorsed Polaroid's action in a column for *The New York Times*. He claimed that South Africa had an acute shortage of skilled labor, and that conscious attempts to upgrade the capabilities of nonwhite workers would ultimately lead to their assuming more responsible positions, restrictive laws notwithstanding:

Paradoxically, attacking apartheid by shoring up the weaknesses in the South African economy is both beneficial to nonwhites and the most effective way of highlighting the senseless contradictions of apartheid and ultimately destroying it.

And speaking at a Harvard University commencement in June, Alan Paton came out strongly in favor of companies such as Polaroid staying in South Africa and trying to better the conditions of the blacks there. Paton, author of the lyrical and prescient novel, *Cry, the Beloved Country*, has long been considered the white conscience of South Africa, a reputation earned through years of unceasingly speaking his unpopular mind. His endorsement of the Polaroid experiment probably meant more in terms of world opinion than the voice of any other white person on the subject.

The most unified support for the Polaroid experiment came from South African nonwhites themselves. African employees of Frank and Hirsch were gratified over the upgrading of their pay and status, and others were hopeful of similar treatment if the influence of the Polaroid program spread. In its September 22, 1971 edition, the *Wall Street Journal* quoted M. T. Moerane, editor of South Africa's largest Black newspaper, the *Johannesburg World*, as saying, "Who are these people who want foreign investments pulled out of South Africa? They certainly aren't friends of South African blacks."

The *Journal* quoted another Black African, "You don't help a man by taking his livelihood from him." White employees of Frank and Hirsch seemed to favor the Polaroid

experiment as well, and generally seemed to have greater respect for their nonwhite colleagues once their "official" positions had been recognized through higher pay and greater benefits.

As Polaroid had hoped, its symbolic experiment was being imitated in various forms by other American firms doing business in South Africa, such as IBM, General Motors, and Minnesota Mining and Manufacturing. One of the largest single influences the Polaroid program appeared to have was the new willingness of some employers to utilize nonwhites in jobs that had previously been reserved by custom for whites only. White management in South Africa traditionally pointed to the fractional productivity rate of the average nonwhite worker as compared ot the average white. But employers who followed the Polaroid lead generally found that increased training and sufficient preparation for any job brought the nonwhite worker up to a par with his white counterpart.

One of the continual problems faced by Polaroid was that no matter what strides were made within Frank and Hirsch or the other companies following their example, South African laws and customs stood in the way of the most significant forms of progress. Nonwhites remained forbidden by law to supervise whites, although Helmut Hirsch reported that junior white employees began treating senior nonwhite employees with greater respect and deference. And within Frank and Hirsch itself, nonwhites held responsible positions in every department except one—sales. White customers refused to deal with nonwhite salesmen.

Despite these severe limitations, many South African nonwhites set great store in Polaroid's continuing with the experiment after the pledged 1-year trial period was up. Chief Gatsha Buthelezi, leader of the 4 million Zulus, South Africa's largest nonwhite population, served on the seven-member board of trustees of the Polaroid educational fund and publicly backed the Polaroid experiment, urging other foreign companies to follow suit. "Any change in the day-to-day life of a black man in this country is something very essential," he said.

In December 1971, Polaroid released a report on the first year of the experiment, calling it a limited success and pledging to continue the program. Aside from the work at Frank and Hirsch and the education grants, Polaroid also participated in the formation of a nonwhite-owned distribution company in Lago, Nigeria. This was part of a long-range policy of increasing the scope of Black capitalism in the free nations of Africa.

An independent study written by John Kane-Berman and Dudley Horner of the Institute of Race Relations was similar in tone to the Polaroid report. They said that while it was too soon to judge the long-range effects of the experiment,

There is reason to be moderately optimistic about the effect of the Polaroid experiment as a relatively important factor in creating a new awareness among businessmen in particular, and the general public, of the depressed condition of the African masses.

Protests over the Polaroid action did not stop. On August 22, 1972, the World Council of Churches, made up of 250 Protestant and Orthodox churches, voted at a meeting in the Netherlands to sell their stock in any corporation doing business in South Africa or Rhodesia. Among the companies affected were Polaroid, Chrysler, General Electric, Ford, Monsanto, IBM, Texaco, 3M, and Gulf. Debate over this mirrored arguments that Polaroid itself had experienced more than a year earlier: whether, in effect, to "boycott" those companies to induce them to change their policies, or whether to try to affect them from within as active stockholders.

For more than 6 years the Polaroid experiment remained in effect, and after about the first 2 years it was no longer referred to as an experiment, but as an ongoing program. The somewhat more enlightened policies at Frank and Hirsch continued, and the educational and cultrual trust fund Polaroid established is now being contributed to by other companies as well. Throughout the period, the attitude and doctrine of the South African government continued to

offend the sensibilities of most decent people of the world, but many of those involved with the Polaroid program and its offshoots inside the country had not given up their hope.

Then, in November of 1977, the *Boston Globe* ran a story claiming that Frank and Hirsch had been selling Polaroid products and supplies directly to the South African government in violation of the original 1971 agreement, under which Polaroid would remain in the country. The *Globe* reported that the film, used in the government Bantu Affairs Department's onerous passbook program, was being shipped in unmarked cartons and vans to various military installations. The government used a pharmacy in Johannesburg as its front for billing, so there was no written record of the transactions.

Polaroid dispatched Hans Jensen, the export sales manager who had gone to South Africa for the company during the original crisis, to investigate the allegations of cooperation between Frank and Hirsch and the government. Despite Helmut Hirsch's protestations that his firm had violated neither the "spirit nor the substance" of the 1971 agreement, Jensen came back with what Polaroid considered conclusive evidence that its products were being used to further apartheid.

Just as the PRWM's actions of 7 years earlier had made it virtually impossible for the corporation to completely vacate South Africa, now the Frank and Hirsch action had made it virtually impossible for Polaroid to remain. It had been the first American company to announce that it was staying in South Africa for ideological reasons. And on November 22, 1977, it became the first American company to announce that it was pulling out for ideological reasons. The official Polaroid statement declared simply that the 1971

... understanding stipulated that the distributor refrain from selling any Polaroid products to the South African Government. As a consequence of this new information, we initiated that same day an investigation from which we have now learned that Frank and Hirsch has not fully conformed to the understanding. Accordingly,

Polaroid is advising Frank and Hirsch that it is terminating its business relationship with that company. With the termination of this distributorship in South Africa, we do not plan to establish another one.

The situation came to light during one of South Africa's periodic ascents into daily headlines, this time for the murder in prison (while being held for no particular crime) of moderate Black leader Steve Biko. With other events in South Africa more politically pressing, the Polaroid withdrawal received its most complete coverage on the business pages.

In typical Land-Polaroid fashion, Community Relations Director Robert Palmer looked back on the South African confrontation as a time of trouble and anguish, but also as something that was basically good for the company. The problem, Palmer explained, had strengthened Polaroid's liberal foundation and moral resolve. One negative effect in the Boston area, Palmer did point out, was that, "Other companies were saying, and some still are, that if such a thing could happen at Polaroid, imagine what could happen here. Pure and simple: It didn't make it easier to get a job in this area if you were black." (Quoted in Paul Dickson's *The Future of the Workplace.*)

Commenting on the overall effect of the 6-year Polaroid influence in South Africa, one company official said, "The effect was like a spoon in an ocean—a very small effect. But for us, it was the right thing to do."

Cooperation

In Cambridge, there is no imposing, readily identifiable Polaroid headquarters comparable to the massive steel or granite towers of Sears, CBS, or Xerox. And the bland, four-story cantilevered block at the corner of Technology Square,

which houses Polaroid's corporate offices, indicates less about the company than the succession of drab, aging white plaster and red brick structures a couple of blocks down Main Street where the laboratories are located.

Polaroid's profile in the Cambridge community has always been high, but it is not the dominating sort of presence that George Eastman established early in the century in his home town of Rochester. Neither the Land nor Polaroid names adorn the myriad of buildings and institutions in Cambridge or Boston.

There are other differences between the two situations. In Rochester, Kodak is not only the city's largest nongovernment employer, it is a goodly part of its history and the single thing most outsiders know the city for. In Cambridge, Polaroid is the third largest employer, behind Harvard and MIT. These two institutions have left an imprint on the area far greater than the amount of income they generate for residents. They, more so than any corporation, dominate the civic and intellectual life of the community, an atmosphere that Polaroid has responded to to a greater extent than it has influenced it. Harvard and MIT are the first two kingdoms of the city. And in the last couple of years, many residents— particularly those associated with the two universities—have begun referring to Polaroid as the Third Kingdom.

It is difficult to determine exactly what portion of Polaroid's corporate development has been influenced by the intellectual character of Cambridge, and what portion has been the result of Dr. Land's personality. Whatever the ratio, it must be kept in mind that Land himself is a product of this intellectual tradition and, since his teens, he has never been far from Harvard and, later, MIT. Even the naming of Technology Square, a modern development built by MIT, indicates a certain orientation and acknowledges the value and faith placed in science. The company sees its rise or fall as dependent on its mastery of science, and the name represents an outlook shared by Polaroid and its university neighbor down the block.

Not surprisingly, the attitude of the average Cambridge

resident to Polaroid is of the "it's just there" variety. Everyone in my private survey knew that Polaroid was the third largest employer in the city, but few remembered hearing about specific programs. Those who did tended to be personally involved in the project, such as having a child in a Polaroid-supported youth group or having gone for x-rays at a Polaroid facility. No one I spoke to had anything negative to say about the company.

Those with more direct involvement in city affairs considered Polaroid a highly responsible corporate citizen. Russell Higley, the Cambridge City Solicitor commented,

Polaroid has been above reproach all through their history here. They're very receptive and have a community orientation. For example, they've always let us use their land for [youth groups] and other recreational purposes. If we had more Polaroids in Cambridge, we'd have no problems.

Patrick Centanni, Special Assistant to the Mayor of Cambridge, stated, "Polaroid has always been more than cooperative. They provide good working conditions and wages and they're responsive and generous with their community programs."

Currently, Polaroid assists about 150 community projects in the Boston-Cambridge area, most having to do with youth and senior citizen affairs, education, and housing. Probably the most significant aspect of Polaroid's community involvement is in the area of job preparation, which also extends into the corporation itself. Polaroid founded Inner City in 1968 as a wholly owned subsidiary in the Roxbury section of Boston. During its 3-month training program, Inner City exposes participants to classroom instruction and actual work. Throughout the program, whose key purpose is to allow unemployed people to develop work records and find entry-level positions in area companies, participants are paid the minimum wage. Inner City is supported through a combination of grants from Polaroid and profits from products produced by the participants. An Inner City official

explained that the emphasis is on career training rather than charity; and though it is only necessary to pass a physical examination to enter the program, participants can be expelled for poor attendance or bad attitudes. The 80-percent retention rate is higher than any comparable program in the city. A large percentage of the Inner City graduates join Polaroid upon completing the course, and many others have been placed in a variety of work situations throughout the Boston area.

Since late 1970, Black employment at Polaroid has been about 10 percent of the total work force, mirroring Black population figures for the urban areas of New England. By 1975, this percentage of Black employees had reached up into most management levels of the corporation. The two-phased Women's Action Program attempted both to hire more women for responsible management and research positions, and to increase the number of women in traditionally male-held jobs, such as in manufacturing.

Prison affairs have been a Polaroid concern for a number of years. In 1972, the corporation's Director of Community Affairs, Robert Palmer, spent 10 days at the Massachusetts State Prison mediating a revolt. More recently Palmer served as chairman of the State Advisory Committee on Corrections, which continually warned of the explosive situation brewing in prisons as the result of severe overcrowding.

Palmer is a sincere and outspoken member of the Polaroid hierarchy. Throughout the 1970–71 South African confrontation, Palmer stated that it was his personal opinion that the company should get out of South Africa completely, though he did not question the motives of Land, Wyman, or the others who advocated remaining. Palmer also condemned a proposal that welfare recipients in Massachusetts be made to carry an identification card. Though it was widely believed that the Polaroid ID-2 system would have been used for these cards (as they are for Massachusetts state drivers' licenses), Palmer declared that the idea was dehumanizing, set welfare recipients up as a separate class, and that Polaroid should not be interested in that type of business.

The Polaroid Foundation, funded by the corporation, is an employee-run charitable organization that accepts grant applications for educational, community, cultural, and medical activities. Because it is small, the Foundation tries to give these grants as seed money, or to programs where the grant would be matched or added to by other organizations. If money is only needed on a temporary basis, the Foundation is also prepared to make low- or no-interest loans. In addition, Polaroid cameras and film are distributed free to various creative programs, particularly those involving school groups. Within the company, the Polaroid Foundation handles the annual United Way contribution and matches employee contributions to educational institutions on a two-for-one basis up to a maximum of $500 a year for each donor.

As with the issue of scenic blight caused by the careless litter of Polaroid film refuse by millions of tourists across the country, Polaroid has traditionally been extremely sensitive to the question of environmental pollution from its manufacturing facilities. In 1970, a committee called Polaroid and the Environment was established to keep track of the ways company plants and buildings were using energy, creating waste products, and affecting their surrounding areas. Although the committee was composed mainly of science-oriented employees and managers, there were also representatives from the business and administrative side. Monitoring efforts were handled by the committee until 1975, when it was disbanded in favor of a full-time director of environmental affairs. This aspect of community involvement has always been a priority to Land personally, primarily because an environment polluted by Polaroid products and systems would be out of keeping with his stated goal of aesthetic enhancement through his inventions. When one has such an all-encompassing vision, it must be equally applicable to each phase of experience.

Polaroid's policy statement on social responsibility is a direct reflection of that totality:

We are ultimately as concerned about the success or failure of the society as we are about the success of our own enterprise.

Indeed, we are convinced that we cannot succeed in our enterprise unless our society is ultimately successful. Our responsibility obliges us not only to accept our share of the burden, but also to influence others to do the same.

It is easy to write off a statement like this as lip service, particularly when it comes from a corporation the size of Polaroid. The only thing that gives one pause before doing so, however, is that the company is still the reflection of an individual mind, and it is not difficult to imagine this statement emerging from that mind.

The SX-70 Experience

Development

Folded flat, the SX-70 camera is slightly larger than a standard-sized paperback book. Unfolded, it takes on the shape of an oddly proportioned polyhedron with an asymmetrical pyramid on top. One's first impression is likely to be that it does not look like a camera. The second impression is likely to be that it does not look like anything else. And the third impression is likely to be that whatever it looks like, it is rather classic and elegant, as are many designs that gracefully reflect their function.

A cartridge of 10 pictures is inserted by opening the hinged front portion of the camera base. Snapping it closed automatically ejects the cartridge's cardboard covering slide with a dull, groaning whir. Light entering the camera's lens hits the viewing mirror attached to the rear plane of the body, is reflected down to the patterned Fresnel mirror in a focused beam, travels up to the viewing mirror again, passes through the viewfinder opening on the top of the camera, strikes the aspheric viewfinder mirror, and is reflected through the viewfinder lens to the user's eye. Focusing is accomplished by turning a small black dial next to the lens opening. The only other controls on the camera are a lighten-

darken dial on the other side of the lens opening and a red rubbery shutter button, also on the front.

When the shutter button is pressed, the shutter instantly closes. A motor powered by a flat battery in the film cartridge turns to unlatch the Fresnel mirror, which springs up out of the way in front of the viewing mirror. On its back is the taking mirror, collecting the light entering from the shutter, which has just opened to take the picture. The light is reflected from the taking mirror down onto the top picture card, which up until this point has been protected from light by the Fresnel mirror. The electric eye measures the appropriate amount of light and then automatically closes the shutter. Then the motor turns again to move a pick, which grabs the top picture card and sends it through the steel rollers at the front of the camera. As it passes through the rollers, a pod of developing chemicals attached to the film card is broken, the developer is spread evenly between the positive and negative layers of film. Once through the rollers, the picture card is ejected from the camera while the Fresnel and taking mirrors are lowered back into position in the base of the camera for the next picture.

The entire elapsed time between the pressing of the shutter button and the ejection of the picture card is slightly over 1 second.

The entire elapsed time between the inventor's conception of the camera and film and its availability for use is slightly under 30 years.

It is no exaggeration to state that the SX-70 is the instant camera Edwin Land wanted to create all along. It is the device for which he had long ago reserved the phrase "absolute one-step photography." And as William McCune noted, everything up until the SX-70 was a compromise for Land.

His original vision called for a slim, pocket-sized camera, which the user need only focus and which would then produce a finished color picture without further manipulation. This is roughly equivalent to the Wright brothers' specifying a 200-passenger, 40-ton load factor for their first

airplane. At both beginnings, the technology simply did not exist.

The story of Land's persistence and insistence upon eventually turning out the camera of his original idea is a revealing one about the man. The chronicles of American industry are full of inspiring stories of men and women pressing confidently on amidst a sea of failures until finally . . . success. But Land's case is equally inspiring—that he persevered amidst a sea of successes. When one is doing exceedingly well already, it is somewhat less than compelling to risk it all on something that may be better if it all works out just the way it theoretically should, but on the other hand, if it does not

As with most of the challenges Land has set for himself, the SX-70 began with the formal statement of the problem: the first step, in Land's view, toward solution. His original instructions to his engineers consisted of a small list typed triple-space on a single sheet of paper: Compact, Integral, Single-Lens Reflex, Garbarge-Free.

This last instruction was as significant as any design element. Preceding Polaroid films produced a mountain of garbage per roll. Not only did Land want to eliminate the delicate step of peeling apart developed positive and negative by hand, he also wanted to end the undeniable visual blight caused by careless and thoughtless users in just about every public place in the United States—this despite the fact that just about every piece of paper contained in a Polaroid film pack bears some sort of proper-disposal reminder.

There is another story that continues to crop up about Polaroid roll and pack film—the one concerning wild animals dying in various National Parks after eating Polaroid film litter. The story was first released several years ago by a reporter for a publication of the American Automobile Association, who got it from a National Park ranger in Nevada. Not surprisingly, the company is extremely sensitive on this matter, and went to considerable lengths to see if the story had any basis in fact. As it turned out, the report had no

validity according to extensive research conducted by both Polaroid and representatives of the National Park Service. But the reputation of killing endangered animals continues to be a tough one to shake.

Though the SX-70 was based on existing Polaroid instant-picture technology, virtually every aspect of the camera was revolutionarily new, and had to be invented anew. The number of variables involved was nearly unmanageable, even with the sophisticated computer programs Polaroid used. Right from the beginning it was acknowledged that the film would have to represent a new dimension in physical chemistry as different from the current Land film as it had been from the previous Eastman stock. But before that even came about, the design of the camera itself was a nearly insurmountable problem.

Scientists and engineers work with a number of constants, unalterable truths that just cannot be manipulated. Under certain conditions, light will be reflected or refracted. Or water will boil. Or reinforced concrete will crack. The scientist or engineer will simply accept his constants as a given, and manipulate every other workable factor. Polaroid engineers had a number of additional challenges, since they had to treat Land's specifications as constants. In most cases, he would not see them altered any more than he would expect light to travel at half its prescribed speed.

Occasionally these requirements had somewhat comical implications. An engineer assigned to the camera design commented, "Land gave my boss a block of wood and told him that's how large the camera could be. He'd decided on that size by what would fit in his coat pocket. So in a sense, you could say that Dr. Land's tailor determined the size of the SX-70."

Actually, the configuration of the camera body was one of the few elements Land was forced to compromise on. And like almost every other aspect of the camera and film, it was complicated by the instant nature of the process. For example, the largest size limits for the camera were determined by what would fit in a coat pocket. Anything larger

than that was deemed too bulky. But on the small side of the size scale, Polaroid had another problem. A conventional camera can use a negative of just about any size. Some consumer-oriented cameras employ one about the size of a fingernail. But since the Land cameras produce prints directly by transfer from negative to positive layers, the size of the negative was governed by what the smallest tolerable picture size would be. In other words, if you want a photograph people can look at without squinting, your instant camera can be only so small. So when he concluded that he could not achieve a large enough image area in the size rigid camera he wanted, he decided upon a folding camera design in which light rays would have to be reflected inside to provide them with single-lens viewing.

The most representative words on the entire SX-70 project come from Land himself, in a lecture he gave before the Society of Photographic Scientists and Engineers in San Francisco on May 10, 1972. The lecture was reprinted in the Society's journal, *Photographic Science and Engineering.* In the talk—titled, appropriately enough, "Absolute One-Step Photography"—Land reviewed all his original requirements for the SX-70. He stated that the assumption that the film could leave the camera and develop in normal light was "our most adventuresome step."

We designed the camera as if we had solved the problem, and carried the camera all the way through engineering while doing the basic research on the chemical task of bringing the picture directly into the light.

At first glance this seems the objective evaluation of one scientist-engineer explaining to his colleagues the working parameters of his experiment. But on another level, it represents in a single technically oriented sentence the basis of Land's vision and his success.

While the journalistic and investment communities were

uneasily looking over Polaroid's corporate shoulder at the multi-million-dollar research and development effort, Land and his scientific associates were breathing considerably easier, serene in the knowledge—at least as far as they were concerned—that the SX-70's workability was a foregone conclusion. Land knew it was all going to work out and come together and that the only way to achieve great things is to forge ahead and assume that the individual pitfalls sure to crop up will be overcome.

To Land, it was a question of perspective: "If anything characterized the company, the thing that drives the analysts wild is that . . . we grow and grow and grow, not on the basis of bottom line but on the basis of faith, that if you do your job well that the last thing you have to worry about is money; just as if you live right, you'll be happy." At that point, profitability was among the farthest things from Land's mind.

Polaroid Vice President Sheldon Buckler had this to say about the task before the researchers: "The program to create our new camera was like a siren. She never came clean to say whether she meant to succeed or not, but she never let us escape." On another occasion, he was more direct as to what he and his associates faced:

There is no such thing as a simple invention. It has to be supported by a whole chain of equally difficult ideas. There were one hundred places where most people would have said, "There is no point in going on."

Each of Land's key associates faced at least one of these obstacles. In most cases, the problem had never been faced before, so there was no body of knowledge on which even to base a theory. The film had to be shielded from light while it developed but then be completely visible right afterward. *Fortune* quoted him in 1974:

The way the camera was defined, something like [a device to shield the film while it developed] had to exist. But the problem was, not just that it didn't exist yet, but that we didn't even know the

phenomenon that would give it the foundation to come into existence. There were some doubts.

The challenges called for unorthodox solutions. In one instance, Polaroid engineers had not come up with a design for the SX-70 motor, which had to be powerful and efficient, but small enough to fit into a corner of the camera's base. One engineer happened to watch his son playing with toy racing cars and figured on the spot (in true Land fashion) that something on the order of the car's motor might work. The next day Polaroid technicians fanned out to most of Boston's toy and hobby shops to study the situation. The motor they finally came up with was patterned on an electric train engine one of them found, purchased, and then completely dissected.

But the most formidable challenge lay in the film itself, which Dr. Jerome Lettvin of MIT called "unbelievably brilliant."

Land had to complete a set of about eighteen interlocked, fusion-controlled processes. It required devising an ultra-thin layer of white with almost no ability to pass light. But then later on you had to be able to diffuse colors through it. And the pictures had to be able to develop even in bright light (an unprecedented requirement). Just that alone was a tour de force of enormous magnitude. A tremendous number of molecular processes have to start and stop by themselves.

All previous Land film had been protected from light while developing, and the film unit was not peeled apart and exposed to light until the development process was completed. But since there was to be nothing peeled apart with the SX-70 film, a way had to be found to block light during the development; but whatever blocked the light had to then disappear so the viewer could actually see the finished photograph. Hundreds of chemical coatings, or "opacifiers," were tried. The solution seemed to lie in some substance that

would be light-tight, but then neutralized by the developer molecules once they had completed their work.

The winning formula was demonstrated successfully in Land's private laboratory on November 4, 1969. Fifty Polaroid scientists crowded around Land to watch a sample of film develop under the blinding glare of two sun guns, equal in power to direct sunlight on the summit of Mount Everest. As the photograph began to develop and the opacifier layer gradually turned crystal clear, a momentous cheer is reported to have gone up from the assembled scientists. Later, Land ordered a cake for the 25 chemists who had been most instrumental during the years spent in synthesizing opacifiers. The inscription on the cake read, "And the darkness shall become light." Several of the researchers went for their *Bartlett's* to discover the source of the literary-sounding citation. But the quote was, in fact, vintage Edwin Land, composed especially for the frosting.

The SX-70 film utilized Howard Rogers' dye-developer concept—using a molecule that is both image dye and developer. Except, this time, not only would the film have to develop in light but the negative and positive would remain part of the same package. After intensive study, Polaroid chemists had decided that a metallized dye (possessing a metal ion in the dye portion of the molecule) would provide greatest permanence, one of Land's "givens." The chemists had been working on such dyes since before the introduction of Polacolor in 1963. By the time the last of the 3 dyes to be used in the new film had been synthesized, Polaroid had committed well over $100 million on facilities to produce the product. Though a failure to come up with a workable yellow dye might conceivably have jeopardized the entire project, the chemists were willing to go with non-metallized dyes if necessary.

A small fraction of the thickness of a pencil line, the SX-70 film is composed of 13 principle layers. Even more complex than the standard Polacolor, the SX-70 development process is still based on the migration of dye-developer molecules from the various negative layers to the positive.

In the SX-70 development process, it does take somewhat longer for the final image to form. But what the user trades off in ultimate speed, he gets back in being able to watch the image actually take shape and color before his eyes. And there is an undeniable kick in "participating" in this phase of the technical process. The result of the metallized dyes is not only more permanent pictures but more vivid and saturated color as well.

Even after research hurdles were overcome, there were the equally formidable challenges of production. Perhaps the most exacting of these was the manufacture of color-negative material. Previous Polaroid color negative had been turned out by Eastman Kodak, with years of experience under its belt. Photographic color-negative production is an extremely complex and technical undertaking. Dupont tried once and gave up. So it was a particularly daring move when Land announced that Polaroid would no longer depend on Kodak, but would produce its own color negative for the SX-70. Polaroid had a small pilot program in color-negative production going at the Waltham plant, and the results had been reasonably satisfactory. But producing the material in vast quantities with the high quality-control standards needed was still an uncertainty. And Kodak, for its part, had never allowed Polaroid personnel into its negative-producing plants in Rochester, so even the specifics of how past Polaroid negative had been manufactured were sketchy.

Even if Land had been able to devise the camera body and incredible film for the SX-70 back in the late 1940s, he still would not have been able to produce the camera he wanted to, because there would have been no way to regulate all of the camera's functions in so small a space. The first Land camera was announced at about the same time that William Shockley, John Bardeen, and Walter Brattain of the Bell Telephone Laboratories announced the invention of the transistor. The development of this tiny semiconductor— which led to the 1956 Nobel Prize in physics—turned out to be the most significant electronic breakthrough of the generation.

Prior to the invention of the transistor and its related circuitry, the electronic components needed to perform the automatic functions Land had in mind would not have fit into a large suitcase. Bell Telephone Labs' perfection of the semiconductor represented a new generation of electronic miniaturization, leading to such well-known items as pocket radios and portable television sets.

But since then, miniaturization has experienced a second generation of ultraminiature components. Solid circuits no larger than a word on this page can be produced containing literally thousands of transistors and other devices. Electronic engineers discovered that one of the major stumbling blocks in the way of microminiaturization was the power source. Certain functions require a level of power that cannot be produced from a tiny battery. But if only a small amount of current is needed to perform the required function, as in today's pocket calculators or digital watches, a small battery can be incorporated in the design without having to expand upon the size of the object overall. A wrist watch would not be much good if the user had to carry a standard 9-volt battery with him. But the requirements of its integrated circuit are so small that a button-sized battery will supply all the power needed.

The SX-70 system took full advantage of the strides in microcircuitry. The camera segment containing the lens and shutter button contains three incredibly complex miniature circuits, controlling the motor, flash mechanism, shutter, and electric eye, and coordinating each of the functions that take place in that second after the shutter button is pressed. The electronic model was initially made up on a circuit board about the size of a living room wall. This entire program was then reduced to the three chips contained in the SX-70 shutter housing by a process not dissimilar from photography. As a standard negative is enlarged to make a positive print, so a plan for the circuit was shrunk to its fingernail size and "printed" on tiny wafers of plastic.

Texas Instruments, one of the pioneers in microchip development, designed the electronic module for the SX-70.

TI had worked jointly with Polaroid in the 1960s on the color television system that was never produced.

Other than the film chemistry, optics was the phase of development in which Land and his associates were most experienced. But they were also faced with two factors they had not had to tackle before: the extremely short distance and Land's insistence on a single lens reflex camera (that is, one in which the user sees exactly what the lens sees, rather than what is seen through a viewer to the side or on top). Since the camera's size and configuration would not allow the light to enter and travel straight to the user's eye, a system of three mirrors and two lenses had to be created to bounce the light in the proper way and concentrate it at the appropriate places. One of the mirrors and both of the lenses were also aspherical, which required new instruments for measuring their accuracy (required accuracy was to 20 millionths of an inch). It took 2 years to come up with a measuring machine. The computer program, which helped implement the design, had to account for a nearly incalculable number of variables. Altogether, about 3 years of full-time computer work went into the design of the lenses, which Dr. Jerome Lettvin calls, "one of the great little triumphs of modern computer optics." The SX-70 lens was produced by Corning. Previous Polaroid lenses had been manufactured by Kodak, Polaroid and others.

The image one comes away with is of a group of men and women, highly knowledgeable in science, taking advantage of the advances in modern technology, but pushing that technology just beyond its functional and predictable limits for the sake of a dream their idolized leader has never given up on. The obvious attendant question is, Was it all worth it? Was it worth spending $600 million and utilizing the best minds in the business on an enterprise about as complicated as the Manhattan Project to design and market a new amateur-oriented camera?

From a monetary perspective, the question is easily

answered by looking at the company's profit-and-loss statements for the several years after the product's introduction. If Polaroid makes more money than the SX-70 cost to produce, it is a success—otherwise, a failure. But the question as to whether the SX-70 was worth the "bother" becomes—as Edwin Land would have it—an individual matter. How, he would argue, can, on those terms, one judge the life-enriching experiences the camera might afford to millions of people?

The Polarized Family

Land stated that the SX-70 would change the course of photography. Before that could occur, though, it set off a more immediate change: It changed the course of his company. Prior to the decision to manufacture color negative, Polaroid was essentially a high-technology "idea" company. Principle camera manufacturing was farmed out, mostly to U.S. Time and Bell & Howell. Color negative was produced by Kodak. Polaroid itself handled sheet and pod production operations and some of the final assembly.

With the SX-70, the beginning of Polaroid's third generation of cameras, Land and his associates decided that they should move toward becoming a vertically integrated company, which would not only come up with its own ideas but see them through to production on its own premises. This move would not only afford greater control, it would also mean greater profits. Kodak's pretax profit on color film is about 70 percent. Polaroid's money men dreamed of approaching that figure with their own product.

From an internal perspective, the decision to get into full-scale manufacturing was as big a decision as the one to design an all-new Land camera in the first place. Aside from the motive for increased profit, which must certainly have been

considerable, Land explained that "these cameras and film are technologically unique, involving new science at each point of manufacture." Clearly, in his view, it was a job for Polaroid itself.

When I commented to Polaroid Publicity Director Donald Dery that the conversion to manufacturing must have been a tremendous problem, Dery countered, "It was a tremendous opportunity. There are no problems at Polaroid; just dozens of opportunities."

From another point of view, the entry into manufacturing could be perceived as a major trauma for a company as ostensibly people-oriented as Polaroid. Between 1969 and 1972 the corporation spent in excess of $200 million to build and equip five factories in eastern Massachusetts. One of them, at Norwood, was supposed to be ruled by a megacomputer, which would leave little for human beings to do other than clean the floors. Because of numerous problems, though, the computer idea was partially abandoned and the building was given back to the humans.

The greatest problem/challenge was not what to do with machines, but what to do with people. When you have a high-technology company of 1000 or 2000, the bulk of whom are working at laboratory counters or designing tables, individuality is a human commodity to be dearly prized and nurtured. When you then bring that employee population up to 10,000, and place a good percentage of them on camera and film assembly lines, individuality—and its concomitant value, dignity—becomes harder to salvage. And this became a severe test for the integrity of Land's humanistic vision.

The citation accompanying Land's 1966 honorary doctorate from Yale read as follows:

> Your superb scientific and engineering resourcefulness has been surpassed only by your ability to give those who work for you the excitement and self-fulfillment of creation and discovery.

Edwin Herbert Land, company spokesmen are eager to point out, has had six major inventions: synthetic polarizers,

instant photography, instant color photography, the SX-70 system, Polavision, and the Polaroid Corporation. Of these six, they say, his favorite is the last.

At the time of Polacolor's public introduction, Polaroid was already beginning to achieve the status of a major corporation. In an interview at the time, Land stated, "We hope to make ourselves a prototype American corporation. Each good American company should be a kind of experiment to find out how people work best together. Our ambition is to do our part toward instituting these kinds of corporations."

Land's view of the purpose of his company is summed up in a corporate memo dated May 1, 1967, and entitled, "A General Statement of Policy." It is based on a statement Land wrote in 1945, when Polaroid was less than 10 years old.

We have two basic products at Polaroid:

Products that are genuinely unique and useful, excellent in quality, made well and efficiently, so that they present an attractive value to the public and an attractive profit to the Company.

A worthwhile working life for each member of the Company—a working life that calls out the member's best talents and skills—in which he or she shares the responsibilities and the rewards.

These Two Products are inseparable. The Company prospers most, and its members find their jobs most worthwhile, when its members are contributing their full talents and efforts to creating, producing and selling products of outstanding merit.

While one detects a strong trace of the Land superlative, the intent is nonetheless genuine. He founded his company as a means of furthering his own scientific work, and felt that for the concept of the corporation to be at all valid the others working there must be able to feel a similar gratification in work commensurate with their abilities. Land seems quite concerned with the personal dignity of the individuals who work for Polaroid. But it is far from a case of isolated altruism. In fact, nothing Land does seems to be isolated. With his carefully unified vision, Land must feel that if he

has not made his working conditions the best they can be, this in some way diminishes from the value of the company's product—the camera—for which, as has been noted, Land makes less than modest claims in terms of human significance.

The point is this: Land still likes to think of his company as essentially an extension of the scientific laboratory. This gives him both the rationale for doing business and an established pattern for the work environment. As Land put it more than 20 years ago, "To be a scientist and manager is one integrated activity. What the scientist can provide is an insight into the future. He doesn't have to ask experts or wait for a vote on some research idea."

At the same time, motivation can be a challenge in a research organization, where productivity is difficult to gauge, and where the effects of an individual's work might not be known for several years. Therefore, it becomes important to imbue each worker with the Land ethic.

What does that "ethic" consist of? For one thing, it implies an involvement to one's work similar to Land's own. In 1975, he said this to a *Forbes* magazine reporter:

I don't regard it as normal for a human being to have an eight-hour day, with two long coffee breaks, with a martini at lunch, with a sleepy period in the afternoon and a rush home to the next martini. I don't think that can be dignified by calling it working and I don't think people should be paid for it.

But the next question then becomes, How do you get them involved? Traditionally at Polaroid, it has meant giving each person a sense of the worth of his or her own job, and letting them see it through, rather than lose it as soon as they are "on to" something. "Any intelligent man can finish another man's sentence," Land has said. "We are all careful never to do that."

For so many years Polaroid was involved with such singular projects that this was more than merely a luxury the company could easily afford. It was, at times, a necessity.

There are certainly disadvantages to working in some pure or applied field of science in which no other organization has any interest or expertise. But one of the great plusses of being involved in a highly specialized area of product development is that employees are encouraged to become the world's leading authorities on whatever it is they do. It was a concept Land had hoped to establish in the academic world. But by its very nature, his own company turned out to be the most likely place for it to happen. Not only is this type of excellence something to be aimed for, but with the type of work Polaroid carries on, in many cases it might even be an attainable goal.

Hand in hand with this attitude is the fact that Land has moved the concept of scientific experimentation into the industrial sphere. He wants the same absence of stigma attached to failure here as in the laboratory. Failure then becomes something to build on rather than to discard. Each public success in Polaroid's history has been the result of a long string of what might be termed failures because, in science, one way to find out what works is to first find out what does not. Contrast this to the Vince Lombardi "winning is everything" approach so popular in American industry today. By and large, the companies that have taken as their own this dogma of the playing field are rather successful from a monetary perspective. They are also conservative, redundant, exploitative, and generally unoriginal in both their production and marketing approaches.

On this subject it also must be stated that, under the right circumstances, there can be a fundamental difference between a company such as Polaroid and (to use two well-known examples) the old National Cash Register or the modern International Business Machines. The primary difference here is that the first company sells its product through retail outlets and the second two companies depend on direct sales. IBM's sales force is substantially larger than Polaroid's entire work force. And, traditionally, a salesman is evaluated on one factor and one factor only—dollar revenues. They are employed solely to make numbers for the firm. And in this pursuit they are continually prodded, robbing them of

real personal dignity. All types of motivation are provided, from Lombardi's hackneyed sloganeering to equating the growth of the company with national Manifest Destiny. And I do not mean to single out IBM. It is not the worst offender.

Polaroid, at least prior to the SX-70 days, depended on a different sort of prodding. One ultimately has to wonder how much of the Polaroid researchers' motivation was provided by the model of Land's scientific genius, and how much simply by his unending enthusiasm. It created at Polaroid an attitude of personal confidence and group confidence, and a related lack of concern with outside competition, even from Kodak. Even today, with Kodak competing head to head in the instant-picture market and Land separated from the rank and file by several layers of management, the effect of Land's personal confidence remains. One wonders if it can last beyond him, the man Kodak executives refer to as "Mr. Polaroid."

This emphasis on the individual—from the company's being personified as one man to the concern for each employee—attaches a particular sort of character to Polaroid as a place to work. Polaroid is a company in the innovation business, so it cannot afford to be too dogmatic; otherwise the employees will lose their initiative to question, wonder and be skeptical. However, there are a few commonly held basic beliefs: There is general faith in the wisdom of Dr. Land, in the good of instant photography, and in the powers and wonders of the SX-70 system. Anyone not sharing in this state of mind "probably wouldn't be happy working here," according to a middle level employee.

Land hinted at this in a statement he made to *Business Week* magazine late in 1974: "I represent a framework of ideas. The men who have come with us know this framework and have chosen to live with it."

Land does want employees to understand his vision and see what he sees in the company and its products. As a result, seminars are frequently being offered explaining to employees how the cameras and film function, and how they can

be most effectively used. The company wants everyone to understand the totality of the Polaroid Experience.

This attitude extends somewhat into the business and financial realms of the company. An unusually high number of employees own Polaroid stock, so the corporation's finanical prospects are a continual topic of conversation. At the stock's lowest selling point in the mid-1970s, hundreds of employees went to the Polaroid credit union to borrow money to buy stock, sharing Dr. Land's faith that renewed prosperity was just around the corner. Shareholding employees, who therefore seem to feel as if they are in part working for themselves, are given time off to attend the annual meeting.

The personal control and enthusiasm Land generates does have its interesting anecdotes. During the research-and-development drive on the SX-70, Land took a photograph with a prototype camera of an employee wearing a distinctively colored shirt. When the picture developed, Land was not happy with the color hues, so he asked the man for his shirt so he could continue experimenting with the camera until he got the colors right. The employee willingly surrendered his garment. At Polaroid, one doesn't deny Dr. Land.

Another story has it that Land arrived at a Polaroid lab one day without his ID card. A newly hired building guard stationed there, who did not recognize him, refused to let him in. Exasperated, Land called over a female employee and asked her to tell the guard who he was. Without blinking, the woman announced that she had never seen him before in her life. After the problem was eventually cleared up, Land reportedly enjoyed recounting the incident. The epilogue to this anecdote, sadly, is unavailable: And that is whether the guard was commended or fired for his stand.

Land has tried to make Polaroid into a microcosm of what he feels society at large should be. Few people are able to put their impress on as large an organization as Polaroid. But it is tempting to speculate that, to Land, the company is just a laboratory test, setting up the "larger experiment."

When he speaks of the work environment, mention of product at all is often completely absent from his pronouncements. The work itself is what he stresses: "It is a wonderful phenomenon to see people serving a cause and working together to share a task. It is only through a unifying purpose that interpersonal aggressiveness and destructiveness can be subordinated."

When Land does speak of product in relation to job, it is often in the philosophical sense of goal or mission. In December of 1958, as Polaroid was nearing its 10th anniversary in the instant-picture business, Land called his associates together to tell them formally of his hopes. The meeting was reported by *Fortune* magazine, from which is quoted:

I think we are going to be magnificently successful and in a very short time . . . [but] if after we succeed in just doing that, we are just another large company, we will have contributed further to the hazard of the degradation of American culture.

[The proper role of industry] is to make a new kind of product—something people have not thought of as a product at all. When you've reached a standard of living high enough for most people, where do you turn next? It seems to me there is only one place to turn. Industry should address itself now to the production of a worthwhile, highly rewarding, highly creative, inspiring daily job for every one of a hundred million Americans."

At a company Christmas party a few days later, Land took his message directly to his employees:

What we are after in America is an industrial society where a person maintains at work the full dignity that he has at home. Now I don't mean anything silly—I don't mean you're all going to be happy. You'll be unhappy—but in new, exciting, and important ways. You'll fix that by doing something worthwhile, and then you'll be happy for a few hours. Alternately happy and unhappy, you will build something new, just as you do at home in the family.

So this was Land's goal, an ideal more than a reality, but an ideal that he made sure the company actively pursued. But along with this, it would be foolish to deny that there are inherent problems connected with personal satisfaction and fulfillment in certain jobs in any corporation, regardless of the level of enlightenment of the leader. And it is nearly as sure as a mathematical theorem that the larger the corporation, the greater and more far-reaching the problems will be. As a practitioner of the new technology, Land has tried to use automation to keep dull, repetitive jobs to a minimum. But when there are five or six large factories and warehouses to staff, large numbers of employees are going to fall short of Land's expressed objective of each person "creating" a job for himself. Company spokesman Donald Dery admits that Polaroid has not been entirely successful in eliminating "boring, dead-end level jobs." It is doubtful that Land or his followers will ever be able to completely eliminate "boring, dead-end level jobs," and even in his moments of soaring idealism, he must realize this. But Polaroid has, at the same time, instituted a number of programs with just such an aim.

These programs have taken several forms. In the early 1970s, after the burgeoning of the work force for the SX-70, Polaroid eliminated the time clock for blue-collar workers in an attempt to diminish the distinction between them and their white-collar counterparts. Extensive educational opportunites are offered both inside the company and at area universities, for which Polaroid picks up the full tab. And throughout Polaroid, there is a policy of "career exposure" that allows employees to "try out" other jobs they think they might find more satisfying. Upward job mobility is an important concept at Polaroid, and because of this, more often a reality than at almost any other corporation of its size.

Under one program known as Pathfinder (another example of Polaroid's recycling of favorite names), blue-collar workers were allowed to divide their workday for a period of time between assembly-line duties and a research—or other

type—apprenticeship. The employee made a bid to work in another area for 90 days. He was paid for his old job and guaranteed that he could return to it. Company officials admit that the program would not be as practical today as when Polaroid was small. Because of the size and complexity of the corporation, the Pathfinder program met with only limited success in placing people in new positions. The standard educational avenues have been more successful. Some might refer to Pathfinder as a token program of the past. But it can also be looked on as a symbol of the general attitude Land and Polaroid management have toward individual employee satisfaction.

Even before the SX-70 gear-up, Land believed in a strong relationship between the lab and the factory, and in a gesture reminiscent of Chairman Mao sending the intellectuals into the rice fields for two weeks a year, Land has sometimes had research people spend time operating machines. He feels that they will have a better understanding of their own theoretical work by being exposed to the intricacies of production. In Land's unified vision, one is the continuation of the other. And it has been reported that when the actual machinery for the production of SX-70 components was being designed, Land, along with William McCune, had a hand in the specific designs. From these experiences on the factory floor, it is not completely unheard of for a researcher to come back with a promising candidate, who will then be taught scientific techniques on the job.

But resistance from within the company can contribute to the slowing down of innovative working practices. During the early stages of Pronto (a nonfolding camera using SX-70 film) manufacturing, about 400 people were needed during the summer months for a third, or overnight, shift. It was decided that a lottery would be held for the jobs, and any high-school- or college-aged child of a Polaroid employee would be eligible. "They loved the jobs because they could work all night and then lie on the beach all day," one observer reported. "They were smart kids and highly produc-

tive. The biggest problem on the shift was which radio station to listen to."

But the experiment was not tried again for a number of years. "We didn't do it again because we ended up taking so much shit from a small number of people who thought it was unfair that these kids were getting third shift premium pay when there were other people in the company who'd been around for five years and had never gotten it."

Unlike many companies, Polaroid neither prohibits nor discourages two members of the same family from working there. Actually, it tends to extend the company's control and enforces its penchant for secrecy. One rationale is that you're going to talk to your spouse about your job anyway, so he or she might as well be a "company man," too. Family is a potent image at Polaroid, as one might expect at a place whose leader places such a premium on living and working together in harmony. Anyone who has fully accepted the Land doctrine has been—in the company's unofficial parlance—"polarized," and becomes a member of the extended Polarized Family. The irony, of course, is that here the term takes on exactly the opposite meaning from its common—or scientific—usage.

Polaroid has decided against consolidating all Boston-area facilities into one giant industrial complex, and prefers to locate plants and warehouses in the nearby towns of Needham, Waltham, New Bedford, and Norwood. One explanation is the company's desire to keep things on a more human and manageable scale. At any one decentralized facility, the average worker has a much better chance of feeling an integral part of what is happening than he would working in one unit of a giant industrial sprawl. The dispersal of company outlets throughout eastern Massachusetts also raises Polaroid's profile and presence in each community in a way one central Cambridge facility could not.

In line with the concept of family, no segment of Polaroid employees has ever been unionized. Votes have been taken from time to time, but there has never been

enough interest to sustain one. Though it would be impossi-
ble to prove, it seems likely that Land would consider a union
as an impediment to productive management-employee
relations. It is doubtful that he is against the trade union
movement in general—that would recall too closely the days
of Andrew Carnegie and George Pullman—but, rather, that
they are not needed at a place like Polaroid. After all, he
might say, does a family need a union?

This style of benevolent corporate patriarchy is currently
as much out of the mainstream as is the depth and scope of
Edwin Land's corporate leadership. But Land feels that if
workers and managers treat each other with mutual deference
and respect, it is the most personal system. The pay at
Polaroid is good. The company's policy is to keep wage rates
between 2 and 5 percent above other industrial companies in
the Boston area. Profit-sharing averages 15 percent of salary
for everyone with 3 years in the company. When all types of
raises were suspended during the hard times of January, 1975,
company officials took pains to assure employees that every-
one in the organization would be tightening belts equally,
and that with the expected cooperation it would not be too
long before they could be reinstated. With the marketing
success of the various SX-70 cameras, it has happened.

Many company problems are handled through the com-
mittee system, a tradition that affords anyone interested the
opportunity to participate, and leaves the rest alone. At
Polaroid, *ad hoc* committees come and go with great
regularity. They form when a specific issue needs addressing
and go out of existence when no longer needed. Occasionally,
they continue to exist on their own momentum, long after
their usefulness has been served. Donald Dery has made the
following comments:

We're not big on committees per se. We are big on participation
and in that sense committees are good. They can also slow things
down and it can take an eternity before a decision is made. An
employee committee can decide on van pooling and there aren't

any marketing consequences to the committee dragging its feet. But we can't afford to lose that kind of time on business decisions.

The individual employee is respected in other ways. Polaroid reserves space in private day-care centers, which is apportioned to employees on a need basis. There is an income cutoff, above which employees are not eligible. Polaroid also maintains a professionally staffed full-time counseling service available to any employee at any time. There is a rigid stipulation that the members of this service do not report back to anyone, inside the company or out, and all meetings are totally confidential.

The Polaroid Newsletter, which comes out about once a month, is more than an internal house P.R. organ. (It is, of course, that as well.) Aside from Polaroid business news, company sports team schedules, classified ads, and news about benefits, there is a particularly interesting feature called "Interact," through which employees can ask questions anonymously and have them answered by company officials. It is not unheard of for these officials to answer by saying, "I don't know," or "We really don't have a policy on that." "Interact" question forms are available in building lobbies throughout the corporation. The column prints only a respresentative sampling of "Interact" questions; answers to the others are mailed to the questioner's home with guaranteed confidentiality.

Confidentiality figured in a significant hiring experiment at Polaroid. For a long time, in keeping with the company's policy of being an active force in the community, Polaroid has been hiring hard-to-employ people, including, to date, close to 200 former convicts. But neither the public relations nor the community relations office would give out any extensive information on the program to the local or national media. It is the company's policy that the dignity and privacy of these employees must be maintained, and will not single them out.

This policy of confidentiality is practical as well as ethical. And like scientific investigation, it is at least partially built on

the mistakes of the past. When the first former convicts were hired a number of years ago, Polaroid management thought it wise to let the employee population know what it was doing. But as soon as the former convicts were on board, internal theft of cameras and lab equipment jumped by more than 50 percent. Apparently, the presence of the ex-convicts was being used as a screen, and the veteran employees figured that they would be the prime suspects.

Throughout Polaroid's major growth period, Land continued to be concerned with the preservation of individual opinion. During 1970, before the South African confrontation flared up, a number of employees were deeply opposed to the Nixon administration's conduct in Southeast Asia. Some people approached Land directly and asked him to make a statement in Polaroid's name condemning the war. He hesitated, feeling that he had no right to speak for several thousand people, whose opinions he was not familiar with.

But after the deplorable "incursion" into Cambodia and the killing of the four students at Kent State University, Land invited Polaroid employees to send messages of their own choosing in telegram form to President Nixon at company expense. His memo of May 8, 1970, circulated company-wide, read, in part, as follows:

> Believing as we do that this is a time for vigorous political participation by individuals in the democratic process, the company has undertaken to cover the cost of a telegram to be sent to the President, your Senator or Representative, or any other member of the Congress with whatever argument, point of view, or comment you want to have heard.

Approximately 2500 people took advantage of Land's offer. No record was kept of the sentiments expressed in any of the telegrams.

Today, Polaroid is too large for Land to manage personally in the style he preferred for so many years. Because of the company's size, his own priorities, and his age, Land seldom tours the facilities any more, and as one associate puts

it, "it's a shame." Today, he says, "the average employee will never see Land and wouldn't know him if they stepped on his foot." Large-scale manufacturing has placed new restrictions on the individual flexibility of certain sections of the Polaroid work force. To avoid massive unfillable absenses from key points in the manufacturing process, the industrial part of the company shuts down for two weeks each summer, around the end of July. Most manufacturing people have to take vacations at this time. (Workers begin at the company with two weeks' paid vacation a year.)

There is also an even greater concern with security at the company. Traditionally, Land's institutionalized propensity for security has often led to communications problems, such as when two departments working on different aspects of the same project could not prove a "need to know" to each other. Code numbers are used to label bottles of most chemical formulas, instead of names, and signs throughout the company challenge, "Do you have clearance for this area?", and offer similar warnings.

As with most other aspects of corporate endeavor, Land's workers mirror him and his personal wishes in the fields of security and control. Nearly every employee I contacted in researching this book was at first extremely reserved—even the ones who did agree to speak to me. And most wanted to know right off whether or not Dr. Land was working directly with me on the project. One asked who at Polaroid had given me permission to write about the company.

Polaroid is far from a perfect company, but it is a place where the challenges are continually being faced up to. The challenges differ with size and era, and of course the greatest ones occur when times are not good. Polaroid's most recent "bad time" coincided with the national recession. In true form, Land saw it as one more opportunity, echoing sentiments he had expressed years before:

During prosperity the challenge is simply to make worthwhile products and to keep yourself busy. But during depressions, the challenge is to create new fields to make work for people who need

it. That lets the scientist and the engineer feel that he is working for his country as well as for himself.

In Land's view, everything is interrelated, and what can be accomplished in the laboratory or on the drafting table can also be attempted in the society of men and women. As the company's scientific and technical endeavors become more advanced, its relation to people becomes more complex and delicate. The needs of each side—the technological and the human—are often mutually exclusive. But at Polaroid one struggle has not been forfeited in favor of the other.

Setbacks

One professional scientist, who had been observing the development of the SX-70 system, thought it represented some brilliant technical achievements. But he had some reservations as well: "Two of the things the camera had going for it were the lens and the film. No one had ever attempted that ambitious a consumer device. Those two refinements alone would have been enough. Then the playing around started."

Land had decided that for his new camera to fulfill his own requirements, the user must not have to worry about the instrument's power source. Dead batteries, causing nonfunction of electric-eye shutters, are traditionally one of the primary causes of bad photographs. And since not only the SX-70's shutter, but its mirrors, film-advance system, and flash sequencer were all electronically controlled, a battery failure would be devastating. Also, nothing makes a camera enthusiast lose that enthusiasm as instantly as a Land picture develops as being all set to take a picture, having three or four packs of film ready, and having the battery conk out in the middle of the Grand Canyon.

The solution to Land was clear. To prevent all of this, the

battery must be in the film pack itself, which means a fresh power supply would be introduced after every 10 pictures. The *way* to go about it was not so obvious. Again, Edwin Land started with the requirements, with the idea of inventing something to fill them. The battery would have to supply 6 volts of power at intervals of less than 2 seconds over a possible temperature range of nearly 100 degrees. And to fit into the film pack, it would have to be nearly flat.

By 1968 these details had all been worked out, and Polaroid went with them to a number of battery manufacturers, and contracted the primary development out to ESB, Inc., of Philadelphia, maker of the Ray-O-Vac battery line. The battery project faced enormous challenges right from the beginning. The 19 layers of metal and plastic had to be bound and sealed to extremely small tolerances, and in incredible quantities. No one had any experience in this type of battery production. Though the company had essentially to start from scratch, going back through all of the scientific and technical literature on battery construction, Land maintains that this was not a factor holding up the SX-70 production schedule. Recently William McCune commented, "Not a single day was lost in SX-70 production because of the battery."

Leakage became a sizable problem. But an even larger problem was that the batteries had an unpredictable effective life, sometimes as short as a couple of months. So by the time a battery was manufactured, shipped to Polaroid, inserted in the film pack, and the film pack shipped to the retailer and eventually sold to a customer, there was often very little time during which it could be used before the pack's battery would be dead. In the first several months of SX-70 distribution, film pack returns caused by dead batteries were staggering.

There had been extended discussion within Polaroid's upper research-and-development levels about scrapping the idea of integrating the battery with the film pack in favor of the normal battery in the camera. But Land was adamant that the SX-70 user should not have to replace his own batteries. This added one more complication to a project

that already had attached to it a nearly limitless set of both requirements and variables.

The wafer-thin battery has some interesting features of its own. In addition to fitting into the SX-70 film pack, it provides large surface areas and short pathway, permitting current to be drawn very rapidly in a high-demand situation like the camera operation. Polaroid has disclosed a number of functions that can be performed by the flat battery in addition to the camera operation involving the taking of 10 pictures, with or without flash. Automatic focusing using ultrasonic echo ranging in the new family of SX-70 cameras, the Sonar One-Step series, is powered entirely by the battery. The battery itself can be further utilized once the film has been used. One patent describes a slim flashlight powered by the "empty" film pack, and enterprising people have explored such applications as the operation of electric trains. Two of the 6-volt batteries connected in series have even been shown capable of booster-starting an automobile that has a near-dead standard 12-volt battery. Polaroid has not, however, begun selling the batteries as a separate product, nor used them commercially for any function other than SX-70 camera power.

For much of the SX-70 development, the shutter mechanism presented an equally arduous challenge. Unlike previous Land cameras, the SX-70 was designed to combine electronic control of shutter speed (the time during which the film is actually exposed) and aperture (how wide the lens is opened—that is, how much light is allowed in). This was a complex problem, even with the advances in electronic miniaturization. The designers at Fairchild Camera were unsure that an integrated circuit of the sophistication required could be economically produced for the space allotted to it in the camera design. The way the operational amplifier, which ran the shutter, was formed sent the costs soaring. At one point Polaroid was paying its vendors between $25 and $30 apiece for the shutter components alone! With that kind of cost factor and the misstarts plaguing the other areas of development and production,

turning a profit would have been almost out of the question.

Both Fairchild and Texas Instruments had been contracted to produce the electronic shutter module, with Fairchild supplying all of the initial units and Texas Instruments scheduled to begin work with its own design several months later. But after Fairchild was unable to come up with a cheaper or more efficient way of layer-forming the resistors involved in the operational amplifier, Polaroid and Fairchild broke off their agreement, and all of the shutter work reverted to Texas Instruments. The shutter module design it eventually came up with was simpler and more economical, and the Texas company was able to turn out the components at a fast enough rate to meet Polaroid's production needs. All in all, however, the shift of vendors and the delay until Texas Instruments could come up with the proper design cost Polaroid several months of profits and public confidence at an extremely crucial period.

Those in charge of the shutter problem at Polaroid apparently had little inkling of the seriousness of the situation until it was nearly too late, and for an even longer time they reportedly refused to apprise Land. Consequently, bringing the cost of the shutter module down to a manageable $6 looked to some more like a salvage operation than a systematic scientific research project. In effect, the SX-70 was the first project too expansive for Land to manage himself. It was, as he had said himself, a fundamental restatement of photography, requiring numerous totally original inventions, all of which had to mesh. Each crisis requiring either Land's or McCune's attention took them away from every other crisis. When Polacolor had been introduced in 1963, Land had said, "Everything we undertake must be important and nearly impossible." With the SX-70 he was coming close to overstepping his statement.

Or so it appeared. There was (and is) in the SX-70 R&D situation a fundamental difference in outlook between the observers and the insiders during the period. As Land himself saw it, "To someone who doesn't understand these things or who has a non-facile scientific mind, or not a good engineer-

ing mind, each of [the] incidents [was] a source of personal insecurity. No incident whatsoever occurred in the course of SX-70 that was anything but a delight, like getting your horse to jump a higher hurdle. We're good riders and we have good horses and we like jumping."

Land felt no personal insecurity, it seems, because he felt he had already worked out the details in his mind. He had dealt with the skeptics in his own company at the very beginning of the project. But before that, even, he had kept them away long enough to convince himself of the practicability of his dream.

William McCune said as much in a statement he subsequently made to *Fortune* in 1974: "One thing about Land—when he is doing something wild and risky, he is careful to insulate himself from anyone who's critical. It's very easy in the early stages to have a dream exploded." If you expect to work with Land, you have to keep the faith.

Introduction

Edwin Land likes to apprise those present of the full significance of each new invention. At the 1972 annual meeting at the Needham Distribution Center, he got right to the point.

"Photography," he announced, "will never be the same."

Land referred to the color—with his usual gift for understatement—as "astounding, having qualities for which we have no names."

Shareholders were permitted to walk along 12 displays set up throughout the warehouse where the multiple purposes and applications of the SX-70 were demonstrated. Not only were the typical home and travel uses included, but laboratory and commercial possibilities as well. Prior to that, Land had held up an SX-70 and shot off five pictures in less than 10 seconds, to the amazed approval of the 3000 guests.

On that same April 25, Eastman Kodak's annual meeting in Flemington, New Jersey, held out the promise of film for Polaroid cameras and its own self-developing system. Kodak President Gerald B. Zornow referred to this possibility as "the result of independent Kodak research," and that "the agreements negotiated with Polaroid in 1969 aren't applicable in any way." In retrospect, it was the opening shot of the fiercest phase of competition between the two companies.

For many months prior to the 1972 meeting, the press had taken to calling the SX-70 the Aladdin, after the remark Land had made about Aladdin never dreaming of it in his most intoxicated moments. It was assumed that this would remain as the product's trade name. But as Senior Vice President Peter Wensberg explained in the Polaroid newsletter,

SX-70 was a code designation used in the early days of Polaroid's photographic development work. It was later revived as a code name, for internal use, for the new camera and film system being developed in the late '60's and early '70's. When we were searching for a public name for the system in 1972, it seemed a natural choice to continue with the internal code name.

Because of Polaroid's carefully orchestrated campaign of alternately revealing and holding back, by the time of its public release the SX-70 was among the most keenly anticipated consumer products of all time. At the 1971 annual meeting, Land had tantalized the audience and press by plucking an SX-70 prototype from his pocket, but then replacing it there without taking any pictures. And from the photographic and technical publications of those months, it becomes obvious that the editors had discerned no clear picture of the process from Patent Office searches. Even after the 1972 meeting, at which the camera was first publicly clicked, Polaroid would not announce any plan for national distribution. This was less a case of trying to build anticipa-

tion than acknowledging that production had not been regularized to the point of normal predictability. Many of the facilities were operating at less than 40 percent of capacity, nor had they yet been effectively coordinated with each other.

The SX-70 Land Camera was formally introduced to the public on the evening of October 26, 1972. On the occasion, 1200 people gathered in the grand ballroom of Miami Beach's Fountainbleau Hotel. The debut was reminiscent of nothing so much as a 1930's Hollywood premier, with giant searchlights out front on Collins Avenue and a single-engine airplane pulling an SX-70 banner overhead.

"Everyone was fascinated," recalled a woman staying at the hotel at the time. "They had two young men and two young women who were taking everybody's picture. And then you watched it develop. We'd never seen anything like it. I went out to Nieman Marcus and bought one on the strength of that demonstration alone."

That demonstration, like all of Polaroid's consumer publicity, was professionally executed for maximum effect. Lighting was absolutely balanced to avoid the harsh shadows so potentially unflattering to the largely upper-middle-aged Fountainbleau clientele, and the photographs were taken against a bright orange background, which beautifully highlighted the vividness of the color. In an expensive consumer product of this nature, first impressions are critical. And since this group of people would be expected to talk up the camera to their neighbors once they got back home from vacation, Polaroid was leaving nothing to chance.

In a further Hollywood touch, Polaroid's Dealer Partnership Program offered year-end cash bonuses to retailers if the company met its sales goals, which were stored in a sealed envelope in a safe in the office of Polaroid's certified public accountants, Peat Marwick Mitchell and Company.

As usual, Polaroid limited allocations to its Florida dealers—only this time to a greater extent than ever before, with each dealer initially receiving only four cameras. It was

reliably reported that many of the original purchases were made by Kodak personnel, who were busy at the time reevaluating their licensing option to produce the Polaroid peel-apart film types.

Their examination of the SX-70 camera and new type of film was apparently sobering. Within a few days, Kodak suspended its plans to begin manufacturing the type of Polaroid film they figured would now begin a slow journey toward obsolescence. If Kodak wanted a bigger piece of the instant-picture action, it would have to begin competing on equal terms or, as Big Yellow's new president, Walter A. Fallon, put it, "We are unwilling to divert further effort and funds from the development of our own instant system into a secondary and more limited marketing opportunity."

Though Kodak waited until the SX-70 bowed in Florida to call a halt to their plans to produce peel-apart instant film, Kodak engineers in Rochester, England, and France had clearly been working on their own version of instant photography for at least a couple of years. Polaroid's decision to produce its own color negative almost forced them into it. Not only would Kodak lose the $50 million a year Polaroid had been paying them, but by cutting out the vendor payments Polaroid would eventually be able to lower its own costs on film to the point where it could either cut retail prices enough to give Kodak even more competition in the mass market, or—leaving prices as they were—squeeze enough additional profit out of film sales to afford more extensive marketing efforts. Either way, to hold onto its own share of the conventional market, Kodak had to give Polaroid a run for its money in the instant field. And as the Rochester men concluded after the night of October 26, this meant a generation of cameras to compete directly with the SX-70.

Nor was it simply a Polaroid-Kodak equation. Two weeks before the SX-70 unveiling, Berkey Photo, Inc., announced that its Keystone Division was ready to offer an instant camera of its own which had been in the works for 3 years. The site for this announcement was New York City's

Regency Hotel and the master of ceremonies for the occasion was the company's energetic president, Ben Berkey. He stated that the "60 Second Everflash" would accommodate three types of Polaroid peel-apart film and would come in two models, priced at $64.95 and $99.95.

Ben Berkey's own success story fits squarely into the annals of American entrepreneurial enterprising. He opened his first camera shop on New York's Lower East Side in the 1920s with a few hundred dollars he had borrowed from his mother. Less than 10 years later he opened Peerless Cameras, which eventually became Willoughby-Peerless, one of the largest retail camera stores in the world. He later began an extensive photo-processing business, and in 1966 acquired Keystone, a camera-manufacturing company. Berkey asserted that the Everflash, which featured a built-in flash mechanism, would not infringe on any of Polaroid's existing patents. Polaroid did not publicly dispute the claim, hoping the camera would not take business away from its own line and could, in fact, help increase the demand for the older types of Land film, which the company intended to continue producing indefinitely.

Polaroid's main thrust of the moment was to try to rush the SX-70 at least into some portions of the market in time for Christmas sales. Camera sales remain very seasonal, since a large percentage of all cameras are given as gifts. It is a general rule of thumb that if a camera company does not do well in November and December, it is not going to have a good year. But as it turned out, production could not be geared up enough to even move sales out of Florida during the fourth quarter of 1972. Reportedly, Land was not as perturbed about this development as were Polaroid's marketing people and the Wall Street contingent, who kept looking for signs of the company's new earnings potential. He had been sitting on the SX-70 project in one form or another for the better part of the decade, and was not about to let a distribution delay of several months throw him off.

He did not even display any noticeable signs of consternation when Polaroid failed to meet its 1973 sales goal by more

than half. In this first full year of production, the company had hoped to sell 1 million SX-70 units. Start-up and production problems, plus the looming recession, kept the actual figure down to 415,000.

One of the most significant roadblocks was still the battery. The exceptionally short battery life meant that production had to closely follow sales. Stockpiling of large quantities of film right off the assembly line for future selling was impossible since by the time it reached store shelves, the batteries could be dead. Therefore, plants could only produce as much film as could be sold in the next month or so, which meant that none of the plants was operating anywhere near maximum efficiency.

As a result, Polaroid found itself unexpectedly—and at first unwillingly—in the battery business. "We didn't intend to," William McCune declared shortly after the move was made. "We've been backed into it." Battery design and production, most experts seem to agree, is as much an art as a science, with fewer "guarantees" than most of the scientific disciplines. So the initial results do not always coincide with anticipated ones. And the flat, several-chambered battery needed for the SX-70 film pack was a revolutionary design, which no one had much experience with. After ESB and the other suppliers were unable to solve the problems of chemical leakage from one chamber to another and find the right combination of materials to assure charge retention for a period of longer than a few months, Polaroid tackled the problem with its own personnel. Months of trial and error, both with new materials and manufacturing techniques, plus an accumulation of new knowledge, eventually led to the design of a battery that remained active for up to 18 months. Today, Polaroid is, by volume, one of the largest battery producers in the country strictly on the basis of the flat Polapulse battery.

National distribution did not begin until the fourth quarter of 1973—about a year behind the target schedule—and then only on an allocated basis. By then, Executive Vice President William McCune admitted that Polaroid was still

losing money on each SX-70 camera and film pack sold. All but the staunchest supporters in the brokerage houses were putting out sell recommendations on Polaroid stock, their former darling.

Land continued to remain calm, if not serene. Neither the battery problem, nor the shutter problem, nor the production delays, nor any of the other holes springing in the dike could shake his faith—a faith in himself. The problems all involved details, and would be taken care of. He responded to predictions that the "details" would undo Polaroid with a characteristic remark: "Once you invent the wheel you've done the hard part, and figuring out how to attach it to an axle will come eventually."

"Wonderful Opportunities"

One of the things Polaroid has never been known for is its market research. Unlike other major producers of consumer products, Polaroid does not spend months gauging the existing market to see what it will bear. At Polaroid, the whole process is rather more intuitive, in keeping with the style of Land's personality. "Industry," he said, "must have an insight into what are the deep needs of people that they don't know they have."

Market research, Polaroid feels, is only valid as a method of delineating an existing market, which in most cases has little relevance to what the company is trying to do. According to the traditional method of market analysis, the SX-70 could not possibly have sold in numbers sufficient to cover Polaroid's expenses, much less make a profit. The logic goes something like this: In 1969—the peak year for camera sales in the United States—14 million cameras were sold. Only 1.7 million of these sold for $50 or more, and, of those, about 800,000 cost more than $100. About half of this figure was taken up by 35-mm sales. So the conventional wisdom

held that even in an exceptionally strong year, Polaroid had a market of only about 0.5 million to work with if it expected to sell the camera for over $100.

Land's entire thrust has been that the product creates the market, rather than the market dictating the product, and nearly each new entry in the Polaroid line has borne him out. It was one of the reasons that he could manage the terrific financial plunge into SX-70 development in the midst of abounding outside skepticism, and maintain the faith in the face of knee-buckling research-and-production delays. So it was with some degree of self- and group satisfaction that Land could announce at the 1974 annual meeting, "The SX-70 seems to be defying conventional marketing presuppositions, as we planned that it should."

He scoffed particularly at those critical of the selling price, seeing it himself in terms of human enjoyment and in light of the other things an average consumer spends money on. "We're trying to get $600 worth of camera to market in the $100 range," Land commented.

In a 1975 interview with Subrata Chakravarty of *Forbes*, he said, "It isn't much money. Consider what you get. When you are buying a car and the dealer asks if you'd like an AM/FM radio or an extra speaker, each of those random trivia costs more than our whole camera does. It is a terrific buy."

And when the SX-70 marketing effort went into high gear, Polaroid found some fairly sophisticated ways of getting the message across. Charles Eames, the Renaissance Man of modern media, was commisssioned to produce a 20-minute film detailing the SX-70's scientific functioning and humanistic uses. Eames, best known in most circles for his classic and often-copied rosewood and leather lounge chair, is this country's most prodigiously talented maker of industrial films, which he produces along with his wife Rae. His chief client in recent years has been IBM, for whom he has made a number of films explaining the computer. The Polaroid work also benefited from the input of Land's friend Philip Morrison, the celebrated physicist at MIT, and boasted a musical score by the prominent Hollywood composer, Elmer Bernstein. Of all the publicity that accompanied the SX-70,

the Eames film probably came closest to capturing Land's own enthusiasm for the technical and aesthetic creativity the camera engendered.

The personality chosen to be the first front man for SX-70 advertising was the Shakespearean actor and director of the British National Theatre, Lord Laurence Olivier, who fit in perfectly with the dignified, artistic image Polaroid wanted to project. Olivier's presence on the television screen conveyed this idea about the product: "This is no run-of-the-mill Tonight Show celebrity. We're very serious about this product."

This was the first time in his distinguished career that Olivier had agreed to do a commercial (for an estimated quarter-million dollars), but he declined to allow the ads to appear in his native England. In the mass marketing land of America, where even Eleanor Roosevelt was persuaded to do a margarine commercial, Olivier felt his image would not be damaged. Marketing Vice President Peter Wensberg, who was in charge of the $20-million first-year advertising budget, said, "How do you tell the world about what seems to be a miracle? We felt there was only one voice. This is the voice." However had Sir Laurence said no, they would have come up with another "voice," as they ultimately did in succeeding campaigns.

The next celebrity to represent the SX-70 was actress-photographer, sometime-journalist Candice Bergen. It is perhaps significant that Polaroid chose as a model and product pusher an actress such as Bergen. Of Ms. Bergen's physical attributes there can be no doubt, but she communicates also intelligence and creativity.

Most of the early SX-70 advertising reflected Polaroid's normally excessive enthusiasm, but the campaign occasionally took on a disturbing rhetorical indulgence with such claims as "photographs of such piercing beauty they seem more real than life." Asserting that pictures reproduce their subjects with astounding accuracy is one thing, but stating that they transcend the original and are somehow "better" than reality sabotages Polaroid's credibility.

Not everyone shared this passion. In the months after it came out, the SX-70 was subject to an onslaught of criticism from a diverse range of publications as *New Times* ("The SX-70: The monster that's devouring Polaroid") to *Physician's Lifestyle* ("Too much money for too little in the way of serious photography"). Though the specifics varied, the general complaint was the same: the camera was an awfully expensive bundle of space-age technology that offered insignificant improvement over previous Polaroid models; and, contrary to the company's advertisements, taking exceptional pictures was anything but foolproof.

And still the production delays continued.

Amidst the many start-up problems, rumors of internal dissension began to surface when Louis D. Scott, vice president of the film manufacturing division and a key manager on the SX-70 project, resigned. Scott had been responsible for designing the SX-70 film assembly line. The indication was that Scott, who had come to Polaroid from Monsanto in 1967, had been engaged in a serious personality clash with Senior Vice President and General Manager Thomas H. Wyman. Wyman, generally considered to be Land's heir apparent, was not a good person to tangle with. Unlike the normal corporate procedure of never resigning until another job is in the offing, Scott broke with Polaroid several months before he was offered a similar post with Combustion Engineering, Inc., of Stamford, Connecticut.

Dissension of this sort under the crunch of the SX-70 program was not unexpected. One Polaroid employee commented on those times: "When a company gets this big, you look for things like that to happen."

Throughout the low points of 1974 and 1975, Land continued to proclaim his company's health. "What problems?" he asked in a *Forbes* interview. "Those problems are largely problems in the press." He also insisted on turning the SX-70 start-up difficulties into experimental plusses: "I think the battery saved us, because without the troubles with it, we would have been spoiled and we would have been growing too fast. It was a happy accident, a cloud with a very silver

lining." There are no problems at Polaroid, only wonderful opportunities.

Land's comments, published as they were in a business publication, were aimed as much as anything at keeping the financial community loyal. Financial analysts tend to be most easily upset and thrown off by surface conditions or trends, which may contradict time-tested traditions. The beginning of the SX-70 experience was clearly a period for trepidation. Every time Wall Streeters have become itchy over Polaroid stock, the company has mounted a spectacle, which included Dr. Land's magic acts at the annual meetings, often in connection with products Polaroid did not set about marketing for 5 or more years. The technological spectacle itself was important.

So, on February 16, 1973, the company invited 140 financial analysts to its recently completed New Bedford film plant—a nearly unprecedented move since Polaroid does not often let outsiders in on any production specifics. That afternoon, when the analysts were finally allowed access to telephones, the stock gained six points. The control and secrecy Polaroid exercises so judiciously obviously has another purpose beside safeguarding its resources. The company executives do not want to dissipate the power they have over affecting the exclusivity of their products by permitting open access to facilities and Dr. Land. Polaroid prefers to orchestrate it own publicity, and thus have a reasonable idea of its eventual effect on the market.

In July 1974, Thomas Wyman went before a group of securities analysts and reporters to explain the continuing decline despite predictions to the contrary. "All the surprises were on the downside," he told them, explaining that the majority of the losses were still attributable to SX-70 cameras and film. He also cited the 6-month shelf-life of the film battery, which kept dealer orders fluctuating substantially and production schedules erratic. In the second quarter of 1974 alone, Polaroid had to take back about 300,000 defective film packs.

In September 1974, Polaroid came out with SX-70 Model

2, which was the same camera packaged in cheaper materials (plastic and vinyl instead of chrome-plastic and leather) and featuring a $30 lower list price. This was the beginning of Polaroid's long-range strategy of using the original SX-70 as the bellwether of the new generation, and then coming out with an expanding product line of SX-70 type cameras, with the line expanding downward in price. Eventually, if the line was to be profitable, Polaroid planners figured, it had to be able to compete directly with Kodak the way Colorpacks of the 1960s did.

But Polaroid sales continued to plunge throughout 1974 as a result of the twin kick of the SX-70 challenge and the economic recession. And in August the company announced that it would have to lay off workers, a severe blow to corporate morale and the general atmosphere of optimism Land normally generated. By November, a thousand workers had been laid off out of a force of about 11,700. And on January 8, 1975, Wyman announced that normal pay increases would be deferred to "conserve our resources to ensure our success when these difficult economic times are behind us." With that announcement, the stock dropped another $1.50 to $16.00.

At about the same time, Corning Glass Works decided to halt production of SX-70 lenses because of insufficient volume from Polaroid to keep the operation profitable. A Corning spokesman told the *Wall Street Journal*, "This is just a story of a product that didn't do too well in the marketplace. From what I read, it seems that they [SX-70's] were a great disappointment for Polaroid—and, as a consequence, a great disappointment to Corning and other suppliers." At least two other vendors followed suit and cancelled their SX-70 component contracts with Polaroid. The trend of 1975 duplicated that of the previous year. The first-quarter earnings were down 17 percent from the already meager 1974 first quarter, threatening to produce the first deficit year for the corporation since the introduction of the original instant camera.

Though the SX-70 was the apple of Land's eye and the

Great Hope for the future of the company, Polaroid did not divert its collective attention from other photographic products. Type 105 P/N film was introduced early in 1974. This 3¼-by-4¼ black-and-white peel-apart film rendered a print and a usable negative after the 30-second development period. It was rated at ASA 75, which was substantially slower than the 3000-speed black-and-white Land films.

Another project that had been the subject of extensive research but little publicity was instant movies, which Land had conceived of as long ago as 1947. But to add to the reverses of 1974, Bell & Howell pulled out of its arrangement with Polaroid to make the equipment for instant movies. Polaroid immediately cast about looking for another vendor, while privately acknowledging that the Bell & Howell move set back the movie introduction by at least a year.

In deciding what to do to stem what they perceived to be a still-temporary financial and production squeeze, Peter Wensberg and the other Polaroid marketing executives seemed to take a page out of the mass merchandising playbook of the late 1960s and attempt another decisive plunge into the inexpensive end of the market. Kodak Instamatics (which were simple, but were not instant) were still selling phenomenally, and Polaroid saw reasons to aim a portion of its sales efforts in that direction.

"Zip" was something of a replay of Swinger. When it was introduced late in 1974, Zip was the lowest-priced Land camera ever marketed, listing at $13.95 and discounted to around $10. It used only the cheapest square Type 87 black-and-white peel-apart film. The target audience was from 8 to 18 years of age, but they had grown considerably more sophisticated than their counterparts of several years earlier. With no color capacity, the Zip, which was manufactured for Polaroid by U.S. Time in Arkansas, did not sell even moderately well.

The marketing people had a problem. But in keeping with Land's dictates, before they could solve the problem they had to be able to state it. Polaroid has traditionally considered market research something to be done by com-

panies without exciting products to sell. Then again, the black-and-white Zip was not generating any tremendous wave of enthusiasm among adolescents. So Polaroid commissioned a survey by Trendex Corporation to find out exactly what those adolescents were looking for in a camera. The survey turned up the not-surprising fact, among others, that about 85 percent of them wanted color.

No drastic new design changes would be possible in the Zip, which had been selling well in the less affluent European market for a couple of years, if the price was going to remain at around $20. If it went much higher, there really would be no point in marketing the camera at all. But an accommodation of the inexpensive Type 88 color film, as well as an electric eye (one of the components with which Polaroid has led the industry) would be manageable. Would this be enough, though? After the dismal reception of the original Zip, the marketing people were not sure. And the last thing they wanted to do was to go back to Land—who was already spending 18 hours a day trying to pull the SX-70 effort back together—with another failure.

What, without adding to its cost, would make the new Zip distinctive enough to make kids want to own it? The answer turned out to be a single word—and the same word that came thundering back from the Trendex survey—*color!* Instead of the traditional black, the Zip would be sold in a bright-colored case, which would instantly suggest the fun of taking inexpensive Polaroid pictures.

Again Polaroid turned to market research, this time at shopping centers and department stores in the Boston area. The colors chosen for the sampling were the big three: red, white, and blue. After talking to over 1000 people, the pollsters found that 50 percent preferred blue, 30 percent liked red, and 20 percent favored a white camera. So the order went out to the factory in Arkansas that half the cameras coming off the assembly line would be blue, 30 percent red, and the remainder white. And the high-impact plastic the bodies were made from meant they could take a fair pounding before showing signs of stress, a prerequisite in

a camera earmarked for a sub-adult market. (Polaroid employs a device known as the "destruction machine," which drops packaged and unpackaged cameras from a variety of heights to test their ability to "take it.") The camera, renamed the Electric Zip, ended up selling for $21.95 retail, which is exactly the price the surveys said that the traffic would bear.

The advertising campaign was weighted heavily toward television and radio, and only on programs watched and listened to predominantly by children and teenagers. Sales were aimed almost exclusively at drug, department, and discount stores; Polaroid people figured there would be virtually no market for the camera in photographic specialty shops.

At Polaroid's July 1975 sales meeting in Durango, Colorado, Electric Zips and unlimited supplies of film were distributed to 130 children between the target ages of 8 and 18. They were turned loose to snap to their hearts' content all around the city, and came back that evening with more than 5000 pictures. This conjures up the rather unnerving image of scores of junior *papparazzi* jumping out from behind bushes to catch lovers in a passionate embrace.

The Electric Zip, with research-and-development costs long behind it, did begin to turn Polaroid earnings around, and offset some of the losses racked up by the SX-70, which by 1974 had cut net earnings to a paltry 3.7 percent of sales. The Zip gave the company a financial breather until it could get the campaign for the new generation of cameras in order. In line with the long-time company policy, the more than half-billion dollars of SX-70 research-and-development costs and plant construction were written off as they were incurred, so the management could now see smoother sailing ahead. And despite all of the death knells sounded in the press and the financial community during the early days of the new camera, and with the consumer economy beginning its upturn, Polaroid executives started seeing the company once again approaching a favorable period.

What the outside observers had perceived as fatal prob-

lems were actually the start-up challenges attending any new product or technology. The challenges were greater than they had ever been for previous Polaroid efforts, and they were more widespread because of the scope of the project. But Land knew that any problem that could be stated could be solved. Once the technology had been developed, Land knew, time would be on his side.

After several years of frantic shuttling between project management and marketing duties, Land could finally sit back and begin doing more of the types of things he liked best.

Upturn

The topic of succession always occasions avid speculation, whether in government or a large corporation. It was a particularly intriguing one at Polaroid, where Edwin Land has held the titles of chairman (chief executive officer), president (chief operating officer), and director of research since the company was founded. His personal stamp had gone on every major decision and product to emerge from the corporation for nearly four decades. No matter what went on in the company, he had something to do with it, and Polaroid's prime focus of attention was whatever Land happened to be most enthusiastic about at the moment. Since Polaroid's founding, Land's brain had been considered the corporation's chief asset. But with Land approaching his middle 60s, a passing of at least some of his torches could not be too far off.

It is difficult for a man who is used to total control to relinquish any of it, most observers would admit, but the annals of American business are full of stories of what happens when corporate patriarchs hang around too long. The mighty Ford Motor Company came close to catastrophe

when the elder Henry refused to step aside, first in favor of his son Edsel and then his grandson, Henry II.

Land has two daughters—neither involved in the company—and no sons, so a familial succession was out of the question. Besides, a man who has subscribed to the type of individual-oriented philosophy Land has would certainly not entrust his lifelong creation to another man or woman strictly on the basis of bloodline.

The first move in Land's acknowledgement of inexorable fact was a surprise to most outsiders and many insiders. To them, the heir apparent was 45-year-old Thomas Wyman, who had been the most visible and vocal of all the Land generals and who had cut an impressive figure through his skillful crisis-management during the South Africa confrontation. Marketing chief Peter Wensberg and head of the international division, Richard W. Young, were both considered outside bets.

But in January 1975, with the full returns not yet in on the SX-70, and the company's immediate future very much in doubt, Land "abdicated" as president of Polaroid and named William McCune to replace him. One of McCune's first official public acts was to announce the 1974 fourth-quarter figures, which were worse than even most of the skeptics had expected.

Though the 59-year-old McCune did not appear to be as inspired by a scientific vision as Land, his appointment should not have been the surprise it was. McCune had been with Land since the company was 2 years old and was the executive vice president. When Land came up with a new invention, McCune had been the one who followed up by building it. With Polaroid's future obviously dependent on the success of the foray into manufacturing heralded by the SX-70, a man of McCune's background was clearly needed. Those who know him claim that McCune is analytical, hard-working, and hard-driving without being compulsive about it. He is reputed to be more down to earth than Land, who has been known to give directions in such philosophical terms that subordinates often came away not

quite knowing what it was he wanted. McCune is always more direct.

With the SX-70 in production and the company's general course set for the next several years, Land apparently felt it was time to give up his administrative title. Certainly his age—65—played a role in the decision. But probably even more significant was his realization that the SX-70 experience had so enlarged the company, and the entry into major manufacturing so changed its character, that he could no longer effectively run it on a day-to-day basis while continuing with long-range decision-making of both a corporate and research sort, and keep up his scientific work all at the same time. Of his three roles, that of administrator was least dear to his heart, and he had many things in his mind left to do in the laboratory. And with the formidable challenge Polaroid currently faced, an energetic, full-time manager was essential. While lamenting the end of the era that Land's presidency represented, many of his greatest admirers in the company privately admitted that the move was definitely called for, and that the company would be better for it. McCune was well trusted throughout Polaroid. And, besides, more than one insider added, they were sure Dr. Land would be much happier with the new arrangement, which relieved him of his administrative burden.

Sharp upon the heels of McCune's appointment as president, Thomas Wyman accepted the presidency of Green Giant Company, the frozen-food producer in Le Sueur, Minnesota. Wyman stated that he had not had a falling out with either Land or McCune, but his comments on leaving clearly hinted at his disappointment at being a perennial Number Two. The move to Le Sueur, he said, was "really . . . a matter of running something myself."

Wyman had come to Polaroid in 1965 from the Nestle Company. He rose to the position of senior vice president and chairman of the management executive committee. When he was named general manager of the corporation in February 1972, *Business Week* magazine reported that "Wyman is probably the closest thing to being a No. 2 man

at Polaroid, where it is said that there is one No. 1 and several No. 3s." If the reports surfacing at the time can be believed, Wyman apparently believed this evaluation, and was quite let down to be passed over in favor of the senior McCune.

According to one Polaroid employee, Wyman's departure had a far more traumatic effect on the company than Land's retirement as president. Wyman was a popular, dynamic executive, much more in the forefront than the reserved McCune. Still in his mid-40s, Wyman was seen as the person who would maintain Polaroid's impressive image in the next management generation. Despite his own disappointments and personal regrets—whatever they may have been—Wyman followed standard corporate protocol (read by some as survival instinct) and kept his own counsel during the time of transition. There were no recriminations and nothing but public praise for his former boss. When he is in the Boston area, Wyman continues to see his Polaroid associates.

Depending on who one talks to, the McCune presidency either coincided with or caused the beginning of Polaroid's return to the type of fiscal and marketing performance it was used to. On July 17, 1975, McCune announced a fivefold gain in earnings from that point in the previous year. The trend continued, and by the third quarter Polaroid had solidly doubled its earnings compared with the same period in 1974. There were no earth-shaking reasons for the upswing other than effective management and the ironing out of the bugs that Land had all along predicted were merely that. Plus Polaroid began the second phase of the SX-70 marketing effort with Pronto, a nonfolding plastic camera taking SX-70 film and listing for $66. This model would bring in a whole new sector of camera buyers to the SX-70 "experience." The move was timed to beat what Polaroid officials considered Kodak's probably entry into the instant-picture field.

"We expect competition in our field," McCune stated, "and have been planning for it."

Pronto automatically ejected the picture in the same way as the SX-70, and was powered by the same 12,000-rpm

motor. Other than the body configuration, the main modi-
fication in the cheaper camera was the optics. Focusing was
accomplished by setting a distance scale instead of a reflex
viewing system, and the lens was a three-element plastic
design with less range and aperture versatility than the SX-
70's four-element glass lens. Polaroid subsequently came out
with a rangefinder version of the same camera, called Pronto
RF, as well as a non-reflex version in the original folding-body
design, called the SX-70 Model 3. This latter camera was
priced midway between the SX-70 Model 2 and the first
Pronto.

Profits continued to rise in 1976, the second year of the
McCune presidency, when more than 6 million cameras were
sold, Polaroid's highest single-year total ever. The $79.7
million in profit represented a 27 percent increase over 1975.
Overall sales were up 17 percent to $950 million. These
results were announced at a lavish luncheon in New York for
600 securities analysts and reporters in February 1977. At the
gathering, seven cameras were unveiled, including another
version of the SX-70, five professional pack films, a
passport camera which took two identical pictures simul-
taneously, and an SX-70 photo booth for shopping centers.

Throughout the upturn, Land remained as outwardly
placid as he had been when everyone was predicting doom
for the company. He had been through all of this before, and
Polaroid getting its own house back in order hardly surprised
him.

"One of the amusing things," he told *Fortune*'s Subrata
Chakravarty, "is that no matter how much tribute people
may pay to what I did last year or two years ago, they're
absolutely incredulous about the new thing. . . . Well, I'm
confident I will succeed."

9

SX-70 and Beyond

Competition

When the news finally broke, it came not in the form of boldface newspaper headlines or a gala press luncheon. Tucked away on page 28 of Eastman Kodak's annual report published on March 20, 1974, under the heading of "Research and Development," the critical passage read as follows:

In the field of rapid-access photography the basic decisions have been reached concerning the chemical and physical configurations within which Kodak products will be realized. Productive work has made feasible a film that will yield dry prints of high quality without waste, to be used in equipment priced for a wide spectrum of consumers.

Or, plainly stated, Kodak would soon be in the instant-picture business with a system to rival the SX-70.

Every time Kodak made an announcement on the subject of instant photography, Polaroid stock was sent to the mat, dropping several dollars in a single trading session. In the boom years of the 1960s, a daily fluctuation of six or eight points was not unusual, but in the new reality of the depressed mid-1970s, a $2 fall would wipe out a number of weeks of slow, steady building.

To understand both the excitement and trepidation (depending on one's perspective) attending Big Yellow's imminent entry into the instant-picture field, it is necessary to appreciate not only Kodak's size but its reputation as well. Since George Eastman's time, Kodak has been known for the quality of its products, which have in many cases set the standards of the industry since their introduction. When asked about the highly rated new films being marketed by Japan's Fuji, a professional photographer responded, "They're probably pretty good. But I've found you always end up back with Kodak."

Kodak's size and financial resources allow it to dominate every field of photography that it chooses to enter, as well as making a creditable showing in the office copier arena (Ektaprint) and synthetic fibers (Kodel). And the quality control at the chief Rochester manufacturing facility at Kodak Park is so good on films, chemicals, paper, and other photographic materials that the vast majority of professional and amateur photographers take it for granted. There is a replacement warranty on every one of the millions of little yellow boxes, but it never occurs to the average user that they may be defective.

Aside from the superior quality of its standard products, Kodak has developed over the years one of the outstanding marketing and merchandizing machines in modern American industry. Throughout the United States and much of the world, the red "K" on a field of yellow is as ubiquitous as the Coca Cola emblem. When Kodak comes out with a new product, especially one such as the Instamatic camera aimed at a mega-mass audience, it is usually the result of years of experience and study. Kodak sales predictions have a reputation for amazing accuracy.

So Eastman Kodak was bringing impressive credentials to bear in its direct confrontation with Polaroid. Polaroid's quality has always been high, and has increased steadily since the middle 1960s, but it has never had the range of Kodak's equivalent 35-millimeter films, and has never performed as consistently in the hands of the average user as Kodak stock.

What was expected of Kodak was an instant version of its best standard film in a camera as simple and foolproof as the Instamatic. In other words, Kodak's system was supposed to be as sophisticated as the SX-70, as high in quality as Kodachrome 64 shot through a Leica camera, and as easy to operate as the latest Instamatic or the old reliable Brownie. No conventional system could do that, however, so those who expected the same from the Kodak instant were bound for disappointment.

The public introduction of the camera—which came in an EK-4 and EK-6 model—was handled in typically staid, dignified Kodak fashion at the 1975 annual meeting in Flemington, New Jersey. Unlike the Land extravaganzas, no photographs were taken with either camera, and the actual samples on view had been matted in unusual ways to mask the true format and configuration of the picture. The big, Polaroid-type show would wait until the beginning of the marketing effort the following year. Then the international press would be invited to the Pierre Hotel in New York, where they would each be given a free camera and film, all the written material they could carry home, and taste-tingling food and drink.

The EK-4 and EK-6 differed only in the film-delivery system: The film card came out of the former camera by means of turning a crank, and out of the latter via a motorized mechanism. This motor, as well as the electric eye in both models, was powered by batteries inserted into the camera, and not contained in the film pack, as with the SX-70. Kodak was not risking a problem of the magnitude Polaroid had with its original batteries simply to make "absolute one-step photography" a bit more absolute.

The differences between the EK cameras and the SX-70 accurately point up the differences in approach between Kodak and Polaroid. The SX-70 was Edwin Land's shot at the ultimate in one-step photography. Any feature remotely practicable was included, and the finished package was proudly wrapped up in high-quality leather. The viewing system, which required a highly evolved expertise in compu-

ter optics, was of the single-lens reflex variety, the same type used in most fine 35-millimeter cameras. And the SX-70 was designed with such a clean, unbusied profile either folded or unfolded, that its outline supplied the only graphic in a recent series of ads. If Land's thinking was correct, the public would come to appreciate all he had tried to do, would pay the money for his product, and learn to take advantage of all the features he and his associates had labored so long to include.

Kodak began from the opposite pole, trying to figure out in advance exactly what the public wanted in an instant camera and how much they were willing to pay for it. Land saw the SX-70 as his legacy to the world. Eastman Kodak saw the EK as the appropriate marketing tool for the moment. The EK is a vertical, or upright, camera, rather than one of the more traditional horizontal design. It does not have reflex viewing. Instead, the user sets the distance by sliding a button. It is rather awkward to hold: it has to be supported in front of the face by both palms and both thumbs. Unlike the sleekly designed Instamatics, the graceful SX-70, or the old Model 95 (which recalled a previous era), the EK is not terribly attractive. The lens, a camera's most interesting feature, is small and lost somewhere near the top. The back bulges out to accommodate the light path to the film, and there is a distinctly un-Kodak-like lack of symmetry to the box.

The film, which is the true innovation of the Kodak camera, is somewhat different from its Polaroid counterpart. It is rectangular rather than square, and comes with a less glossy covering, which also covers the white borders. On the SX-70 picture, the borders form a mat for the photograph itself. But both films do develop before one's eyes in a matter of minutes (the Kodak PR-10 film takes slightly longer to get started and reach full color) and both films are rated rather high at ASA 150, to enable use of small aperture lenses. Both films depend on the movement of reactive molecules within their layered structures to create the negative and then the positive, and both come in 10-picture cartridges, which slide

right into the base of each camera. The SX-70 and PR-10 films, however, are not interchangeable.

Significant chemical differences exist in the way Land and Dr. Albert Sieg, Kodak's project director, dealt with the issues of keeping light out during the development process, the material between the positive and negative portions, and the exact function of the dye and developer molecules. But the overall effect of the films is startlingly similar, so much so that McCune immediately sent Polaroid's chemists and attorneys combing through their tall stack of patents to see just how similar the two actually were.

Even some of the outward differences in the film itself reflect the two companies' difference in concept of usage. The flat Kodak "Satinlux" print finish is now preferred by many amateurs—a point Kodak researched carefully—because it does not show smudges and does not pick up much glare. Kodak marketing people like it because the dense surface structure hides many fine-detail flaws in the photograph. Most professionals and serious amateurs prefer the clear, smooth Polaroid-type surface, which they consider more revealing and "honest."

While Polaroid brought out its third generation of Land cameras primarily on the basis of Land's intuitive feelings for what the state of instant photography should become, and let not a single prototype into an outsider's hands prior to the debut in Florida, Kodak conducted an overwhelming number of consumer tests before venturing onto Polaroid's turf. Though it did not go to the outside, Kodak had more than 1000 employees across the continent check out test cameras extensively during 1975 under all manner of circumstances. The only condition was that all snapshots had to be taken on weekends and turned in on Monday morning, and no one outside the employee's family was allowed to cast eyes upon the unit. A signed security agreement accompanied each camera check-out. Amazingly, not a word of this logistical feat leaked out until after the test was completed. And as a result, no one—including Polaroid—had any idea what to

expect. This is one of the reasons the public and press expectations for the new system were so high.

The initial reaction from most dealers and professional photographers was that they saw little difference between the Polaroid and Kodak instants. One informal but telling test was that the security director of a large east-coast drug store chain reported that SX-70 film was greatly preferred over PR-10 by both casual shoplifters and more sophisticated warehouse thieves. But this could have been partially attributable to the greater number of Polaroid cameras in circulation for which the robbers could peddle their booty.

Kodak's initial production experience mirrored Polaroid's quite closely, despite the company's years of practice with their own standard films and Polaroid's color negative. Production delays and inadequate supplies for the Christmas season led to the sort of substantial losses in 1973 that Polaroid had faced 3 years earlier.

Polaroid did not take the challenge lying down. This was, after all, an invasion into what had been Land's own backyard, and he was clearly not happy with the uninvited guests, former customers and suppliers though they might be. While the EKs were still in the design stage, Land had already anticipated the intrusion. At the 1973 annual meeting at Needham, Land had 326 SX-70 demonstration tables set up. Later he responded to a question from the floor about competition from Kodak: "The experience you had today was born in our minds, not in theirs." There is nothing Polaroid is quite so proprietary about as its inspiration.

When the Kodak instant cameras did hit the market shortly before each company's 1976 annual meeting, Land and his staff analyzed the new entry and its film. And at his own gathering he publicly stated that the SX-70 film dyes would prove extremely stable, perhaps an oblique prediction that Kodak PR-10 dyes would not. As it turns out, Kodak itself subsequently confirmed this notion in a secret internal lab report obtained by the Rochester *Democrat and Chronicle*. The report showed that Kodak researchers rated their

own instant films as "poor" and "very poor" in their ability to hold color over a long period. Polaroid's SX-70 films were rated "good" and "fair." Even before the Kodak report was leaked, several Polaroid employees had decided to test out Land's opinion by taping EK prints to their office windows in the direct sunlight. Each print was periodically, and gleefully, checked for signs of fading.

But the print-fading issue was small-time. The real action, meanwhile, was taking place in the United States District Court for Boston, where Polaroid attorneys filed suit against Big Yellow for infringement of 10 instant-picture patents held by Polaroid: four for the camera and six for the film. The suit was filed April 27, 1976, just one week after Kodak brought out its EK line.

Kodak counterclaimed that Polaroid had constructed a great wall of patents based on trivial additions or improvements to keep others permanently out of the instant picture field, and had made its patents so complicated that it was impossible to discern just where they did have a legal right. Polaroid, they said, had "intentionally drafted [patent applications] to be exceedingly lengthy, obscure and virtually inextricable from the prior art and which obfuscate the alleged invention therein." No one had ever accused Polaroid of making its patents simple.

The conflict became a double offensive. While Polaroid was suing Kodak in Boston and London, the Eastman Company was taking legal action against Polaroid in Ottawa asking that nine Polaroid patents be declared invalid. Kodak announced that similar actions would be launched in Germany, Japan, and Australia. Once Polaroid was denied requests for injunctions against the sale of Kodak instant products, the legal and business experts settled back for a protracted suit. The cases hinged on such a complexity of highly technical details that, barring an out-of-court settlement, no one was predicting when a verdict could be expected. At the time of the 1977 annual meetings, there were rumblings about such a settlement, but both sides called the speculation highly tentative.

Kodak had been spending quite a bit of time in court. In 1973, General Aniline and Film (GAF) had sued them for antitrust violations, a specter that has haunted the market-dominating Kodak off and on for years. One of the concessions GAF was demanding was that Kodak give up the word—or, more properly, The Word—claiming that it was a generic term and should be made part of ordinary unrestricted parlance. Challenged in this way to the very core of its existence in the suit in U.S. District Court in Manhattan, Kodak got tough on its own, asking some embarrassing questions about GAF product quality. By 1977 the smaller company was worn down to the point where it threw in the towel on consumer photographic products, not having been able to win its suit, and claiming that Kodak represented overwhelming competition in the market. Many impartial observers, however, suggested the reason for GAF's failure to cut into Kodak's share was more a result of uninspired management and an inferior product.

While GAF was sitting back licking its wounds, scrappy Berkey Photo, Inc., was pressing its own antitrust suit against Kodak in federal court in New York, charging a monopolization of the amateur still-photography market. On January 21, 1978, after 109 days of testimony, the jury (unusual, since most cases are heard by a judge only) decided that Kodak had, in fact, used its sizable power to damage Berkey though the jury did not find any criminal conspiracy in doing so. Kodak's Chairman Walter A. Fallon predictably announced that an appeal would be made. But the boardrooms in Rochester were unquestionably shaken by this first courtroom victory over Big Yellow.

Nor did Berkey stop with Kodak. In 1975, a year abundant in legal activity in the photographic community, Polaroid sued Berkey in federal court in Delaware, just a month after Bell & Howell had hauled Polaroid into court. But more about that one shortly. In the Berkey action, Polaroid charged patent infringement for the Keystone camera designed to use SX-70 film, the Wizard XF 1000. Polaroid had essentially given its blessing to the

Berkey camera that employed the earlier peel-apart film, but moving into the SX-70 area meant threatening competition to Polaroid. Certainly the Wizard would help move more film, but with the SX-70 camera market just beginning to grow and nowhere near a stabilization point yet, Polaroid felt the Berkey product was taking sales away from its own line. When Polaroid had licensed Berkey to produce a camera using Polaroid peel-apart film in December 1974 (somewhat after the fact), no mention was made of a similar licensing arrangement for the SX-70 generation of film.

Despite the undeniable fact that the Wizard XF 1000 used Polaroid film, Berkey claimed that there were no valid claims of patent infringement in the Polaroid suit. Ben Berkey also countercharged Polaroid with fraud in obtaining patents and of misusing the ones they possessed. Even worse—and here Polaroid began to share the high-profile worries of its major competitor—Berkey charged that, like Kodak, the name Polaroid had become generic in photography, and should therefore be made available for general market use. The court disagreed.

This general usage of brand names is a phenomenon that has terrified large innovative corporations for years, recalling such examples as aspirin, which began as the exclusive trademark of one company but later became a general designation for a type of pain killer. Xerox Corporation was so concerned with the possibility of losing the proprietary interest in its own corporate name a few years ago after repeatedly hearing the phrase "Xerox this document for me," and hearing office managers referring to their "IBM Xerox machines," that it launched into a major advertising campaign to combat the erosion. The program sported such headlines as "Xerox is not a verb!"

The Berkey suit was settled out of court in the spring of 1978 on "a mutually satisfactory basis." Berkey agreed to discontinue manufacture of its camera, acknowledge the validity of SX-70 patents and their infringement by the camera in question, and dismiss its antitrust counterclaim against Polaroid. From the look of it, Polaroid won the round, but since there were no money damages collected,

Berkey did keep its several years of profit on the Wizard.

Polaroid had been through the litigation mill from the other side—suing rather than being sued—several times before against companies bearing such names as Polaraid and Polarad. As for Berkey's contention that Polaroid should become a free-use term, as far back as 1955 when only a single company name was associated with instant photography, the U.S. District Court for Massachusetts had decided in Marks vs. Polaroid that the name was still a valid and protected trademark, and that Polaroid was not a generic term for light polarizers.

The legal actions continued throughout most of 1975. About 9 months after pulling out of the instant-movie program, Bell & Howell sued Polaroid for more than $20 million, charging the corporation with not paying money owed to Bell & Howell and breaching written agreements. The $20 million was to cover expenses, the use by Polaroid of Bell & Howell design drawings, and damages for breaking a 1968 agreement preparatory to a manufacturing contract. Bell & Howell claimed that it agreed to design and develop equipment at cost with the understanding that their profits would come from its manufacture. They subsequently informed Polaroid's representatives that what they wanted was not economically feasible and, according to the charge, Polaroid began dealing with foreign manufacturers rather than trying to come up with a mutually acceptable alternative plan with Bell & Howell.

Land had been talking about instant movies off and on since 1947, but the joint effort with Bell & Howell was the first push to work out an actual system and make it a marketable reality. According to court documents introduced in the Bell & Howell suit, Polaroid originally planned to have the instant-movie system—target-priced at around $350 retail—in the stores by the summer of 1975. The Bell & Howell withdrawal cost more than 2 years in delays at a time when both outsiders and insiders were looking for all hopeful signs from Polaroid.

As Bell & Howell expected, Polaroid countersued in federal court in Chicago in July 1975, charging that Bell &

Howell had unilaterally withdrawn from the project. The $27 million Polaroid sought in this case included money the company claimed had already been invested.

This spate of protracted legal proceedings was as much a result of bigness and saturation in the photographic industry as anything else, following a Darwinian-type principle as applied to business. Before, while there was still room for reasonable and sensible growth among all the parties—Kodak, Polaroid, GAF, Bell & Howell, Berkey, and the German and Japanese entrants—there was calm and moderate coopera- tion. The biggest fish, Eastman Kodak, took what it wanted, and there was plenty left for the others to divide amongst themselves. But as each party—particularly Kodak and Polar- oid—grew larger, more successful, and more technologically advanced, two related phenomena began to occur. Each affected company had a greater need to protect its own products and market share, and the market itself reached a saturation point beyond which it could not absorb much more expansion. At the point where the companies collec- tively became greater than the market's ability to support their continual unchecked growth, fundamental changes were bound to take place. The stronger companies were able to remain in something of their present form. Polaroid, which had created a large chunk of the market was an example. Others were able to survive by adapting, as the protean Kodak has done through its extensive marketing research. Some participants weakened under the strain of competition, as was the case with Bell & Howell. And some died off completely, as when GAF announced in 1977 that it was pulling out of the consumer photographic market.

At the same time that each party would like to have seen its case through to a final legal victory, businesses have above all an instinct for pragmatism. After public posturing on both sides and some back-and-forth maneuvering, the Bell & Howell case was settled out of court by a Polaroid agreement to purchase some Bell & Howell equipment for use on the instant-movie project. And it is likely that the legal confron- tation with Kodak will also be settled privately. Both have too much to lose from what could be a winner-take-all public

bloodletting. For Edwin Land personally, the bottom line may be in heaven. For most corporate thinkers, however, the bottom line is the bottom line.

Never far from any responsible discussion of industrial growth is the question of the need for and use of that growth. Unless one takes, by itself, the accumulation of capital by large corporate entities to be a self-justifying good, then one is faced with the question of why a corporation must continue to grow, expand the market, and take over a greater share of that market to be considered vital. The simplistic notion that the health of our society is solely dependent on the continued growth of the major corporations—exclusive of what is causing that growth—and that individual human beings are the beneficiaries of that growth has been effectively and eloquently refuted years ago by such visionaries as Lewis Mumford. But still the notion persists, fueled by the financial establishment, which can interpret solidity and progress only in quantitative terms.

And this is one of the reasons Edwin Land—revered corporate institution though he may be—remains something of an anomaly to the breed that orbits around that financial establishment. Through the largely successful implementation of his dreams, Polaroid has now—like many of its corporate brethren—reached a size at which it is no longer controllable by one brilliant human being. This is in many ways unfortunate. But still, Land's best instincts have always been toward some rational pattern of growth and technology. Because of its high stock value, Polaroid was for years in a perfect position to acquire other companies and diversify its own holdings with little actual cash investment. But when, in 1969, a reporter from *Forbes* asked Land why Polaroid did not acquire other companies and grow as far and as fast as possible, Land replied, simply, "Why?" Or, as he explained to *Newsweek* in 1963, "We like to keep our growth down those avenues which teach us new arts." For Land, there has to be a viable reason for expansion, a process that takes as much as it gives. For other less introspective corporate leaders, there would have to be a viable reason not to expand; because, to them, 15 percent a year is an article of faith. And

the fact that the SX-70 had turned Polaroid into a manufac-
turing company of 10,000 employees might account for
Land's decision to retire from the everyday administrative
affairs of the company. Basically, Polaroid was still in his
image, but the compromises were coming more frequently
now as the company continued to expand.

For many years, Polaroid and Kodak were radically
divergent in style and substance. Kodak was the calm,
conservative corporate giant, a major power that did not
make a move without all the facts and figures. Polaroid
consisted of a small group of scientist-engineers who came up
with dreams, and then saw to it that those dreams were
shared with the public. Since before Eastman's death, Kodak
has been run by efficient company men. But there have
always been similarities between the two companies. Neither
is unionized, and both are somewhat paternalistic, in a
nonpejorative sense, toward employees. Both are financially
conservative, and neither goes to the money market for
capital, preferring to finance from within.

And there are more basic similarities. Contrary to the
popularly held notions, Kodak is quite technologically astute,
just as Polaroid is a sophisticated marketer. Of course, there
will always be sustantive differences between almost any
other corporation and Polaroid as long as Edwin Land
remains alive and active, but since the mid-1960s, the two
photographic kingpins have been growing increasingly similar
in their business outlooks, and both have been going for the
same market. Volume has come to be a byword at Polaroid
almost to the extent that it is at Kodak. The tactics, however,
do occasionally differ in interesting ways.

While Polaroid was suing Berkey for marketing a camera
designed for SX-70 film, Kodak was selling the technical
information about its own instant camera to *encourage*
others to get into the act. What has always paid the bills at
Kodak are not the cameras, but the profusion of little yellow
boxes. This type of marketing strategy has been effectively
used by industry leaders before, most notably by Columbia
Records in releasing Dr. Peter Goldmark's patent on the

long-playing record album to the recording industry at large. This instantly expanded the interest in, and market for, LPs, of which Columbia was of course the greatest supplier.

Kodak may have had another reason for releasing the information. For years the Justice Department has been considering antitrust action against it. Some industry observers feel that Big Yellow would actually like to be outflanked in the instant-picture field to demonstrate that the company is not an insurmountable heavy in the photographic industry. And for this reason it is doubtful that Kodak will venture any time soon into the instant-movie field.

Kodak sold about a million instant cameras in the first full year of production, at a loss. In fact, Kodak had been selling the EK-4 and EK-6 to retailers at significantly less than it cost the company to produce them. Whether the company wished to show an initial loss on the camera for the benefit of the Justice Department (a far-fetched idea) or whether they were more interested in carving out at least some market share than earning early returns is speculation at this point. But there is strong evidence popping up from time to time that Kodak's antitrust worries run deep. In August 1977, *Advertising Age* noted that Kodak's traditionally saturating advertising was not keeping pace with market growth, and that it was possible that the company was purposely holding back from an even greater share of the market to avoid further antitrust threats.

There is wide disagreement inside Kodak as to the seriousness of the Justice Department threat. There is much less disagreement over the seriousness of the Polaroid threat. And so, by and large, Kodak has been taking its chances with accusations of market dominance, and has tried its best to establish a foothold in Polaroid's specialty, which may be the eventual primary trend in still photography. The unit losses on cameras continued into 1977, with Kodak cutting revenues further by offering $5 rebates on all instant cameras, so important did they see the future of the market. And during the entire effort, the people guiding Kodak kept glancing over one shoulder, realizing that, equally as important to

their own future as growing in the instant market, was keeping Polaroid from growing too much.

Completing the Cycle

The amateur photography market continues to move simultaneously in two directions. At one end, enthusiastic amateurs demand more and more sophistication and precision in their equipment, with ever-increasing esoteric capabilities. At the other end, the average casual picture-taker wants the lightest, simplest, most foolproof device for recording where he has been, who else was there, and what color it all was. It is this second trend that has sold tens of millions of Kodak Instamatics, and it is this trend that Polaroid has been trying to lock into since 1949. With the SX-70, Land was trying to take advantage of both trends.

Land sees the SX-70 as helping to fulfill his vision of man. "My basic faith," he told *Forbes* in 1975, "is in the random competence of people in all walks of life, at any level of income, of any derivation. There is a common sense of beauty and of manual aptitudes.... I believe that this camera and what it does will be a necessity to everyone, once they learn to use it."

On a basic level, no one who has ever used a previous Polaroid roll or pack camera can deny that the SX-70, despite its longer development time, is a quantum leap in design. And anyone who was first introduced to Polaroid photography through the SX-70 and then tried to use any of the second-generation cameras was probably staggered by how difficult it seemed by comparison, and how much more prone to human error. And then working the SX-70 design process backward in the mind, one is likely to be overwhelmed by Dr. Land's visionary achievement. It took me an entire pack of Type 107 black-and-white film before I could figure out how to peel the print apart from the negative. It took me three

additional packs before I came up with a print I was aesthetically pleased with. I was willing to take Land's concept of experimentation up to a point, but four packs of film seemed to me somewhat excessive.

But the SX-70 represents more than a mere improvement in convenience and error-resistance. It is becoming, in a sense, a new "form" of still photography. A number of celebrated professional photographers had glowing things to say about the SX-70, even in the midst of the outpouring of negative comments from critics who claimed the camera was nothing more than a high-technology gadget.

Walker Evans made his reputation in the 1930s, photographing the stark lives of Southern sharecroppers, first for Roy Stryker and the Farm Security Administration and then as a collaborator with James Agee in their brilliant book, *Let Us Now Praise Famous Men.* Evans was noted for his formal, dignified black-and-white images of everyday people and objects, raised to the level of existential symbols by his vision. Before the SX-70, which came out very near the end of his life, he had never worked in color. But as he told a group at Yale in 1974,

I'm feeling wildly with [the SX-70]. A few years ago I would have said that color is vulgar and should never be tried under any circumstances. It's a paradox that I'm now associated with it and in fact I intend to come out with it seriously. You photograph things that you wouldn't think of photographing before. I don't even know why, but I find that I'm quite rejuvenated by it.

Ansel Adams had been using Polaroid film since it came out, but generally the black-and-white variety, and generally in larger view cameras with adaptor backs rather than the standard consumer models. He called the SX-70

. . . an absolute miracle. The film is very short-range and as long as the subject is also of short contrast range you can get absolutely magnificent color. It's sometimes difficult for professional photographers who are used to controlling wide ranges. But to the amateur

it gives a tremendous, high level of response because they instinctively live in a world of an agreeable total contrast range.

Because of the size and format of the SX-70 picture, interesting differences can be noted in the work of both Evans and Adams when they used the new camera. Certainly there was the obvious shift from black and white (a pure type of photography concerned primarily with form and contrast) to color. But there were other differences as well. Both men got much closer to their subjects, letting a single object dominate each frame, where previously, their picture's "message" would have been conveyed by a much larger panorama. In the case of Adams, best known for his vistas of the American West, the black-and-white scenes often have a depth-of-field of several miles. With the SX-70, he began exploring scenes from the perspective of a few inches.

And there is the added dimension of selectivity. Evans and Adams, and the schools of photography they pioneered, totally visualized and planned their subjects in advance of snapping the shutter. But the compactness, portability, speed, ease, and quick response of the SX-70 meant that the photographers were taking a good deal of pictures of things they might not have considered before. In this way, the SX-70 does not replace or supplant traditional photography; instead, it adds another dimension to it.

The fact that the SX-70 is at its best with small, close scenes and that the picture actually develops in full view give a sense of intimacy between photographer and subject that has never before been possible. There is an undeniable kick in watching an image materialize before one's eyes. It is bound up in the whole concept of the creative process and in discovering how well one saw what he thought he saw. It is this sense of curiosity that Polaroid capitalizes on.

For a number of technical reasons having to do with the dye-developer chemistry and the luminous backing layer, SX-70 photography also possesses an illusion of depth difficult to achieve in a two-dimensional medium. This alone makes it an advance over previous Polaroid color cameras. The unusual

sense of depth can be difficult to get used to at first (it was for me) because it seems to violate a photographic convention we have become accustomed to. Photographs ought to be flat, it seems, and the SX-70 print somehow appears to take up more "space" than its several thousandths of an inch of thickness would indicate. Once mastered, however, the camera can yield fascinating new results, and familiar objects can be seen in unusual relationships to each other. And in this sense, the camera actually does enhance the user's vision and perceptual understanding of the world around him.

The same is true for color. Rendition from one SX-70 print to another tends to vary considerably, under different exposure conditions. But with proper exposure it is possible to obtain great subtlety of color. At the same time, it is not the type of color we have come to accept as the norm through the use of Kodak standard films. It can be more subdued or more intense (not to be confused with Polaroid's advertising claim of "more real than life") than that of the subject, so it is generally not as accurate for producing a "true" record of the subject as Kodacolor. But the results tend to be much more individual and impressionistic. The same subject photographed by 50 inexperienced amateurs with an Instamatic would probably look very much alike on each print. They would probably be considerably different when taken by the same 50 amateurs with an SX-70. An experiment similar to this was actually conducted by a photography class at the Smithsonian Institution in Washington.

So the SX-70 does possess far-ranging potential as a form of creative expression for both professional and amateur, encouraging each to explore new visual experiences. While the SX-70 does not make it substantially easier to take excellent pictures, it does make it substantially more difficult to take terrible ones. As with any other form of photography, the more the user understands the processes and limitations of the medium, the better quality he will produce.

There are limitations to the SX-70. The very size of the film can be a limitation to the majority of serious photogra-

phers used to seeing their work larger than 3¼ inches square. Of course the pictures can be reproduced and enlarged, but the user has to wait for those as long as he does for a standard lab-processed print. Lighting can be a problem, as the SX-70 is unusually sensitive to low-light situations, a factor not fully compensated for by the use of a flash. Low-light situations can produce interesting results with the SX-70, but perhaps not the results the photographer had in mind. Pictures taken in dark conditions tend to be much darker than the subjects themselves, and the red-yellow range is all but lost.

And the SX-70 will not take black-and-white film, considered the basic medium by nearly all professionals. The reasons, in this case, are purely economic. Polaroid officials may not feel there is a sufficient amateur market to support the research, development, and manufacturing costs associated with bringing out a black-and-white SX-70 film. Most of the professionals who like to use instant black-and-white film generally do so in a 4-by-5 inch format with conventional cameras. Polaroid does not rule out the possibility of eventually coming out with a black-and-white SX-70 film, but it does not seem to be an overwhelming priority at the moment. This is unfortunate, because the camera cannot be considered a versatile photographic tool until the photographer can translate his ideas into instant prints in black and white. Polaroid genuinely desires to have all professionals take it seriously, but it is willing to invest just so much for the consideration.

The limitations in the lens itself can also present artistic problems. The 116-mm lens (glass in the more expensive folding models, plastic in the Pronto line) is slightly wide-angle to take advantage of the film's square format and to make the best compromise among all the possible situations under which camera users might be operating. Professional cameras solve the problem by offering interchangeable lenses ranging from extreme wide-angle to super telephoto, depending on the photographer's needs. Polaroid has partially solved the problem by coming out with a close-up lens, which slips over the standard lens by means of an accessory holder and

allows pictures in which tiny objects fill the frame. Taking pictures of individual people is not as easy, however, since the wide-angle lens tends to flatten the edges and distort anything trying to fill up too much of the frame from too close a distance. Therefore, if the user wants to take a portrait of a single individual, he has the choice of getting far enough away so that the subject looks normal but does not fill up the entire frame, or getting close enough that the edges of the face tend to flatten. A telephoto lens attachment recently brought out could solve the problem.

Eventually, Polaroid will offer a complete line of accessories, which will make the SX-70 into more of a true camera system. Polaroid has not yet marketed any other accessories, first, because of the obvious cost consideration; developing a wide range of subsidiary products at the same time that the initial camera and filming gear-up was taking place would have represented a substantial capital outlay. But equally important, it appears that Land believes in "educating" his market and bringing them slowly up to a sophisticated level for manipulating his hardware before offering more. He feels that the telephoto lens, for example, which allows a fuller range of photographic options apart from those now available with the SX-70, can be fully appreciated by the average user only after the camera itself is mastered. It is the same strategy that is now being followed with Polavision. Once the consumers learn to use the basic system, sound will be added. Land says he wants people to understand the "magnitude" of his inventions, which apparently means bringing the public along slowly at first.

Living Images

On February 6, 1977, the United States Patent Office took official cognizance of one of the steadiest customers in its history by inducting Edwin Land into the National

Inventors Hall of Fame. In recent years, Land has been honored many times. But this honor was more important to him than most. He attended, paying a return sort of homage to the system he had always felt was so instrumental in his success.

At the ceremony, Land was presented with his then four most recent patents—numbers 497 through 500! To give some perspective on the magnitude of Land's achievement, only a handful of individuals hold nearly so many patents. The record number of patents awarded to a person is Thomas Alva Edison's 1093. No one else has ever come close, and this record is more likely to endure than even Joe DiMaggio's 56-game consecutive hitting streak. But by accumulating nearly half as many patents as Edison, Land carved out his own enduring place in technological history.

Land's respect for the patent system is illustrated by a story related by U.S. Patent Commissioner C. Marshall Dann:

He and I were talking after the induction ceremony and Land asked me if I'd sign his five hundredth patent. I said that my signature was already printed on the certificate, but he said that he really wanted my actual one. I don't think if God himself had asked me to sign His program from the ceremony could I have been more overwhelmed.

The year 1977 was one of several milestones for Land. Along with his 500th patent, it also marked the 40th anniversary of the founding of the Polaroid Corporation and the 30th anniversary of the birth of instant photography, an event celebrated by a luncheon in New York in February presided over by William McCune. At that gathering, McCune announced an 8-by-10-inch instant color film for standard view cameras, which has been met with more enthusiasm by professionals than any Polaroid product in recent memory. Among other things, the new film would allow studio-quality portraits to be produced and framed immediately. It also had wide-ranging uses in the tremendous fashion photography business.

Now that the major challenge of SX-70 research and development was behind them, McCune stated that Polaroid would once again concentrate heavily on its marketing efforts, and concentrate more heavily on the commercial and industrial spheres. One of the devices on display was a photo booth called the "Face Place," a variation on the old four-snapshots-for-a-quarter automatic stands prevalent for years in drugstores and amusement arcades. The modern Polaroid version produces color photographs on SX-70 film.

Around the time of the luncheon, Polaroid launched a magazine ad campaign in such publications as *The New Yorker*, showing Polaroid pictures taken by distinguished professional photographers and exhibited in the collections of well-known art museums. ("This Polaroid SX-70 photograph is part of the collection of the Museum of Modern Art.") The purpose of the campaign was to move the public away from the notion that Polaroid cameras and film are only for novices and are shunned by professionals. It was somewhat akin to American Airlines' campaign of several years back, stating that it was the airline of professional travelers. The ads, of course, were aimed primarily at nonprofessional travelers.

But even as early as the February luncheon in New York, public and media attention were focused on the upcoming annual meeting in Needham. It had been a couple of years since Dr. Land had put on one of his super shows—the SX-70 introduction had been the last truly big splash—but the rumors were already surfacing that this year's extravaganza was to be a rip-roaring one.

The formal announcement that something was in the offing came in the Chairman's Letter in the annual report. After several pages of reminiscences and philosophical musings about the first 30 years of instant photography, Land addressed himself to the next phase of the Polaroid story:

I take you into this, not as a statement of presumably transient advantage, but rather to prepare you for the discussion of our longest and perhaps most important cycle rooted deeply in the

earliest history of our Company and coming to its first maturation this year. In this cycle we utilize all of our experience with the permanence of silver and the permanence of dyes, with latent image formation and image transfer, with optics as learned from the early days when our company was essentially a company in physical optics. We utilize all this to expand the role of your company from the field of still images to include the new field of living images.

The philosophy motivating the instant movie would be the same one that had dominated Polaroid since the beginning:

Clearly then our task was not to displace or compete with still images, but rather to take confidence from the lesson we have learned: People will be grateful for and responsive to the removal of all mechanical obstacles between them and the exercising of a new art.

Land ended his letter with the declaration, "A new art has been born." And clearly, the 4000 shareholders, financial analysts, and media representatives who crowded into the Needham Distribution Center on April 26, 1977 were there to witness history.

Outside, the skies were gloomy and overcast, and the block-long queue of people waiting to get in hoped they could do so before the threatening rain or snow began coming down. One employee-shareholder standing toward the middle of the line commented, "I've figured that Dr. Land had some pretty high connections for a long time. If the sun suddenly comes out just as the meeting is about to start, I'll be sure of it."

Inside, as we saw in Chapter 1, Land did not disappoint the faithful. At a press conference prior to the meeting, he had made the same sort of claims for the Polavision system as he had for the SX-70. That the device took motion pictures and allowed the user to see them a minute and a half later was not, in itself, enough. It also had to be "a new

mechanism for relating ourselves to life and to each other."

At the meeting itself, he told the sea of rapt shareholders, "This is not just another field, not the home movie field, not a boring field. This is a way to relate ourselves to life and each other." This was certainly the philosophical essence of Land's purpose, but here he was actually addressing himself to a different sort of skeptic—the sort who felt that Polavision was another self-fulfilled Land dream with little relevance in the modern market.

Once again, conventional wisdom was rearing its persistent head. By 1977 amateur movie systems were estimated to have found their way into about 10 percent of American homes. With all its marketing resources, Eastman Kodak had not been able to increase this figure; and many people felt that, for all its technological impressiveness, Polavision would do no better. Land, who had challenged convention as many times as he had created markets where none existed before, was not perturbed.

To begin with, Land studied all the reasons why home movies have not been popular. He feels that both still and motion picture photography are very personal media, and he eliminated all of the things that stood in the way. One of the problems with home movies has been the necessity of setting up a projector and screen, moving furniture, turning off lights, generally disrupting the household, and still not having it dark enough during daytime hours. Polavision does away with all of this by showing the film on a brightly illuminated, easy to carry, 12-inch screen player similar in appearance to a television. There is no threading. Instead, the 3-minute (figured by Polaroid to be a reasonable length for most subjects) cartridge is popped into a slot on the viewer, and the system is ready to go.

The camera itself is also nearly as easy to use as the SX-70 and, like the SX-70, Polavision's operational simplicity masks the staggering technological advance it took 10 years to reach. Not only were Land and his associates able to accomplish a number of scientific feats no one had been able to master before, many of those feats appear to be mutually exclusive—

obtaining fine grain, high resolution, and high ASA speed all at the same time.

The Polavision color system actually hearkens back to the nineteenth century in the color-mixing work of the physicist James Clerk Maxwell. All previous Polaroid color systems had employed the subtractive process, in which combinations of cyan, magenta, and yellow were subtracted in varying degrees from white light (representing the full visible spectrum) to create a full color range. The subtractive method was the one employed in the creation of Koda-chrome by Leopold Godowsky and Leopold Mannes in the early 1930s. These Kodak researchers invented the first widely used color film, a product that more than 40 years later remains the standard of the industry.

Polavision, on the other hand, is an additive process based on the use of an ultra-fine, microscopic screen made up of nearly countless sets of red, green, and blue lines (about 4500 lines to the inch). Integral with this is an extremely thin layer of very fine grain silver halide emulsion along with other essential layers. Though all of the system's components represent sizable technological leaps, the key to Polavision's instant developing process is neither in the camera nor the player, but in the cassette itself, which contains a pod with the equivalent of about 12 drops of viscous fluid.

A complete technical explanation of the system is contained in Land's paper, "An Introduction to Polavision," printed in the September/October, 1977 issue of *Photographic Science and Engineering*. A difficulty with movie film not encountered with Polaroid print film is that it has to be transparent, which means the negative layer cannot be "hidden" in the back of the positive where it will not be seen. In transparency film, light shines through the back of the film to create the positive image. What Land and the many other Polaroid chemists came up with was a negative layer so effective that it rendered vivid color across the tiny 8-mm frame, but transparent enough so that (while it does cut down on the light passing through it) it can "stay where it is" after developing, and not block the illumination—while at

the same time producing a positive image capable of extremely high efficiency in light absorption.

Once the film cassette is run through the Polavision camera, it is slipped into a slot in the player. As it rewinds, a foil pull tab on the processing fluid pod is yanked, and the fluid coats the strip of rewinding film. The fluid is spread in an even layer 7 microns (3/10,000ths of an inch) thick, and the entire length of film is completely coated in about 20 seconds. The player then waits another 45 seconds to allow processing reactions to be completed, and then the film is ready to be shown. The film within the cassette is wound forward, and the player directs the image through a prism and onto the screen. Illumination is provided by a 150-watt tungsten-halogen projection bulb.

Polaroid has many ideas as to how Polavision is going to be applied. For the moment, the company seems not to be aiming its "living-images" system at the traditional sort of home-movie continuity, since the film cannot at this point be easily edited or spliced onto larger rolls. Each cassette becomes, then, a living image equivalent of a family snapshot. It is, in effect, a still picture that moves. Land believes that people will store cassettes in library format, and both adults and children will look at them in varying sequence, depending on their mood at the moment.

In keeping with what seems to be Land's long-held concept of slowly educating the market, as usage increases, to the totally new product, Polaroid plans to wait at least a year after the national introduction of Polavision before marketing larger cassettes, editing equipment, or sound. Once the average user is comfortable with the basics of Polavision, Land apparently feels, he will be in a better position to appreciate and utilize its varied possibilities.

Polavision cassettes, the most technologically significant component of the system, are manufactured by Polaroid at its Norwood plant. The camera and player are produced by Eumig, an Austrian firm specializing in conventional projection equipment. Eumig was chosen after Bell & Howell dropped out of the project, although Bell & Howell claimed

that Polaroid began soliciting other vendors after the Chicago company stated it could not meet Polaroid's original specifications. This represents the first time that major Polaroid product components for the American market have been manufactured outside the United States, although Land products for foreign sale have been produced overseas since the early 1960s.

Before the chastening era of the SX-70 and Polaroid's temporary retrenchment, a Land display of this type would have had the Wall Street sophisticates buzzing and sent company stock prices soaring. But in marked contrast to the exuberant, almost devotional, atmosphere inside the Needham warehouse that afternoon in April, reaction to Polavision in the days following the 1977 annual meeting from the critical community was not overwhelming. While everyone was careful to laud Dr. Land's technical achievement, nobody was quite sure who would want to buy Polavision (no price tag had yet been affixed to the system) and for what reason. The convenience value of being able to watch one's own movies on a TV-like screen was difficult to gauge. And how much value should be placed on the instant nature of the system? One of the great benefits of Polaroid still photography is the ability to compare the print to the actual scene. A directly analogous situation does not obtain, however, with instant movies, since a scene in motion by its very nature changes every fraction of a second. And the user is not likely to stage the action over again if he did not like the way it turned out the first time, as he might do with a still picture.

Another marketing imponderable was the absence of sound in an era when even relatively inexpensive Kodak and Bell & Howell systems have acceptable (though fairly low-fidelity) sound built in. Land said that the lack of sound was temporary, and even stated that one of the reasons for its absence was Polaroid's dissatisfaction with available audio quality. But a living image would seem to be incomplete without the sound dimension, which had been expected by the Polaroid-watchers up until April; so its lack was disheartening.

And then there was the question lurking in the back of everyone's mind: How long can Polavision remain attractive and commercially viable when Sony, RCA, Zenith, Panasonic, and a host of others are making great strides in the field of home video equipment? Not only are the high prices coming down as production and competition increases (paralleling the color television wars of the early 1960s), but the units themselves are becoming smaller and easier to operate as miniaturization and video technology become more advanced. The user watches video tape on the same sized player that Polavision employs, plus video tape offers the added advantages of longer and erasable tapes, fast-forward and rewind cueing, and the capacity to record one's favorite programs from television.

But perhaps the market is divergent enough to accommodate Polavision. After all, the introduction of audio tape did not eliminate the phonograph, nor did the original type video tape of the 1950s destroy the market for 35-mm and 16-mm professional motion picture film. However, the issue is more complicated, and the full impact will not be felt for several years at the earliest. In the past, Land has been accurate in his evaluation of the market when critics were doubtful. So perhaps his track record alone is cause for optimism.

Polavision does have a number of immediate professional applications: industrial and scientific laboratory work, short but highly detailed technical training pieces, advertising agencies, news reports, and sports training. But to properly attempt to evaluate Polavision, one probably has to think as Land did about it. It is important to keep in mind that he regards Polavision as a total experience and, as such, that it is more than the sum of its parts. Polavision is likely to be utilized differently from either conventional Super 8 movies or video tape. It will not replace either of those media, any more than Polaroid's still-photography products could be expected to replace the Eastman-pioneered variety. For the time being, the short, convenient Polavision system will probably record more pointed, personal experiences, which will be viewed time and time again. And once the system

comes to include sound and long-length cassettes, it could eventually supplant the commercially processed amateur motion picture market.

For the foreseeable future, Polavision will be more convenient and economical to use than video tape. A color video camera, for example, is many times more expensive than the all-inclusive $700 (list price) Polavision system. And Polavision requires only the camera, whereas video tape requires the camera, a bulky recorder (even in portable form), and generally more complicated lighting. Plus, there will always be a considerable number of people who simply like the "look" of film, with its rich tones and impressionistic quality, more than the sharp, hard-edged images of tape. Even on television the difference between programs recorded on film and those recorded on tape is apparent. Polavision may never take the place of video tape, but it does have a very real chance of becoming equally popular and, like previous Land inventions, carving out a place of its own.

Polaroid's 10-year research-and-development effort that produced the instant-movie system can be counted on to bring forth a number of related innovations. The greatest single breakthrough in Polavision is the ability to develop a positive image on transparent film without "removing" the negative. If this can be done for a frame of film 8 mm wide, it can be done for any size transparency, which means that the technology now exists to produce high-quality instant color slides, a market of tremendous potential. During its first few months on the market, Polavision has found a wide range of important technical and business applications, in addition to its use in family and pictorial photography. Pharmaceutical research laboratories are using the system to document growth and change in living specimens. Subjects for Polavision training films range from medical technology to golf instruction to high school sports. Marketing applications include real estate films and hotel and resort promotions. And other possibilities will, no doubt, occur to Land and his successors in another moment of "instant image."

Larger Formats, Larger Ideas

Throughout the weeks surrounding the introduction for Polavision, the man on center stage was, of course, Edwin Land. The week following the annual meeting—during which he celebrated his 68th birthday—Land flew to the west coast and electrified the normally staid meeting of the Society of Photographic Scientists and Engineers. He recounted the technical history and details of his living-images system. Each of the news, business, and photography magazines carried the usual article and picture.

But after the hoopla, Land returned to his Osborn Street laboratory and his work, the effects of which might not be known for several years. The day-to-day control of the company continued with William McCune and the second-generation managers, who concentrated their attention on the marketing of Polavision and the increasing number of other products, which would be Polaroid's bread and butter for at least the next half decade.

One of those products, a stripped-down Pronto known as OneStep, is a fixed-focus bottom-of-the-line camera using SX-70 film. It represented the ultimate in instant-picture simplicity; no focusing is required. The OneStep was the latest example in the trend toward matching, model for model, with Kodak instants; this one competed directly with Eastman's low-end Handle, a fixed-focus camera utilizing PR-10 film. But unlike the Handle, the OneStep employed the SX-70 motor-drive system, which automatically ejects the finished print. The camera has been doing extremely well in the market segment that demands easy, foolproof snapshots.

Now that the new generation of products was firmly established, Polaroid began mending its fences with photographic retailers, with whom the company had never had particularly good relations and who felt particularly burnt by the early SX-70 experience. The problem had been a *Catch-22* situation for some time. Because of Polaroid's shaky

relations with dealers as a result of the emphasis on discount and department stores, there has always been a high turnover rate among company salesmen servicing the specialty shops. And because there is such a high turnover rate among Polaroid salesmen, the dealer rapport is that much weaker. When compared with Kodak's wholesale marketing approach, the take-it-or-leave-it stance many dealers were faced with from Polaroid gained a frigid welcome for company salesmen.

The Special Edition (SE) line of five cameras, from the $200 SX-70 Alpha 1 to the $25 Minute Maker Plus, was introduced partially in deference to camera stores, which had always felt at an unfair disadvantage in competing with mass-marketing outlets for Polaroid sales. All five SE cameras were finished in professional-looking black, carried a 5-year no-questions-asked repair or replacement guarantee, and, most interesting, a scheme whereby any picture the user did not like for any reason would be replaced by Polaroid once a whole pack's worth had been accumulated. The Special Edition cameras were available only from specialty stores, which meant that Polaroid was guaranteeing that the price would not be undercut.

Since none of the Polaroid films are inexpensive for casual shooting, the Special Edition film-replacement offer amounts to what Washington video specialist Kenneth Showalter called "a free course in instant photography." Actually, it is a wonder more companies have not tried similar programs. But as Polaroid's Consumer Products Publicity Manager Jean Anwyll commented,

Marketing managers always tear their hair out when you announce any sort of unlimited return program like this. But in actuality, the number of people who take advantage of this is always extremely small. It's good public relations for us and the people who really do want to use it are very happy.

In contrast to the decidedly mixed reactions that met both the SX-70 and Polavision, the 8-by-10-inch Type 808

Polacolor film was greeted with cheers by professional photographers and the photographic press. The film was marketed in packs of 10 individual sheets in a format not unlike the second-generation peel-apart Land film. The key difference is that after each sheet is exposed in the special 8-by-10 camera back, it is run through a motorized processor whose rollers automatically spread the reagent. This eliminates the greatest single problem with the peel-apart films—human errors in pulling the film straight and evenly through the camera rollers.

Experts reported excellent color quality with the 808 film, and *Popular Photography* even stated that detail was so fine that fashion photographers sometimes had to use diffusing filters to cover up models' complexion problems. The primary benefit most photographers mentioned, other than being able to know that they had what they wanted before they left the studio, was the factor Marie Consindas had mentioned with regard to using Polacolor when photographing children. The instant feedback tends to make a subject much more involved and animated in the shooting session. It contributes to the generally increased level of visual awareness that Land has been talking about since 1947.

Land, meanwhile, was applying the technology he had developed to some more esoteric projects that caught his interest. At the Boston Museum of Fine Arts, Land and a group from the Vision Research Lab, headed by John McCann, constructed a room-sized camera with which they made life-size photographs of paintings and tapestries. The "camera," which is actually a lens, a giant easel containing positive and negative film rolls, and powerful strobe lights, produces a contact print 6 feet 8 inches by 3 feet 4 inches.

At this point there does not seem to be any commercial application for what Land calls "large format pictures." It does, however, take full advantage of color quality and resolution characteristics of Polacolor II. Primarily, though, the process is another example of Land's personal interests, which represent one of the reasons he founded his company. The first painting reproduced by this technique was his

favorite Renoir in the museum, "Bal à Bougival." In 1977, Land's people began photographing a wall-sized fifteenth-century French tapestry, "The Martyrdom of Saint Paul," which had been taken down to allow restoration work on its linen backing. After photographing the front of the nearly 7-by-10-foot tapestry, Polaroid technicians also photographed the back, which, not having been exposed to sunlight, had not faded significantly over the centuries. The result of the several weeks of work was a public exhibition entitled, "A Medieval Tapestry in Sharp Focus." Accompanying the newly rehung tapestry was an actual-size Polacolor photograph of its reverse, which not only showed the work's true colors but also the techniques that went into its creation. On one more level, Land was taking his "partners" into a more complete understanding of the creative process through photography.

Predictably, Land went one step further than the curators and art historians who called the Polaroid macrophotography a boon to understanding and appreciation of art. He called this "wonderfully effective experience" a technique that would "change the whole world of art." In speaking of the possibility of eventually making minutely detailed full-size replicas available to every school in the nation, Land said, "You will see exactly what you see on the actual painting." And because of the perfect rendition, Land added, "There'll never be another art fraud." Perhaps. But idealistic men often underestimate their less well-meaning counterparts. It is said that the Wright brothers were certain that, once the airplane developed the capability to survey enemy troop and supply movements and to carry explosives over civilian targets, war would be out of the question.

Regardless of their ultimate public acceptance or use, Land's professional pursuits—both scientific and commercial—have been intimately concerned with the individual's orientation to the physical and social world around him. This has been the hallmark of his life. The indelible Land stamp has gone on every Polaroid product, and is the essence of the

Polaroid experience. "It is," he commented in a Phi Beta Kappa address at Harvard in the spring of 1977: "as if all science has been schooling itself to acquire the new techniques of speculation and experiment appropriate to using the mind on the mind."

What, then, is the eventual end result of this pursuit, the deeper realities he has been exploring, the summit to which he has been striving his entire adult life? To Land, the resolution lies in the very nature of the inquiry: "I find it helpful to think of a symphony, in which the opening theme asks a question, and the closing theme states that the question is itself the answer."

10

Conclusion

The Man Behind the Camera

Edwin Land has never regarded his inventions primarily as products. When he introduced the SX-70 at the 1972 annual meeting, instead of telling his investors what it would mean in terms of corporate profitability, the message Land wanted to get across was that the camera "engenders a system that will be a partner in perception enabling us to see the objects around us more vividly than we can see them without it, a system to be an aid to memory and a tool for exploration."

It is in the nature of the man that his comments and essays can be seen as philosophical journeys toward his vision of bringing the world closer together through his inventions. It should not be surprising that he sometimes makes claims for his devices that others might find unfathomable. He has spent a lifetime uncovering realms never before imagined.

One of Land's most illuminating commentaries is found in a 1974 Polaroid publication entitled, "The SX-70 Experience." The body of the 22-page booklet consists of 10 photo essays, each told using nicely reproduced SX-70 photographs. It is also one of the few times that Land has allowed himself to be pictured informally, in this case as a sort of Everyman Photographer. The captions for the essays themselves reveal a

particular orientation: "A trip around Boston in which I was picked up by these delightful children and brought to their home"; "Return trip a year and a half later to record the transiency of childhood and the dignity of new growth"; "New Mexico. A cow or bull, as the case may be, stares me down ferociously"; and "The permanence of Boston."

The piece of expository writing accompanying these pictures is indicative of Land at the top of his romantic-visionary form, and it is worth quoting at some length:

We could not have known and have only just learned—perhaps mostly from children from two to five—that a new kind of relationship between people in groups is brought into being by SX-70 when the members of a group are photographing and being photographed and sharing the photographs: it turns out that buried within us—God knows beneath how many pregenital and Freudian and Calvinistic strata—there is latent interest in each other; there is tenderness, curiosity, excitement, affection, companionability and humor; it turns out, in this cold world where man grows distant from man, and even lovers can reach each other only briefly, that we have a yen for and a primordial competence for a quiet good-humored delight in each other: we have a prehistoric tribal competence for a non-physical, non-emotional, non-sexual satisfaction in being partners in the lonely exploration of a once empty planet.

Is it magic that our magic device in its technological innocence appears on the scene suddenly as an invaluable instrument for discernment of prehistoric bonds to each other? Or does the race simply await the random arrival of technologies that prove benign, interspersed amongst those that prove to be evil?

When Siobhan, on the cover, took our hands and brought us home to her family so that they could share her SX-70 experience, and when during the next few hours we found that without knowing each other's name (except for Siobhan and Billy) we had achieved a polite and companionable friendship, I began to sense the role of SX-70 as an explorer of new countries, not geographic countries, but human countries—millions of which exist throughout the world. I began to discern that a tourist in each of these

"countries" could find the excitement and wonder and beauty which Goethe found in his trip to Italy. Our own trips with SX-70 have been modest adventures comprising the lighthearted perception by small groups of people of all ages that an important human opportunity was at hand: a domain was opened in which friends can share the deep satisfaction of creating together and in which strangers while photographing together can explore the pleasant periphery of friendship.

This essay is absolutely rife with the leitmotifs of Land's philosophy: The instant picture as a natural adjunct to a child's exploration of the world; the latent but primordially potent ability of people to relate to each other; the capacity of the ordinary person to achieve significant artistic insight, given the proper tools and guidance; and the pondering of the question of technological determinism. One nearly forgets that what Land is talking about is a sophisticated consumer product. But to him, it is an aspect of life that engenders more than merely the dazzling chemistry, engineering, and computer optics that made it possible. And because these beliefs are such an inherent part of Land's whole mode of perception, he can legitimately (at least from his perspective) make claims for his device that the slickest public-relations man would never go near.

Land is a man of outstanding accomplishment in many fields, but it is difficult to separate those fields because of the pervading sense of wholeness that accompanies his work. Not only must everything he does make sense to him, it must make the same kind of sense. And that is why his scientific achievement with the SX-70 system would be incomplete to him if its users did not understand its humanistic value the same way he does. Also, it is not enough that his employees feel fulfilled in their work, they must also understand the value of that work to Polaroid's individual customers.

Ansel Adams, whose precise and powerful photographic images brought him together with Land when the instant camera was still in its infancy, says of his close friend, "Edwin

Land is a great humanist, and as one science fan told me, that not only has he one of the greatest brains of our age, he has one of the biggest hearts. And I think that's a very fine description."

Commenting on the technical seeds of Land's success, MIT's Dr. Jerome Lettvin said, "Land is a master of timing processes in physical chemistry. All of these things are based on critical timing and that has been the key to his success all along. He has an incredible feeling for what can be done."

And a business associate stated, "I like him in a curious way. He represents one of the magnificent industrial giants, who completely carved out his own place."

So was it primarily his great humanism that allowed him to achieve such formidable heights, or his mastery of a particular phase of chemistry, or merely the will to carve out his own place? Of course it is all of these things, and many more. There is no careful delineation between traits, and one phase of his personality overlaps another. This is seen most concretely in his writing. Even in articles for straight-laced scientific journals, Land permits himself the freedom to diverge from the norm. In "Absolute One-Step Photography," for example, instead of employing the characterization, "integral film packet," Land writes that the "film packet is so beautifully self-contained."

His annual chairman's letters to Polaroid stockholders are totally anomalistic to the standard fare of corporate prose. The letter dated March 25, 1974 (and this was going to 38,000 ordinary shareholders) began, "This annual report, like those of all dynamic companies, must have a Bergsonian flavor: the present is the past biting into the future."

A year earlier he had begun his letter, "To describe this most extraordinary year requires a sentence with Rabelaisian sweep." Hardly ever do the subjects of profit, loss, or capital intrude into the chairman's messages to his investors. Other corporate leaders might head up businesses. Land sees himself as heading up an "experience."

Any man in Land's position must certainly possess an ego

of monumental proportions. Land is no exception. Any statement coming from him or a high Polaroid official that is not stated in the superlative is likely to be suspect. During student seminars he has casually put down the chalk and stopped his equations long enough to make reference to "my wonderful camera."

He characterizes his inventions and discoveries as among the most significant in American social and technological history. It is most apparent in Land's frequently drawn analogies to the telephone, as if the SX-70 will not be considered to have achieved its full and rightful impact until it matches the telephone's ubiquity.

At the 1972 annual meeting, "My fantasy is that this camera will be as widely used as the telephone."

To *Time* magazine, also in 1972, "I think this camera can have the same impact as the telephone on the way people live."

And in the 1973 annual report,

> It is as if the telephone company, having learned to build instruments, transmission lines and switching stations, suddenly stood ready to encourage people to try talking over the system in order to find new ways in which people's lives could be enriched by the use of the telephone.

Coincidentally, Land maintains his private office and laboratory in the same Cambridge complex in which Alexander Graham Bell perfected the telephone. His spiritual affinity with the father of America's greatest technological invention is probably more complete than even he would care to admit.

However, when speaking of their own encounters with him, Land's associates seldom mention his ego. Actually, in one-to-one situations he is often retiring. A Polaroid employee who works closely with Land noted that he is always tense and ill at ease before sitting for one of the rare interviews he gives. He reportedly frets that he is going to be misunderstood because he tends to express his thoughts at

length, formulating his responses as he talks. His days of concise, competitive interscholastic debate have transformed themselves into his showman-like public demonstrations, during which he can exert the full measure of control that is so important to him.

Now close to 70, Din, as he is called by his friends, has not diminished the pace of his activity or the scope. He still maintains the same all-consuming dedication to the company and his research. One snowy morning in the late 1950s, it suddenly occurred to him that one day the snow might keep him from driving from his home to the office, so he bought a four-wheel-drive vehicle to prevent this unspeakable predicament from happening. Land's concentration on work several years ago led him to give up his interest in tennis and sell the summer home he and his wife owned in New Hampshire.

Land's home in Cambridge, which he and his wife have occupied for several decades, is a large, comfortable, clapboard building, but it is not nearly the nicest on the block (though Land is certainly by far the wealthiest of his neighbors). The guards who now protect Land's house around the clock occasionally peer into the living room of one of his neighbors, fellow inventor Henry Kloss (of KLH and Advent fame) to watch Kloss's giant VideoBeam television. Automobiles are another of the material realms which do not interest Land. Unlike the vehicles of William McCune, who is a sports car fanatic, close associates could not remember any of the cars Land has owned, with the exception of the Land Rover. And one stated that this was the only car Land was ever enthusiastic about. (One must assume that the coincidence of names had no bearing on the preference.)

With Polaroid's marketing plans for all major products now being implemented, Land is spending much of his time on research related to further advances in Polavision and new SX-70 films. He continues to consult with William McCune and other officers, and reviews most of the corporate advertising for style and taste. He is also deeply involved with his

retinex theory, one which he perceives bears relevance to all peoples' relationship to the physical world. And his philosophy and vision continue to be bound up in an ideal of the way people *should* live and work: "Optimism is a moral duty."

According to the 1977 *Fortune*-500 listing, Polaroid was the 239th largest industrial corporation in the United States, a major company with more than $1 billion a year in revenues. "Land is no longer the emperor he was prior to the SX-70," commented one analyst.

"Ultimately, the company got so large it was taken over by the managers," said a former employee.

Though he no longer rules Polaroid on a personal basis, Edwin Land still dominates his company to an extent virtually unmatched in American business today. There seems to be little room left in the modern corporate structure for men of Land's magnitude. The Edisons, Eastmans, Fords, and Disneys, have all died off; Land is, in a sense, an anachronism.

Even at a time when the company is anxious to point out that the new generation of management has the situation well in control, Land's presence is still felt as strongly as ever. Though Land is far from being the only inventor inhabiting the Polaroid research laboratories, his interests, confidence, and personal dreams have determined each direction the company has followed. Will another individual emerge with both his inherent authority and his persistence of vision? Or will Polaroid's corporate direction be determined by the committee system in the future?

Regardless of Land's pervasive influence as Polaroid's single guiding force, the corporation will probably survive his loss at least as well as the Ford Motor Company survived the loss of Henry Ford and Eastman Kodak weathered the loss of George Eastman. Whether the basic nature of the institution Land created will remain the same is a matter of speculation. One corporate structure that is often compared with the relationship between Land and Polaroid is that of Walt

Disney Productions. In both cases, the product and social impact of the company arose out of the imagination of one master.

When Walt Disney died in 1966, numerous observers predicted that the organization would not long outlive the Mouse King, just as many predict that Polaroid cannot continue in the same spirit without Edwin Land. But Disney Productions did survive, and continues generating both product and profit at an unprecedented rate. On the other hand, while the company is still brilliantly successful—in television and films and the two theme parks—it has not moved out in any new creative directions since Disney's passing. Instead, it has optimized what was already in the hopper when he died. Polaroid's second-generation leadership must obviously be cognizant of the lesson in this for them.

With the less personalized management style dictated by Polaroid's growing size, the same question applicable to all major corporations that started from a single idea can be asked of Polaroid today, namely: If a young Edwin Land showed up now with unique ideas and no college degree, would he be welcome? More than one person with a practical, original concept has reported that Polaroid has been extremely reticent in accepting new ideas from the outside. This could be a sign of the rigidity that often accompanies growth in size, or it could be another manifestation of Land's control drive, or it could be that the ideas in question simply were not worthy.

Land himself offers little seriously on the subject of who will come after him at Polaroid. Back in 1970, Philip Siekman wrote, in the November issue of *Fortune,*

When he was recently asked what qualities his successor should have, Land launched into a description of such a paragon of talent, intelligence, and virtue that even he paused, laughed, and said, "We're making him down in the laboratory."

The most carefully Land has publicly addressed himself to this issue was in the interview he gave *Forbes* in June 1975:

There is only room for one of me in this company, and if while the one is there, all the others are growing and learning, the worst thing that could happen is that we could become one of the two or three best companies in photography and running along steadily. The best thing that could happen is that we would not merely do that, but one or two or five of the young people around me—the apprentices in every sense—will take over and we might go three or four times as fast.

In that same *Forbes* interview, Land was asked how he sees himself. His self-evaluation was no less ambitious than his evaluations of the products that are inextricably tied to his personality. And it should come as no surprise that this was so.

I suppose that I am first of all an artistic person. I'm interested in love and affection and sharing and making beauty part of everyday life. And if I'm lucky enough to be able to earn my living by contributing to a warmer and richer world, then I feel that it is awfully good luck. And if I use all of my scientific, professional abilities in doing that, I think that makes for a good life.

At the basis of his entire being is this regard for the possibilities of science to better the human lot. "It bothers us at Polaroid," he said in 1972, "to see a world that could be ever so much more tender and beautiful if the full potential of science were realized."

As a 13-year-old, I came away from the 1964 New York World's Fair dazzled by the exhibits of General Motors, General Electric, the Bell System, and several others. GM's Futurama featured an incredible moving diorama of a city of tomorrow, aesthetically pleasing, free of traffic snarls, a compelling vision of what the future held in store. At the time, I was fully convinced, as the exhibitors would have had

me be (and as my father had been at the 1939 Fair) that an infinitely perfectable world lay before us, and it would be the doing of the scientist. Edwin Herbert Land, one of the preeminent philosopher-scientists of our age, apparently still feels that way.

Appendix

EDWIN HERBERT LAND—
Curriculum Vitae

Chairman of the Board, Director of Research, Chief Executive Officer. Former President and Chief Operating Officer, Polaroid Corporation, Cambridge, Massachusetts 02139

Business Address

549 Technology Square
Cambridge, Massachusetts

Birth

May 7, 1909, Bridgeport, Connecticut

Education

Norwich Academy
Harvard University (no academic degree)

Honorary Degrees

Sc.D. Tufts College, 1947
Sc.D. Polytechnic Institute of Brooklyn, 1952

LL.D. Bates College, 1953
Sc.D. Colby College, 1955
Sc.D. Harvard University, 1957
Sc.D. Northeastern University, 1959
Sc.D. Carnegie Institute of Technology, 1964
LL.D. Washington University, 1966
Sc.D. Yale University, 1966
Sc.D. Columbia University, 1967
LL.D. University of Massachusetts, 1967
L.H.D. Williams College, 1968
Sc.D. Loyola University, 1970
Sc.D. New York University, 1973

Fellowships and Honorary Memberships

American Academy of Arts and Sciences, Fellow, 1943–;
 President, 1951–1953
Sigma Xi, Harvard Chapter, 1946–
Photographic Society of America, Fellow, 1950–
Optical Society of America, Director, 1950–1951;
 Honorary Member, 1972–
National Academy of Sciences, Fellow, 1953–
American Philosophical Society, 1957–
Society of Photographic Scientists and Engineers, Honorary
 Fellow, 1957–
New York Academy of Sciences, 1957–
Royal Photographic Society of Great Britain, Fellow, 1958–
Royal Microscopical Society, Honorary Fellow, 1958–
German Photographic Society, Honorary Member, 1963–
National Academy of Engineering, 1965–
The Royal Institution of Great Britain, Honorary Member,
 1974–
Phi Beta Kappa, Harvard Chapter, Honorary Member, 1977–

Awards

Hood Medal, Royal Photographic Society, 1935
Cresson Medal, Franklin Institute, Philadelphia, 1937

John Scott Medal and Award, Philadelphia City Trusts, 1938

National Modern Pioneer Award, National Association of Manufacturers, 1940, 1966

Rumford Medal, American Academy of Arts and Sciences, 1945

Certificate of Appreciation, United States Army, 1947

Certificate of Appreciation, United States Navy, 1947

Holley Medal, American Society of Mechanical Engineers, 1948

Duddell Medal, Physical Society of Great Britain, 1949

Progress Medal, Society of Photographic Engineers, 1955

Potts Medal, Franklin Institute, Philadelphia, 1956

F.W. Brehm Memorial Lecture Medal, 1957

Progress Medal, Royal Photographic Society of Great Britain, 1957

Progress Medal, Photographic Society of America, 1960

Jefferson Medal, New Jersey Patent Law Association, 1960

Golden Society Medal, Photographic Society of Vienna, 1961

Presidential Medal of Freedom, 1963

Proctor Award, Research Society of America, 1963

George F. Kettering Award, 1964

Industrial Research Institute Medal, 1965

Popular Science Award, 1966

Albert A. Michelson Award, 1966

Diesel Medal in Gold, German Association of Inventors, 1966

National Medal of Science, 1967

Frederic Ives Medal, Optical Society of America, 1967

Kulturpreis, Photographic Society of Germany, 1967

Cosmos Club Award, 1970

Photographic Science and Engineering Journal Award, 1971

Founders Medal, National Academy of Engineering, 1972

Interkamera Award, 1973

Award for Distinguished Contribution to Communication Arts, University of Miami, 1973

Karl Fairbanks Memorial Award, 1973

Kosar Memorial Award, Society of Photographic Scientists and Engineers, 1973

Perkin Medal, 1974
Vermilye Medal, Franklin Institute, Philadelphia, 1974
ASMP Technical Achievement Award, 1975
Lieven-Gevaert Medal, Society of Photographic Scientists
 and Engineers, 1976
National Inventors Hall of Fame, 1977
Saturday Review Honor Roll, 1977

Academic and Civic Activities

Member, Visiting Committee, Department of Physics, Har-
 vard University, 1949–1966, 1968
Fellow, Massachusetts Institute of Technology, School of
 Advanced Study, 1956–
Visiting Institute Professor, Massachusetts Institute of Tech-
 nology, 1956–
Member, President's Science Advisory Committee, 1957–
 1959
Consultant-at-Large, President's Science Advisory Commit-
 tee, 1960–1973
Member, President's Foreign Intelligence Advisory Board,
 1961–
Member, National Commission of Technology, Automation
 and Economic Progress, 1964–1966
William James Lecturer on Psychology, Harvard University,
 1966–1967
Member, Carnegie Commission of Educational Television,
 1966–1967
Trustee, The Ford Foundation, 1967–1975
Member, President's Committee on the National Medal of
 Science, 1969–1972
Morris Loeb Lecturer on Physics, Harvard University, 1974

United States Patents

507

Bibliography

Most of the written material used in researching this book was in the form of periodicals covering the period of Polaroid's founding in 1937 through December of 1977. Those publications, to which I am indebted, include the following:

Advertising Age
The Boston Globe
Business Week
Forbes
Fortune
Life
Modern Photography
The New York Times

Newsweek
Popular Photography
Popular Science
Scientific American
Time
The Wall Street Journal
The Washington Post

In addition, the following books and articles were used in the research for this project:

Adams, Ansel. *Singular Images*. Dobbs Ferry, New York: Morgan & Morgan, 1974.
Butters, J. Keith, and Lintner, John. *Effects of Federal Taxes on Growing Enterprises Study #2*. Boston: Graduate

School of Business Administration, Harvard University, 1944.

Carroll, Jane. "Polaroid—Why They're Marketing a Big Zip." *Boston Phoenix* (October 7, 1975).

Chubb, L.W., Jr. "Polarized Light for Auto Headlights. Part I." *Traffic Engineering* (April, 1950).

Clark, Ronald W. *The Scientific Breakthrough.* New York: Putnam's, 1974.

Dickson, John. *Instant Pictures.* London: Pelham Books, 1964.

Dickson, Paul. *The Future of the Workplace.* New York: Weybright and Talley, 1975.

Editors of Camera Magazine. "A Concise Chronology of Instant Photography 1947–1974." *Camera* (1974).

Editors of Time-Life. *Color.* New York: Time-Life Books, 1970.

Farrer, David. *The Warburgs.* New York: Stein & Day, 1975.

Gooding, Judson. *The Job Revolution.* New York: Walker, 1972.

Heyn, Ernest V. *Fire of Genius.* Garden City, New York: Anchor Press/Doubleday, 1976.

Killian, James R., Jr. *Sputnik, Scientists, and Eisenhower.* Cambridge: MIT Press, 1977.

Kistiakowsky, George B. *A Scientist at the White House.* Cambridge: Harvard University Press, 1976.

Lahue, Kalton C. *Polaroid Photography.* Los Angeles: Petersen, 1974.

Land, Edwin H. "Vectographs: Images in Terms of Vectorial Inequality and Their Application in Three-Dimensional Representation." *Journal of the Optical Society of America* (June, 1940).

———. "A New One-Step Photographic Process." *Journal of the Optical Society of America* (February, 1947).

———. "One Step Photography." *The Photographic Journal* (January, 1950).

———. "Some Aspects of the Development of Sheer Polarizers." *Journal of the Optical Society of America* (December, 1951).

———. "Color Vision and the Natural Image. Part I."

Proceedings of the National Academy of Sciences (January, 1959).

———. "Color Vision and the Natural Image. Part II." *Proceedings of the National Academy of Sciences* (April, 1959).

———. "Experiments in Color Vision." *Scientific American* (May, 1959).

———. "Thinking Ahead: Patents & New Enterprises." *Harvard Business Review* (September-October, 1959).

———. "The Role of Innovation in Organized Society." *Product Engineering* (March 2, 1964).

———. "Absolute One-Step Photography." *Photographic Science and Engineering* (July-August, 1972).

——— "An Introduction to Polavision." *Photographic Science and Engineering* (September-October, 1977).

——— "The Retinex Theory of Color Vision." *Scientific American* (December, 1977).

Land, Edwin H. and Chubb, L.W., Jr. "Polarized Light for Auto Headlights. Part II." *Traffic Engineering* (July, 1950).

Land, Edwin H., Rogers, Howard G. and Walworth, Vivien K. "One-Step Photography." *Neblette's Handbook of Photography and Reprography* (1977).

Manchester, Harland. *New Trailblazers of Technology.* New York: Scribner's, 1976.

Meiselas, Susan (ed.). *Learn to See.* Cambridge: Polaroid Corporation, 1974.

Mumford, Lewis. *The Pentagon of Power.* New York: Harcourt Brace Jovanovich, 1970.

New Hall, Beaumont. *The History of Photography.* New York: Museum of Modern Art, 1964.

Parson, Ann. "Can Art Be Instantaneous?" *Boston After Dark (The Boston Phoenix*—December 28, 1976).

Pollack, Peter. *The Picture History of Photography.* New York: Abrams, 1969.

Unger, Craig. "The Little Camera That Couldn't." *New Times* (November 29, 1974).

Wilson, Mitchell. *American Science and Invention.* New York: Bonanza Books, 1960.

Index